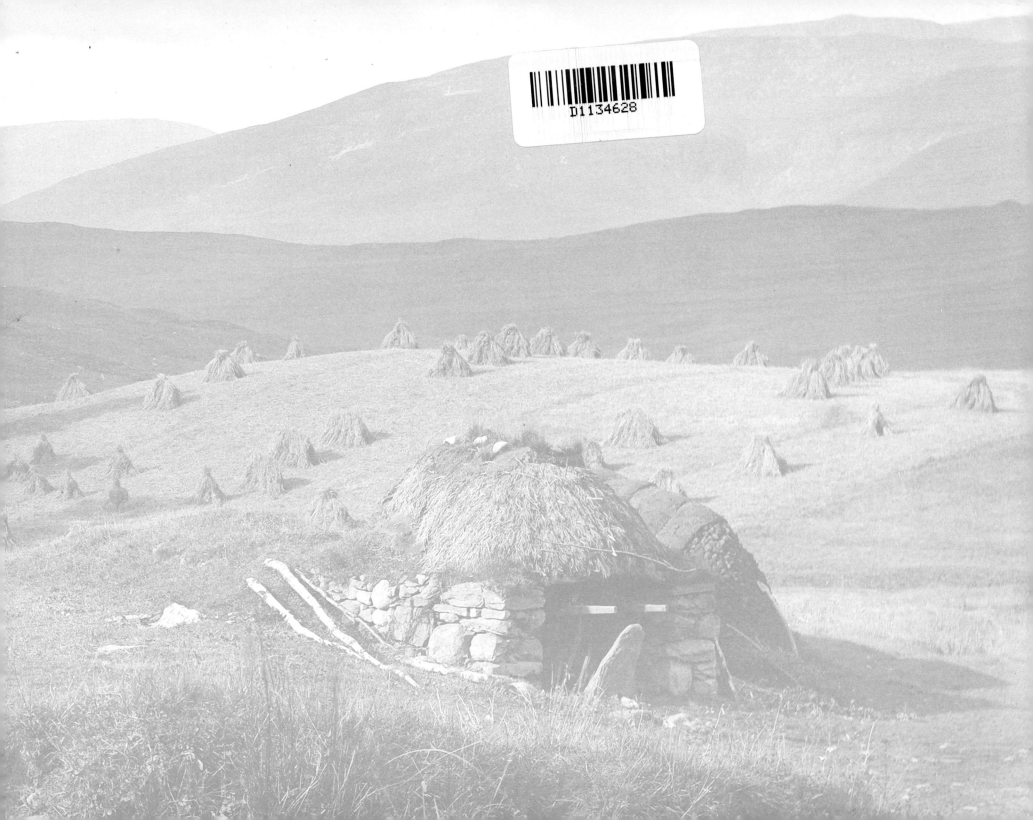

Wanderings with a Camera in Scotland

Wanderings with a Camera in Scotland

The Photography of Erskine Beveridge

Lesley Ferguson

Royal Commission on the Ancient and Historical Monuments of Scotland

**Royal Commission on the Ancient
and Historical Monuments of Scotland**
John Sinclair House
16 Bernard Terrace, Edinburgh EH8 9NX
tel +44 (0)131 662 1456
fax +44 (0)131 662 1477
info@rcahms.gov.uk
www.rcahms.gov.uk

Published in 2009

British Library Cataloguing-in-Publication Data.
A catalogue record for this book is available from
the British Library.

ISBN: 9781902419527
Registered Charity SC026749
Crown Copyright © RCAHMS 2009

Typeset by Mitch Cosgrove
Printed by Gutenberg Press, Malta

Jacket front: Blarmachfoldach, Inverness-shire
1883 (detail). SC746281

Jacket back: Dundas Street, Stromness, Orkney
1894 (detail). SC748821

Front end paper: Glen Scaddle, Argyll 1883
(detail). SC742964

Back end paper: Cuil Bay, Duror, Argyll 1883
(detail). SC1115954

Contents

Acknowledgements

Several individuals have assisted with research for the publication: Isla Robertson, National Trust for Scotland; Neil Maylan; Rachel Hart, St Andrews University Library; and Sara Stevenson, Scottish National Portrait Gallery. Various colleagues within RCAHMS: Jennie Marshall; Michael Marshall; Oliver Brookes; Alan Potts; Rebecca Bailey; Strat Halliday; Heather Stoddart and Kristina Watson. Particular thanks are extended to Kitty Cruft: had she not salvaged the glass plate negatives in the early 1960s, this volume would not have been possible.

Royal Commission on the Ancient and Historical Monuments of Scotland

List of Commissioners

Preface

This volume highlights one small but significant part of RCAHMS' extensive and rich archive. During the survey of an industrial building in Dunfermline in the early 1960s a collection of glass plate negatives was recognised as being the work of Erskine Beveridge and was subsequently deposited in the Commission. A small number of the photographs had been published in Beveridge's volumes on *Coll and Tiree* or *North Uist* but most had not been seen before and offered an insight into life in late-nineteenth- and early-twentieth-century Scotland.

Erskine Beveridge was a photographer of the first rank, and one until now comparatively unrecognised. A wealthy and influential man, he could have contented himself with the usual activities of his class, but instead he pursued his interests in historical research and photography, and must rate as one of the finest amateur photographers of his generation. At a time when Scotland was on the brink of major social and economic change, he recognised the power of the camera to record and document his surroundings and was fascinated, even obsessed, with landscapes, boats, buildings and archaeological monuments.

For that reason his images are not just fine, well-composed representations of their subjects. They also convey a sense of the underlying intangible qualities which made these objects and places meaningful to him. It is this attribute which makes many of his photographs real works of art. He had an acute feeling for place, a consideration which is of critical importance to the continuing work of RCAHMS in recording and collecting.

The photographs in this volume represent only a small selection from the Beveridge collection held in RCAHMS which can be viewed in its entirety through the Canmore database at www.rcahms.gov.uk. There is no doubt that his photographic output was considerably greater than current knowledge would suggest, and RCAHMS would be very pleased to hear of other photographs, and indeed to have more information about this remarkable man.

Scottish Photography: A History by T Normand notes that 'the archive of photography from Scotland is undernourished and incomplete'. This volume, with its biographical introduction and enduring images, provides testament to the talents and skills of Erskine Beveridge as a Scottish photographer.

John R Hume, Chairman
January 2009

Wanderings with a Camera in Scotland

The Photography of Erskine Beveridge

Erskine Beveridge was the owner of a Dunfermline based company specialising in the production of fine table and bed linen, with an active interest and enthusiasm for history and archaeology. He was also a keen and prolific amateur photographer who

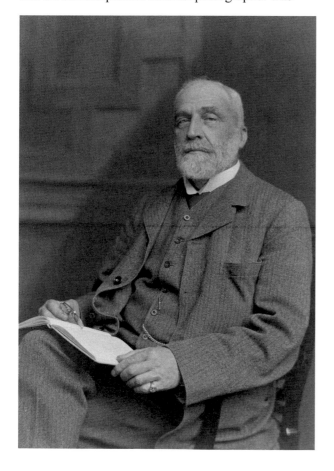

Portrait of Erskine Beveridge (1851–1920). Courtesy of Fife Council Libraries and Museums. SC1106636

took his camera on his travels to America, Canada, Europe and around the United Kingdom. An extensive collection of his glass plate negatives survive today in the archives of the Royal Commission on the Ancient and Historical Monuments of Scotland (RCAHMS), documenting a bygone era of rural and village communities, historic buildings and monuments across the country. This volume provides a biographical introduction to the life and work of Erskine Beveridge and illustrates a small selection of images from this remarkable historic photographic collection.

Born in Dunfermline, Fife on 27 December 1851, Beveridge was the third child of Erskine Beveridge and his second wife, Maria. Living in Priory House, Dunfermline he had a comfortable and secure childhood in one of the wealthiest households of the area, surrounded by an extended family of step-brothers and sisters, and siblings.

Beveridge senior was one of a growing number of affluent linen manufacturers and merchants contributing to the development of the Dunfermline area. Known as 'the successful boy of the family'(Beveridge 1947, 16 inset) he started as a draper's apprentice, and within a few years established his own business in the drapery trade, later focusing on damask weaving. Always with a vision for the future expansion and development of

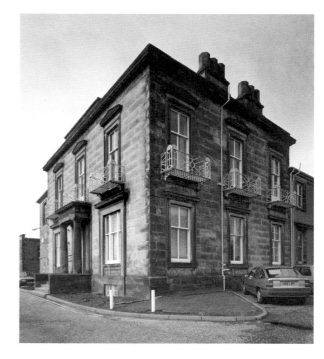

Priory House, Dunfermline, 1994. The childhood home of Erskine Beveridge. Priory House became the administration offices for the Dunfermline and West Fife Hospital (seen here) and has now been converted back into housing. SC1126578

the business, he constructed a factory at St Leonard's, Dunfermline, which was one of the first to use steam power successfully. He recognised the business potential of a direct railway link between Edinburgh and Dunfermline via Queensferry, contributing to influential meetings in the 1860s and offering financial assistance for the formation of such a route.

Table covers by Erskine Beveridge senior, 1851.

© National Galleries of Scotland. Licensor www.scran.ac.uk

With a business focused on quality, he employed the finest designers, including Joseph Neil Paton, and successfully displayed his linen tableware at the Great Exhibition in London in 1851. By 1864 he had expanded the company to employ some 1,500 people. As a businessman and employer, Beveridge senior was highly respected, constructing St Leonard's School for the children of his workers in 1860 and establishing a works library which by 1870 had expanded to hold some 1,500 books.

Away from business, Beveridge senior was active in the town, twice as Provost, a member of the volunteer rifle corps, founder of the Dunfermline Press in 1859, supporter of the Anti-Slavery Movement and the Reform Bill, and a generous benefactor to various churches and other local causes. The Beveridge family could trace their antecedents back eight generations, and one relative described how in the early nineteenth century they had a 'stranglehold on the municipal life' of Dunfermline and that so many Beveridges held office in one guise or another that 'a meeting of the Dunfermline Council must have been like a Christmas family party' (Beveridge 1947, 7).

Beveridge junior was still at school when his father died suddenly in December 1864. As there were several sons from both marriages, provision had been made to safeguard the succession of the business. His uncle Robert, a former accountant of the Chartered Bank of India, managed the Company to allow Beveridge to continue with his education. He matriculated in the Faculty of Arts at Edinburgh University in 1867 where he studied for a number of years before jointly taking over the business in 1874 with his younger brother Henry and older step-brother John. At their father's insistence they had already become familiar with all aspects of the business, working in each area of the factory and were well-prepared to take responsibility for the company. The business continued to thrive under

their direction and in September 1875, Erskine made his first trip to New York on board the Clyde-built *Abyssinia* to explore the highly lucrative North American market. There were tensions amongst the brothers and it was not the most comfortable of working relationships but in 1887, following the death of John, Henry stepped down from the company leaving Erskine in charge.

Having bought the entire St Leonard's factory, Beveridge was now the sole owner of a thriving business producing elaborately designed damask linen. He displayed great business aptitude and under his direction the firm expanded and prospered, building a new factory in Cowdenbeath in 1890, and purchasing two further factories in Ladybank and Dunshalt in 1903.

In his private life, he was a happy and committed family man marrying Mary Owst in Leeds in 1872, where their first son Erskine Owst Singleton was born the following year. Five further sons and a daughter (John, Mary, James, David, George,

St Leonard's Mill, Dunfermline, warehouse, c.1885. Built in the 1860s, the warehouse and office building was located next to the factory at St Leonard's. Display rooms showcased the products of the company. The building is now converted to flats with the address Erskine Beveridge Court. SC383645

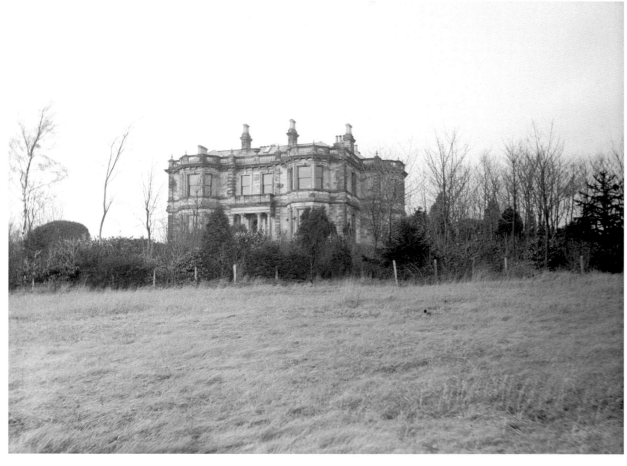

St Leonard's Hill House, Dunfermline, c.1900. Built for his widowed mother Maria, St Leonard's Hill House was also home to Beveridge and his family from the 1870s. SC1117991

Frederick) followed. After the death of his first wife in 1904, Beveridge married Margaret Scott Inglis at Dailly, Ayrshire in 1908 and a further son, Charles, was born in 1910. Sadly, Beveridge's first son, Erskine, spent much of his life in the Crichton Royal Institution in Dumfries and David died on active service in the Gallipoli campaign in 1915. Home was at St Leonard's Hill House, at that time on the southern edge of Dunfermline from where

Beveridge was reputed to drive a carriage pulled by black horses to the factory each day.

Although 'of a retiring disposition' (*Proc Soc Antiq Scot* 55, 1920, 5) and known to have little taste for public debate and controversy, Beveridge held a number of positions within Dunfermline: as Local Councillor, Chairman of the Hospital Committee, Convener of the Baths Committee, Chairman of the Unionist Association, Justice of the Peace and Honorary Sheriff Substitute. He generously supported worthy causes, such as offering warehouse space in an appeal during the First World War for 'comforts for

Indian troops at the front' (*The Scotsman*, 16 January 1915) or contributing financially.

The success of the company brought financial security enabling Beveridge to indulge his interests. One of these was photography, and the collection that survives in RCAHMS reflects his other interests in archaeology and history. As a young boy Beveridge may have encountered the pioneering photographer, David Octavius Hill (1802–1870), who was the son-in-law of Joseph Neil Paton (1797–1874), chief designer in the Erskine Beveridge Company. The earliest evidence of an interest in photography dates to 1867 while he was studying at university. In March he became a member of the Edinburgh Photographic Society and in November was one of the exhibitors in a display of members' photographs. The invention of photography had been announced to the public in 1839 and by the 1860s equipment and processes had evolved considerably, opening the way for the development of both professional and amateur photography.

Ainslie Place, Edinburgh, c.1880. While studying at Edinburgh University from 1867 onwards, Beveridge lived in Great Stuart Street. It is likely that this photograph was taken from one of the upper floors of his 'student flat'. SC520301

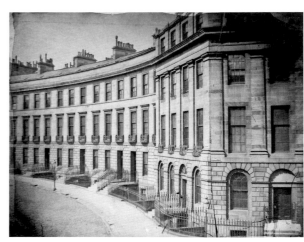

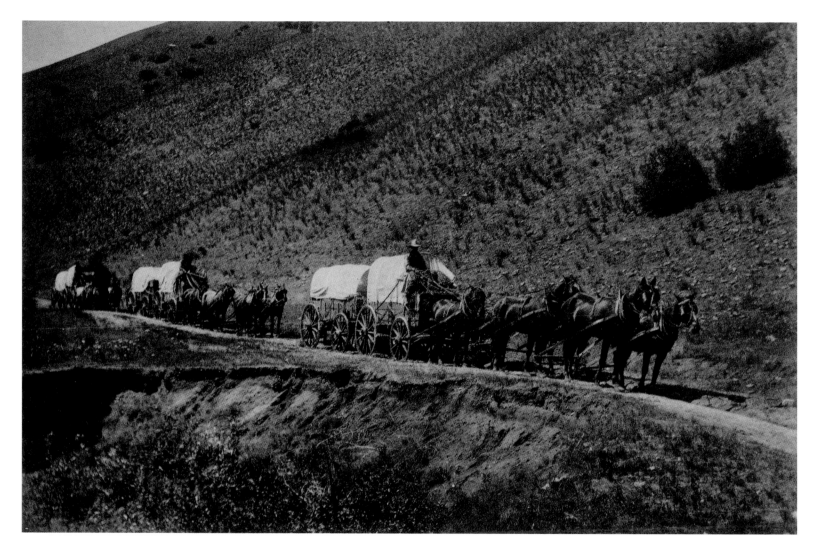

Wagons and team, near Boisé City, Idaho, USA, May 1885. Beveridge made two business trips to North America and Canada in 1875 and 1885. On the second visit, Beveridge took his camera to record his travels. This is one of the photographs published posthumously in Wanderings with a Camera *in 1922. DP042682*

Presentations to the Society in Beveridge's first year of membership would have provided inspiration and introduced him to the work of other photographers, including William Donaldson Clark (1816–1873), primarily a photographer of architecture and landscape, who spoke on his recent photography of Melrose Abbey; and George Washington Wilson (1823–1893), the highly successful commercial photographer who illustrated a talk on a tour of the

Highlands 'by means of oxyhydrogen lantern' (Minutes of the Edinburgh Photographic Society 1867).

As far as can be ascertained from the limited dating information, the earliest photographs in the RCAHMS collection are from the early 1880s, after which a pattern emerges of travels in the summer months, usually holidays but sometimes business trips. A typical year was 1883, when from July until early

October there are photographs illustrating Beveridge's travels in west Scotland using steamers, trains and horse-drawn carriages to visit Appin, Duror, Lismore, Loch Creran, Glencoe, Fort William, Loch Sunart, Loch Shiel, Arisaig, Morar, Mallaig and Eigg.

In March 1885 Beveridge once again sailed to New York, where business was thriving and a warehouse had been established to house goods ready for

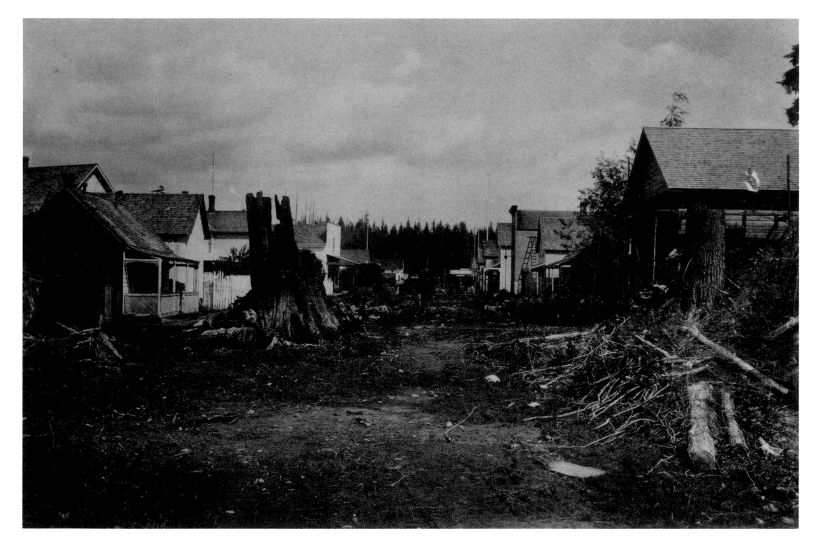

Main Street, Granville, Canada, June 1885. On his trip in 1885, Beveridge spent almost four months travelling thousands of miles across North America and Canada. Clearly an area of forest was felled for the construction of the houses but the massive tree stumps remain. Copied from Wanderings with a Camera, *1922. DP042683*

distribution around the country. Photographs provide evidence of his extensive travels from New York; to St Louis, Missouri; Gunnison, Colorado; Salt Lake City, Utah; Boisé, Idaho; through Canada to Kamloops, New Westminster, Granville and Vancouver Island (all British Columbia); before returning to the USA and visiting California and San Francisco, a journey of several thousand miles lasting almost four months.

The first photographs to be published were specially commissioned by Beveridge's cousin David who lived at Durham House, Torryburn, Fife. Described by a family member as a 'bookworm, great talker and voluminous author' (Beveridge 1947, 16 inset), David produced a volume on the history and antiquities of *Culross and Tulliallan* in 1885, and in the preface thanks Erskine for taking the photographs for the volume. The glass plate negatives of the

Culross area are known to have been rescued from destruction by an Erskine Beveridge Company employee in the 1960s. Beveridge was developing a reputation for the quality of his photographs which appeared in publications such as *The Early Christian Monuments of Scotland* by J Romilly Allen, 1903, or indeed the RCAHMS Inventory of the *Outer Hebrides, Skye and the Small Isles*, 1928, where they were used to excellent effect.

It is clear that Beveridge had a fascination with the past and was keen to engage actively in research to develop and share his knowledge with others. As was typical of the time, he became a collector of artefacts, amassing a substantial collection of objects ranging from prehistoric material through to nineteenth-century agricultural implements. In 1890 he was elected as a fellow of the Society of Antiquaries of Scotland and was Vice President between 1915 and 1918. Membership of the Society as well as other groups such as the Old Edinburgh Club brought Beveridge into social contact with many of the leading archaeologists, historians and other academics of the time. He was one of many people to contribute financially to the 1911 publication of *A Roman Frontier and Its People – the Fort at Newstead* by James Curle. He generously gifted the *Dictionary of National Biography* to the Society of Antiquaries Library, as well as his substantial collection of objects to the National Museum of Antiquities. As President of the Dunfermline Archaeological Society he contributed to the creation of the local museum and was there to welcome Andrew Carnegie at the official opening in 1897.

In the late 1880s, Beveridge spent several successive summers in the East Neuk of Fife photographing the fishing villages and historic buildings, from which some 200 images survive, one of the most extensive components of the collection. He developed a special interest in Crail and undertook detailed research into the graveyard and other antiquities in the burgh, publishing in 1893 *The Churchyard Memorials of Crail*. Aware of the erosion and consequent loss of inscriptions, Beveridge wanted to contribute to the preservation of this historic information. He had earlier commissioned A W Cornelius Hallen (Hallen 1890) to research the history of the Beveridge family in Dunfermline and from his own experience realised the importance of creating a record of inscriptions. Various individuals, such as Andrew Jervise (1820–1878), had been recording gravestone inscriptions

Crail, mural tomb, c.1890. The tomb of William Bruce, laird of Symbister in Shetland, who died c.1630 lies in the churchyard at Crail. Aware of the erosion and damage to graveyard monuments, Beveridge recorded inscriptions in a number of graveyards across Fife and at Crail used photography to create a visual record of the mural tombs. SC388559

in Angus and Fife for some time but Beveridge was one of the first to use photography to document systematically one particular type of graveyard monument. The published volume provides a thorough review of the history of Crail, its church and carved stones, before summarising and illustrating the mural tombs in the churchyard. One hundred and thirteen copies were printed privately and *The Scotsman* reviewer noted 'The "weel-aired ancient toun o' Crail" will henceforth have no reason to complain that its "Churchyard Memorials" have been allowed to drop into the wallet of oblivion without care being taken to examine them' (25 September 1893).

Crail was to be the only volume on graveyards that Beveridge produced, although he recorded inscriptions on early gravestones at Aberdour, Beath, Crombie, Culross Abbey, Culross West, Dalgety, Dunfermline Abbey, Elie, Inverkeithing, Rosyth and Saline between 1893 and 1896, probably with the intention of publishing the results.

A holiday on the islands of Coll and Tiree in 1896 provided the inspiration for research for the next few years. Beveridge traversed the islands exploring archaeological sites, initially focusing on the brochs and duns before extending his interest to ancient monuments generally. Thorough with his research, Beveridge gathered information from local sources; studied the place names, historical records, and accounts of other travellers; reviewed the limited published archaeological sources; and consulted others such as Dr Joseph Anderson (1832–1916), Director of the National Museum of Antiquities. Anderson was one of the most influential and encouraging archaeologists of the time directing many 'gentlemen' in their archaeological endeavours. Beveridge travelled extensively to visit similar monuments for comparative purposes: North Uist in 1897 and thereafter Lewis, Harris, Jura, Colonsay, Knapdale, Glenelg and Sutherland, 'in addition to a somewhat laborious drive in Irish cars round the coast of Donegal'

Valley House, North Uist, shortly after construction, c.1902. Having visited North Uist regularly since 1897, Beveridge bought the estate of Vallay and built this house. He spent most summers there until 1920. The estate was inherited by his son George, who lived permanently here until his death in 1944. SC1117996

(Beveridge 1903, vi). A number of broch sites had recently been excavated in Caithness by Sir Francis Tress Barry, and Beveridge experienced at first hand the results of this work on a visit to Nybster in 1899.

The result of six years' research, *Coll and Tiree: Their Prehistoric Forts and Ecclesiastical Antiquities* was published in 1903, and provided an exhaustive survey of the archaeological remains of the islands. Following guidance from Joseph Anderson, Beveridge described each and every site or place within its geographical context and tried not to draw inferences about the chronology of the different sites. The 300 copies produced were well illustrated with photographs by Beveridge, many of which are included in the RCAHMS collection.

After his initial visit to North Uist in 1897, Beveridge returned annually, purchasing the island of Vallay in 1901. With the estate came land at Griminish, Scolpaig, Balelone and Kilphedar but it was on Vallay that Beveridge decided to build a house.

Constructing a house on a tidal island was an expensive undertaking, with building materials landed by barges on the beach and water piped across the sands. Here he was to enjoy the island life each summer, breeding Highland ponies and exploring the countryside locating and identifying historic sites and monuments. Fishing featured as a pastime with plenty of local potential and, as a subscriber to the Hebridean Sporting Association, he may have fished from their bases at Rodel House and Finsbay Lodge in Harris (Gardner 2008, 198).

Following several years of extensive and detailed research, *North Uist: Its Archaeology and Topography* was published in 1911 and largely followed the same descriptive style as *Coll and Tiree*. However, there was one significant difference – rather than just measuring and surveying the sites, from 1905 Beveridge had started carrying out excavations to clarify his understanding of the remains and to find artefacts. Three hundred and fifteen copies were printed and, as before, were well illustrated with photographs including some views of his excavations.

Valley is particularly rich in archaeological sites and this may have been one of the attractions for Beveridge, who spent several years excavating a number of sites on his estate in the years following the publication of *North Uist*. His excavation techniques were not ideal but were typical for 'gentlemen archaeologists' of the time. Likely sites were located and labourers employed to dig until structural remains were uncovered. The site would then be cleared and all objects removed. Beveridge took a number of photographs to illustrate his discoveries and kept a comprehensive working diary. The First World War brought the work temporarily to a halt but it was resumed in 1919. Draft reports on his discoveries were prepared in anticipation of a publication but Beveridge died before the work was completed. However, the records made by Beveridge were sufficient to enable J Graham Callander (1873–1938), who had succeeded

Erskine Beveridge bookplate. Beveridge was an avid collector of books and gifted much of his personal collection to the Dunfermline Carnegie Library. DP045154

Joseph Anderson as Director of the National Museum of Antiquities of Scotland, to publish a written account of the excavations in the *Proceedings of the Society of Antiquaries of Scotland* in 1930 and 1931.

With a long history of family involvement in Dunfermline, Beveridge undertook extensive historical research into the area, accumulating a unique collection of books, pamphlets and drawings relating to the district which he generously gifted to the town. He worked tirelessly and in 1901 the culmination of twelve years of research came to fruition with the publication of *A Bibliography of Works Relating to Dunfermline and West of Fife*. Well respected by his

contemporaries, and in recognition of his scholarly work on this, as well as the volumes on *Crail* and *Coll and Tiree*, Beveridge was made a Fellow of the Royal Society of Edinburgh and an Honorary Doctor of Laws of the University of St Andrews in 1904.

Beveridge continued his research, spending months transcribing and studying a vast number of historic documents in General Register House in Edinburgh and in the library in Dunfermline, publishing *The Burgh Records of Dunfermline 1488–1584* in 1917. It was indeed a labour of love and was the last volume Beveridge would see through to publication. He died on 10 August 1920 at St Leonard's Hill, Dunfermline, aged 69, leaving manuscripts of two unfinished works.

One of these was a volume relating to the gathering and tabulating of place names containing 'Aber' and 'Inver'. In his earlier research, particularly for *Coll and Tiree* and *North Uist*, Beveridge had discussed the importance of place names for historical research and both volumes contained analyses of the derivation of names. His widow, Margaret, entrusted the final editing of the unfinished manuscript to Walter M Campbell and in 1923 *The 'Abers' and 'Invers' of Scotland* was published. Although a comprehensive volume, the place name research was basic and was to be largely superseded in later years. Beveridge had also been editing a volume of old Scots proverbs from the original printed Latin text of 1641, augmented with an early-seventeenth-century rare pamphlet from his own personal collection. Financial and editorial arrangements were made for the completion of this too, and in 1924 *Fergusson's Proverbs* appeared in print.

After a service in the Holy Trinity Episcopal Church, Beveridge was buried in Dunfermline Abbey Churchyard. He was held in such high regard that ten coaches followed the hearse to the churchyard and a large number of people, including workers from St Leonard's, lined the streets of Dunfermline to pay their respects.

Location Map

Places photographed by Beveridge in Scotland.

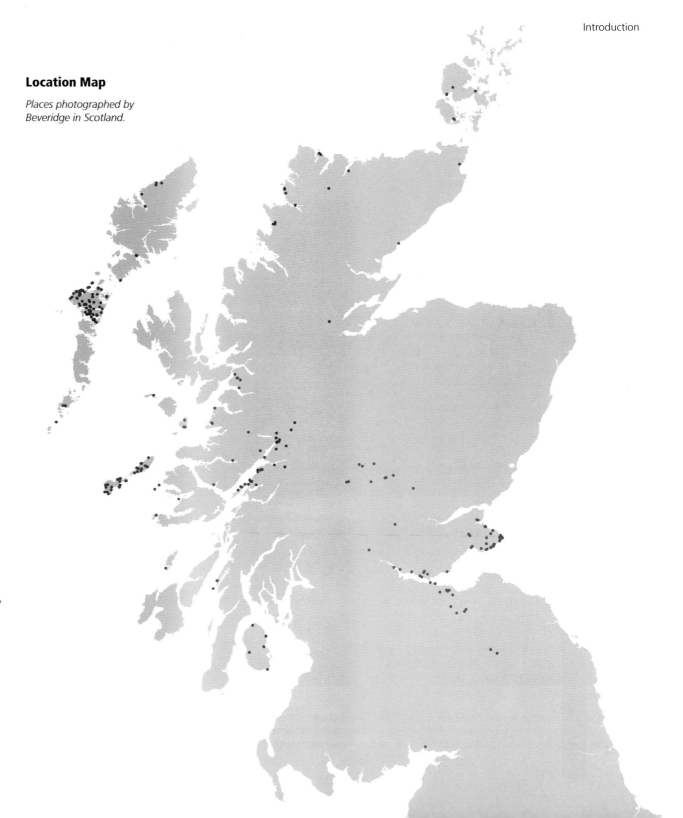

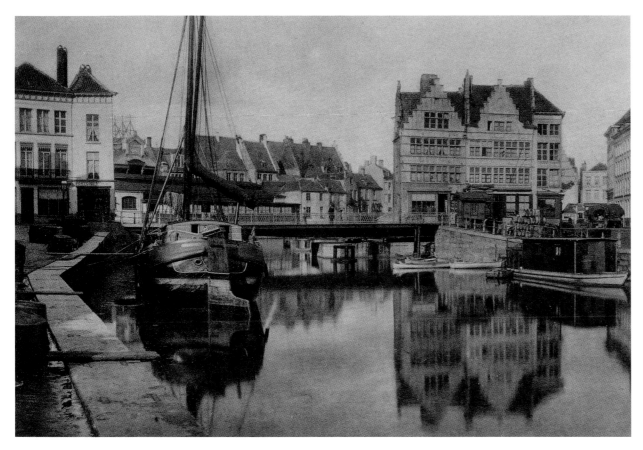

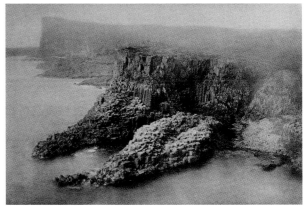

Canal in Ghent, Belgium, September 1894. In 1893 and 1894 Beveridge visited various locations in Belgium and the Netherlands, including Ghent, Dinant, Tournai, Bruges and Maastricht. Copied from Wanderings with a Camera, *1922. DP042687*

The photographs

In the early 1960s some of the buildings at the St Leonard's Works in Dunfermline were being assessed to ascertain whether a survey should be undertaken prior to their demolition. During the survey, some 700 glass plate negatives were discovered and in 1962 the Erskine Beveridge Trustees transferred the collection to the Scottish National Buildings Record (incorporated into RCAHMS in 1966). While the glass

plates were discovered to be by Erskine Beveridge and were identified and catalogued according to their content, their significance as a collection was never fully realised. There is no doubt that the glass plates in RCAHMS represent only a small proportion of Beveridge's total output as a photographer.

The title of this volume, *Wanderings with a Camera*, has been borrowed from a rare work by Beveridge, published posthumously in 1922, which highlights some 300 photographs of his travels in America, Canada, Europe and Scotland between 1882 and 1898. Only fifty copies of the two-volume work were produced for private circulation, with the result that few people have had the opportunity to appreciate

Top: Flax-steeping, Courtrai, Belgium, October 1894. Similar to Dunfermline, the economy in Courtrai was largely based on the flax and textile industries. Copied from Wanderings with a Camera, *1922. DP042686*

Above: Staffa, 1895. Like many Victorian tourists, Beveridge took an excursion to Fingal's Cave, Staffa. This photograph is of the west side of Staffa and is one of many general landscape views taken by Beveridge. Copied from Wanderings with a Camera, *1922. DP042680*

the quality or full range of Beveridge's photography. Unfortunately fewer than 100 of the photographs in the volume survive amongst the glass plate negatives at RCAHMS. In publishing *Wanderings with a Camera* in 1922, Beveridge's son John states that his intention

was to preserve part 'of the result of many years field work by my father' and suggests that the publication of other volumes of imagery had been planned by his father for Caithness; Crail, Anstruther and St Andrews; Culross and Tulliallan; Dunfermline neighbourhood; Leuchars and Earlshall; Lewis; Perthshire, including Rannoch, Crieff, etc.; Sutherland; Bamburgh and Holy Island; Cornwall and Devon; English Lakes; Hampshire and Wiltshire; Hexham and Blanchland; and South Wales.

As well as the glass plate negatives, RCAHMS holds a small number of original photographs illustrating Beveridge's research visits to various brochs in Caithness, Sutherland and Lewis in 1897 and 1900, and to Iona in 1895. Other images have been copied from small collections held elsewhere to establish a comprehensive catalogue of Beveridge's photography accessible through the RCAHMS on-line database. This includes some twenty-five glass plate negatives of historic buildings and monuments in Northumberland held in the National Monuments Record Centre in Swindon, as well as some eighty glass plate negatives in the care of the family of a former employee of the Erskine Beveridge Company. These illustrate Culross and surrounding villages, and include some fascinating interior photographs of the long gallery in Culross Abbey Mansion House and ships in the harbour at Charlestown, Fife. There are also two portraits which are unique amongst the surviving photographs. One is identifiable as his Aunt Jemima (1795–1885) who lived in the Culross area.

The Victorians had embraced the art of photography, and improvements to photographic techniques and equipment gave Beveridge the freedom to travel without the burden of transporting his own darkroom, chemicals and equipment. Ready-made glass plates could be purchased, and processed at a later stage, but the size of the whole-plate camera and tripod, not to mention the weight and fragility of the glass negatives, indicated a level of commitment to the craft.

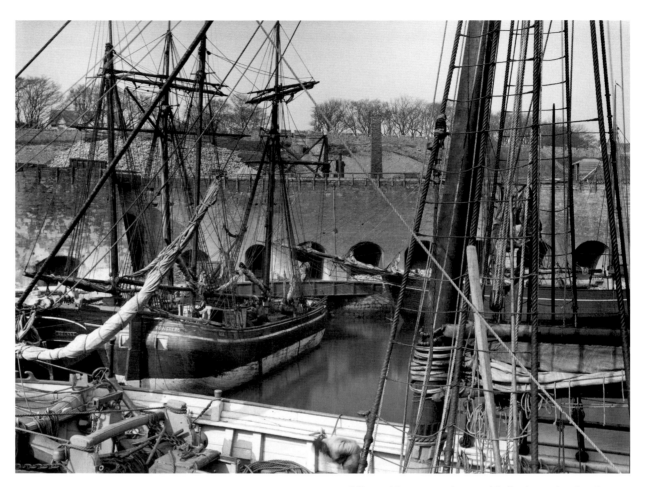

Charlestown, Fife, harbour and limekilns, c.1880. One of a number of places in the vicinity of Culross, Fife, photographed by Beveridge in the early 1880s. His cousin, David Beveridge, a resident of the village, published some of the photographs in Culross and Tulliallan *in 1885. Courtesy of Neil Maylan. SC1125520*

Without surviving journals or photographic logs it is difficult to know the rationale behind the photographs. Whatever the original purpose, there is no doubt that Beveridge was an accomplished photographer. Some of the archaeological sites, by their very nature, were decidedly not photogenic,

and Beveridge, sometimes with forthcoming books in mind, was essentially taking photographs for illustrative purposes. For other views, such as the island duns, Beveridge structured the images to provide a sense of purpose for the sites and, in comparison to other contemporary views of the same sites, successfully captured the excitement of such monuments. His composition was skilful, deliberately incorporating the landscape into many of his rural photographs to convey the atmosphere of the places. People appear in many of the views of houses or street scenes, often standing relaxed in doorways or in groups, but never as the central subject of the

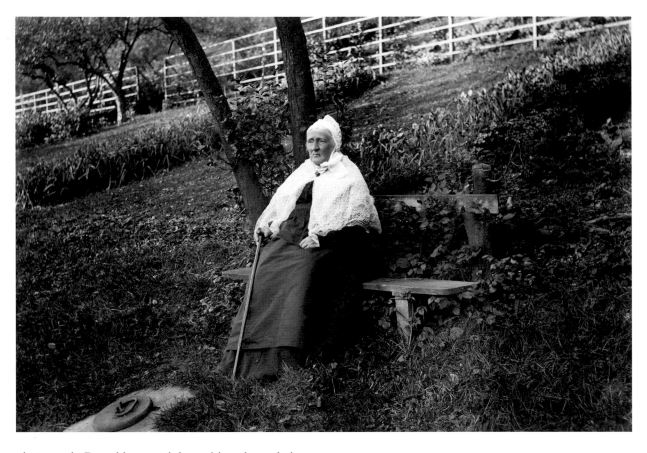

Jemima Watt, c.1883. This is a rare example of a family portrait by Beveridge. Known as 'Aunt Henry', Jemima (1795–1885) resided at various houses in the Culross area and this was probably taken at Keavil in 1883–84. Her son David was the author of Culross and Tulliallan *and her grandson was Lord William Beveridge (1879–1963), economist and social reformer. Courtesy of Neil Maylan. SC1129266*

photograph. Beveridge certainly positioned people in some of the shots, occasionally as a scale or in some instances he even took two photographs of the same view, one with people and the other without. In the 100 years or so since Beveridge was photographing Scotland, the landscape and economy of the country has changed drastically adding to the significance and importance of the surviving images documenting this bygone era.

Beveridge was a remarkable man: an astute and successful businessman, accomplished photographer and author of historical and archaeological works. Hopefully, through this volume his photographic legacy is secure.

Publications of Erskine Beveridge

1893 *The Churchyard Memorials of Crail*

1901 *A Bibliography of Works Relating to Dunfermline and West of Fife*

1903 *Coll and Tiree: Their Prehistoric Forts and Ecclesiastical Antiquities*

1911 *North Uist: Its Archaeology and Topography*

1917 *The Burgh Records of Dunfermline 1488–1584*

Published posthumously

1922 *Wanderings with a Camera 1882–1898* edited by John Beveridge

1923 *The 'Abers' and 'Invers' of Scotland*

1924 *Fergusson's Proverbs*

Fife

The map shows locations in Fife:

Dundee

Leuchars • Earlshall
St Andrews
Boarhills
Craighall Castle • Kingsbarns
Kellie Castle • Crail
Upper Largo • Kilrenny
Lower Largo • Anstruther
Kilconquhar Pittenweem
St Monance

Kirkcaldy

Tulliallan • Dunfermline

Edinburgh

Glasgow

The county of Fife was the area most intensively photographed by Beveridge between 1880 and 1890. As well as being the location of his home and that of his family, he was to spend three successive summers in the East Neuk of Fife. Beveridge photographed the fishing communities, with their distinctive buildings and harbours, at a time when the East Neuk had become a popular destination for tourists following the opening of the railway in the 1880s.

Many of the views are recognisable today but, by documenting some buildings which have since been demolished, Beveridge has provided a valuable record.

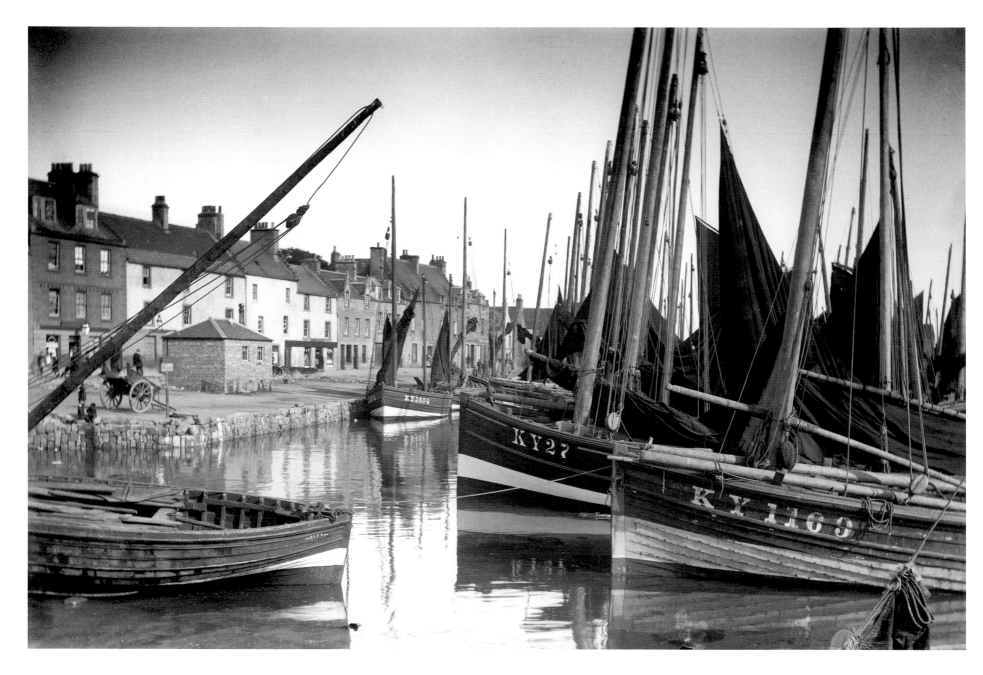

Anstruther Easter, harbour, c.1885. This was once the main herring port in Scotland. These Kirkcaldy registered sailing boats are of the 'Fifie' type, a local two-masted design. SC747686

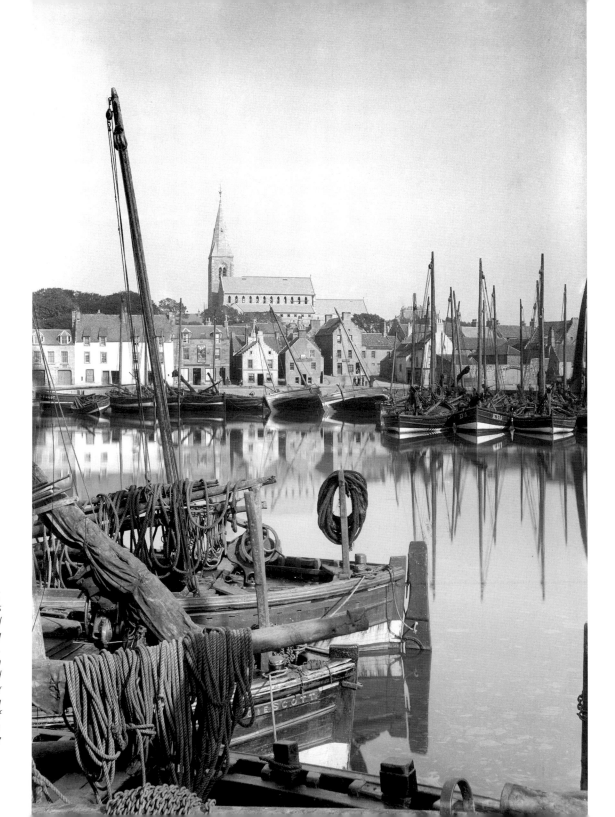

Anstruther Easter, harbour, c.1885. When this was taken, Chalmers Memorial Church on the hill was being built (scaffolding is visible). It opened for worship in 1889 and was demolished in 1991. This is one of many photographs highlighting the quality and clarity of Beveridge's photography. SC747687

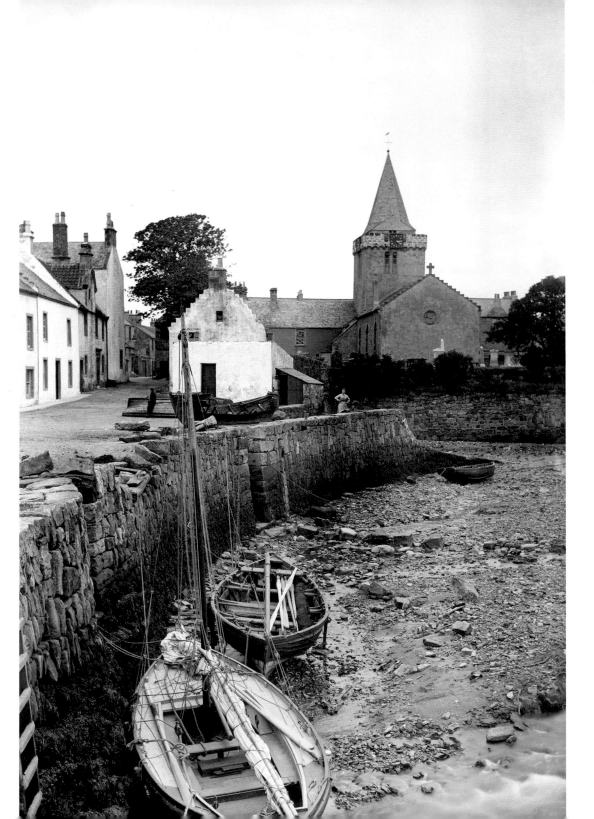

Anstruther Wester, harbour and former Parish Church, c.1885. The former Parish Church with adjoining graveyard is separated from the sea by a high wall. The gap in the pier wall leads down to stepping stones crossing the Dreel Burn to Anstruther Easter: some of the stones are just visible. SC747690

Anstruther Wester, The Esplanade, c.1885. Fishermen preparing their nets on The Esplanade with fine examples of early-eighteenth-century houses and the former parish church behind. SC747688

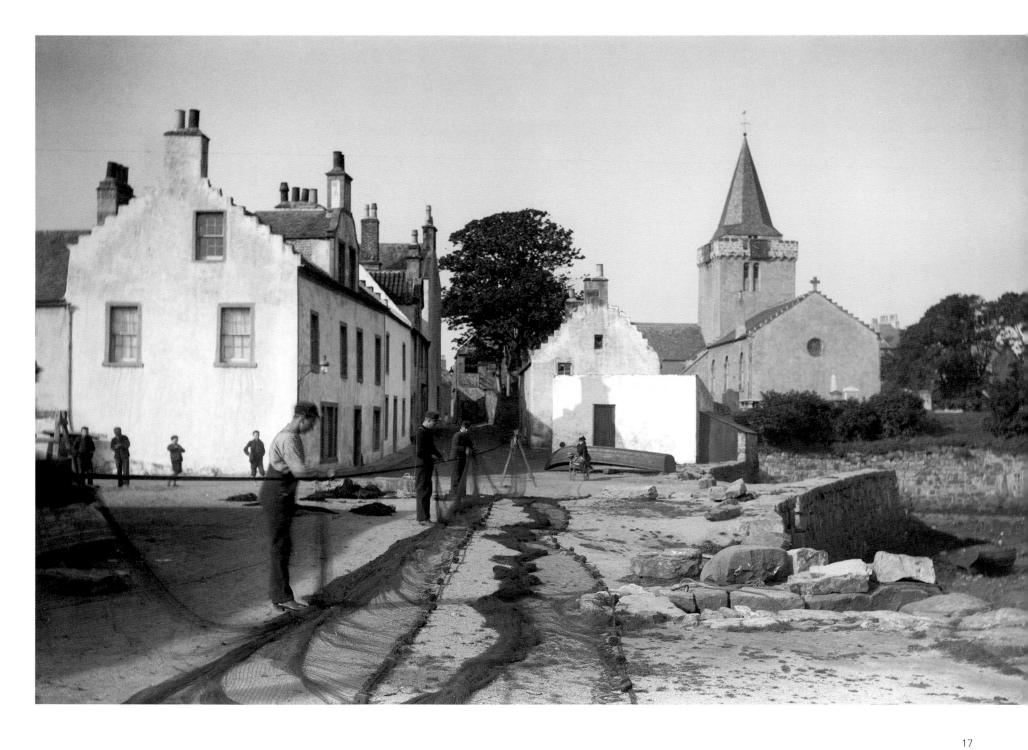

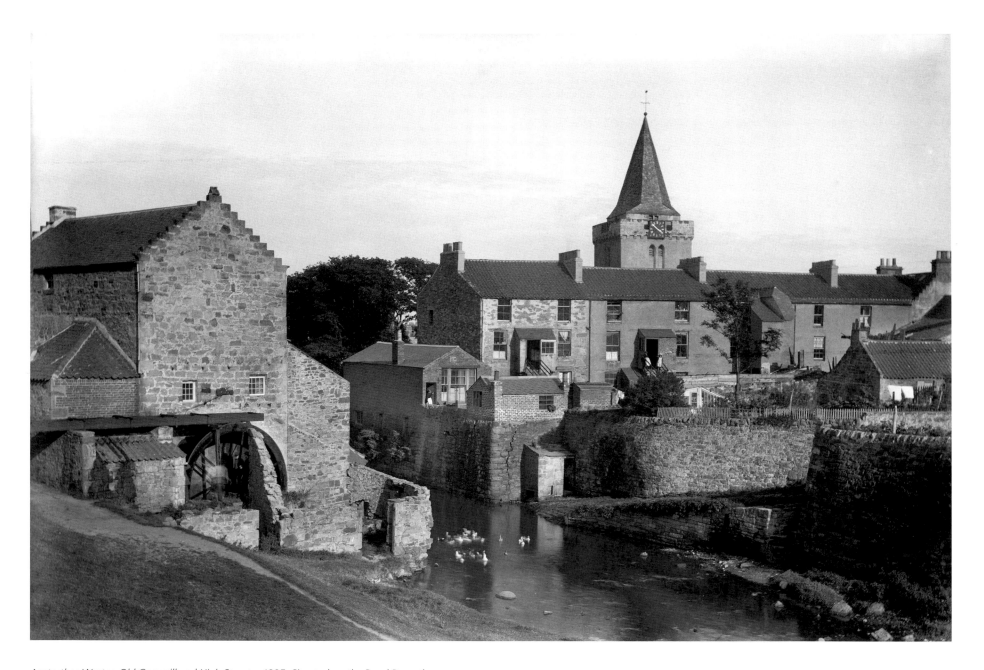

Anstruther Wester, Old Cornmill and High Street, c.1885. Situated on the Dreel Burn, the Old Cornmill was built in 1702 and has now been converted to a private house. People from the houses on the High Street are enjoying the late afternoon sunshine. SC387090

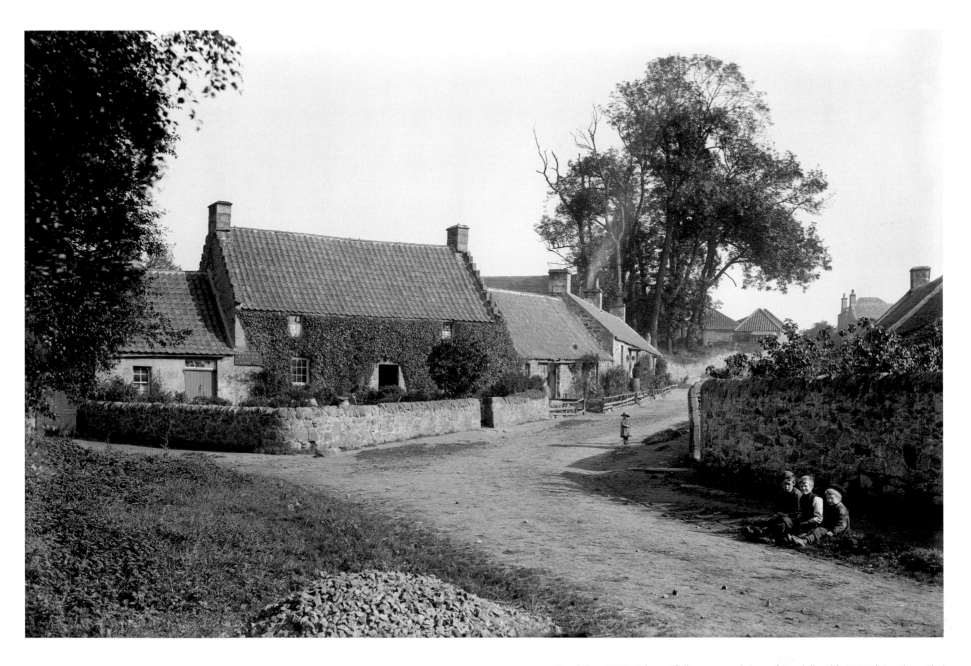

Boarhills, c.1885. A beautifully composed view of Boarhills with its traditional pantiled cottages. The sign on the wall of the ivy-covered house reads 'Arthur Scot, Grocer'. Three boys have been positioned discreetly in the shadow on the right. SC747775

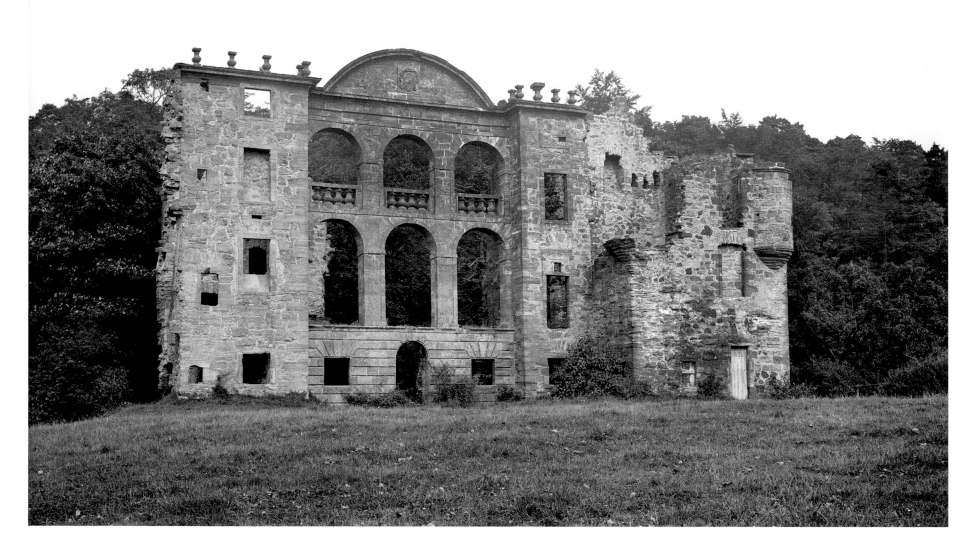

*Craighall Castle, 1889. The ruin of the early
seventeenth century Craighall House which
was demolished in 1955. SC739304*

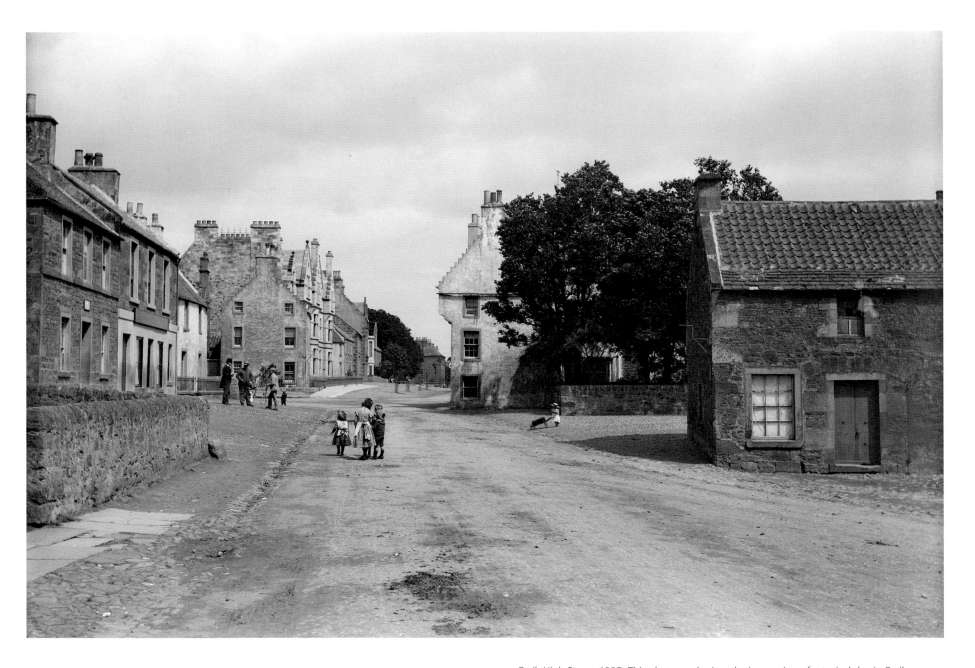

Crail, High Street, 1885. This photograph gives the impression of a typical day in Crail: a group of men stand chatting; an artist works at his easel; three children walk away from the camera; and a rather forlorn looking child stands with a wooden wheelbarrow. SC739242

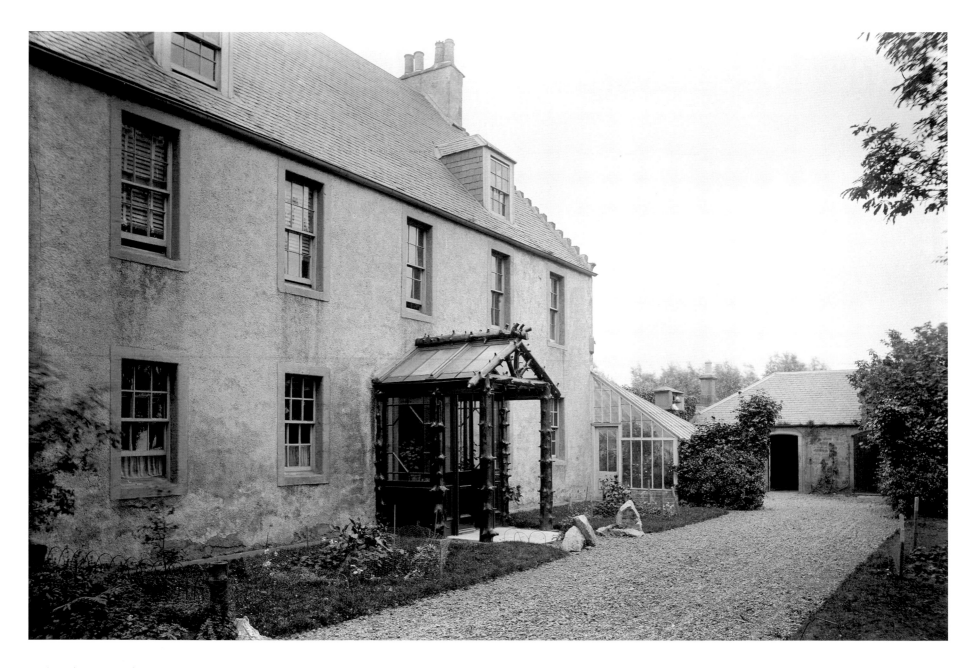

Crail, Marketgate, Denburn House, c.1890. Standing within a large walled garden, Denburn House is one of several large houses built in Marketgate in the eighteenth century for wealthy merchants. SC739193

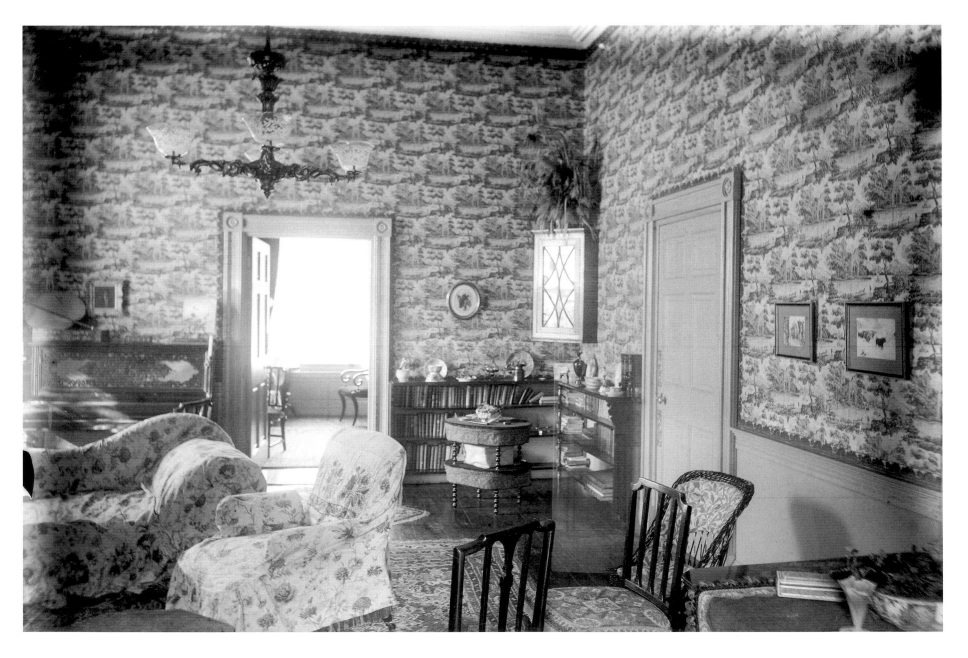

Crail, Marketgate, Kirkmay House, 1885. Described in 1845 in the Statistical Account of Scotland as 'the finest modern structure in the parish', Kirkmay House was built in the Marketgate in 1817 for Robert Inglis, a tea and coffee importer. This is one of only a small number of interior photographs taken by Beveridge: here illustrating the décor of the Victorian drawing room. SC739265

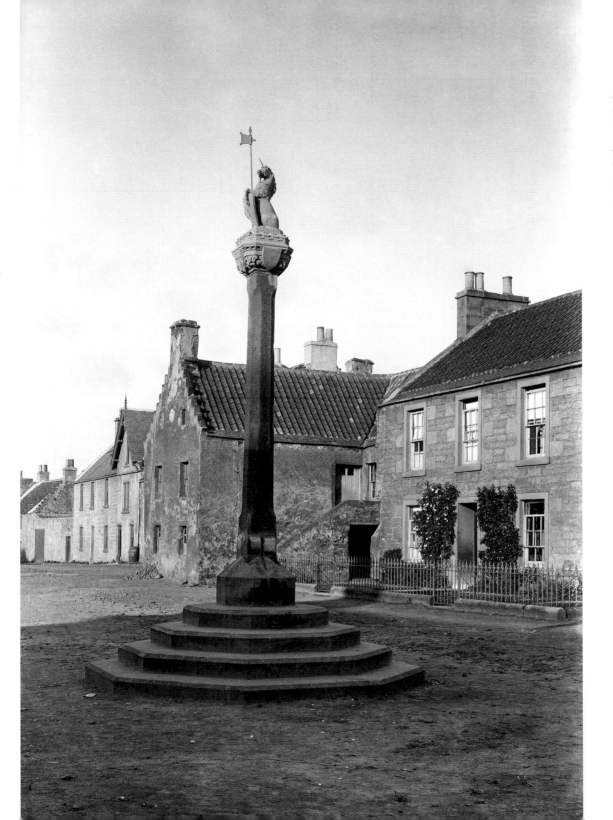

Crail, Market Cross, c.1890. A symbol of the town's authority, the cross was re-erected at this location for Queen Victoria's Golden Jubilee in 1887. Beveridge spent several successive holidays in the East Neuk of Fife and became particularly interested in the history of Crail. SC739271

Crail, Marketgate, c.1885. This late afternoon autumn view of the Marketgate is centred on the tolbooth and the whitewashed Golf Hotel. Crail once held one of the largest medieval craft markets in Europe. Permanent stalls or luckenbooths were erected near the tolbooth so that the townguard were close by to prevent theft of highly valued goods. The children may be Mary and James Beveridge, accompanying their father. SC739288

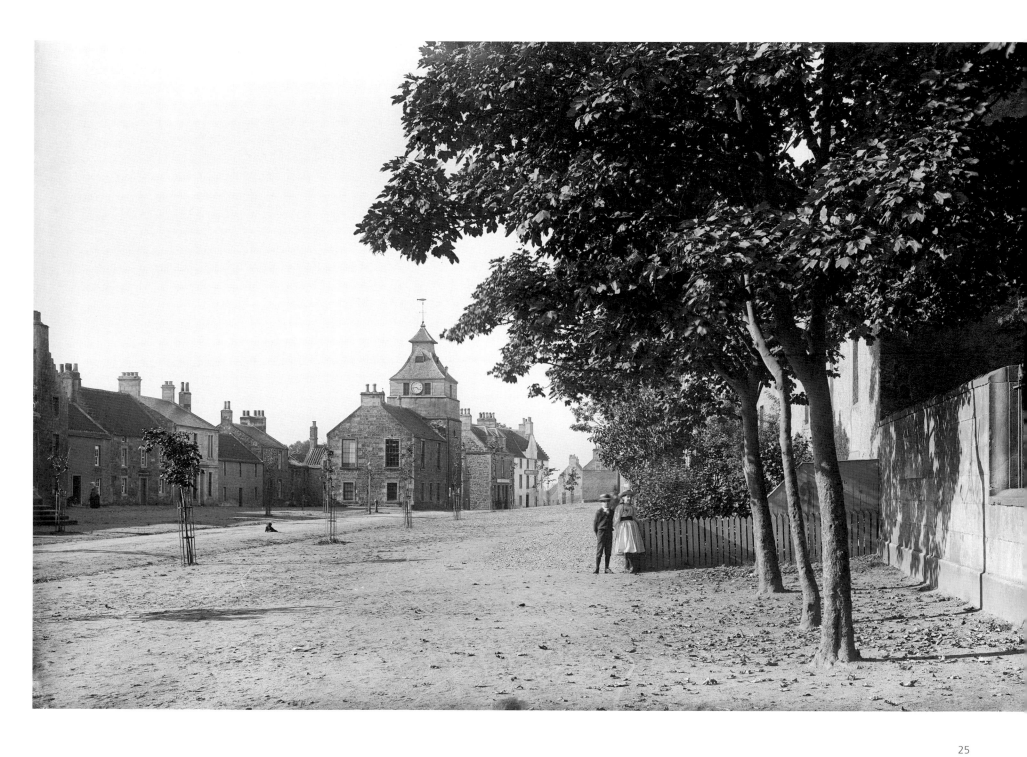

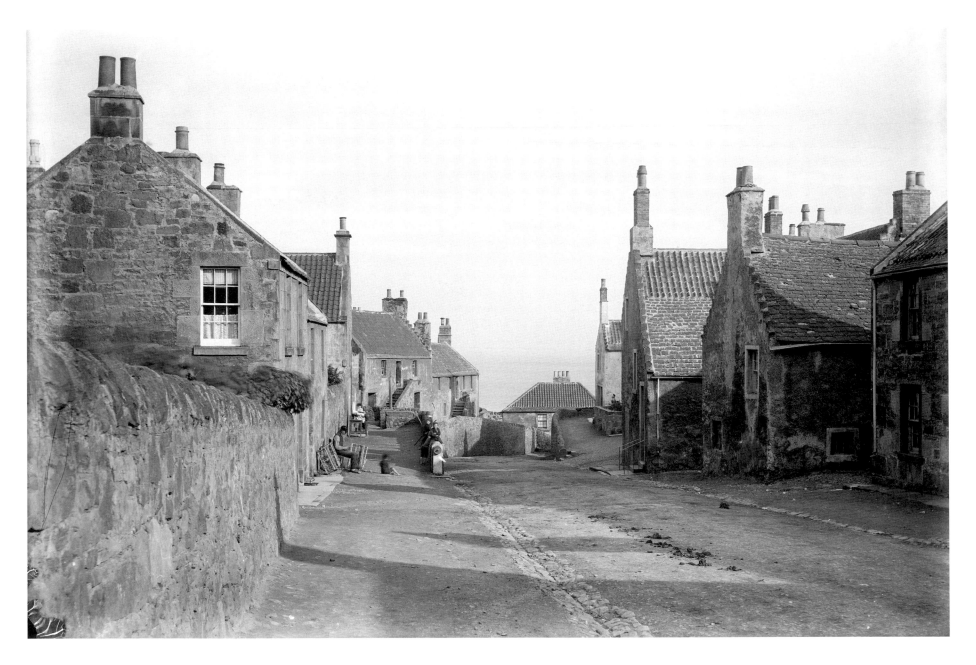

*Crail, Shoregate, c.1885. The oldest street in Crail leads from the harbour to the High Street.
Crail was famously known for its sun-dried haddocks, 'Crail capons', but fishermen also
caught shellfish. Here a fisherman sits outside possibly repairing a creel. SC388538*

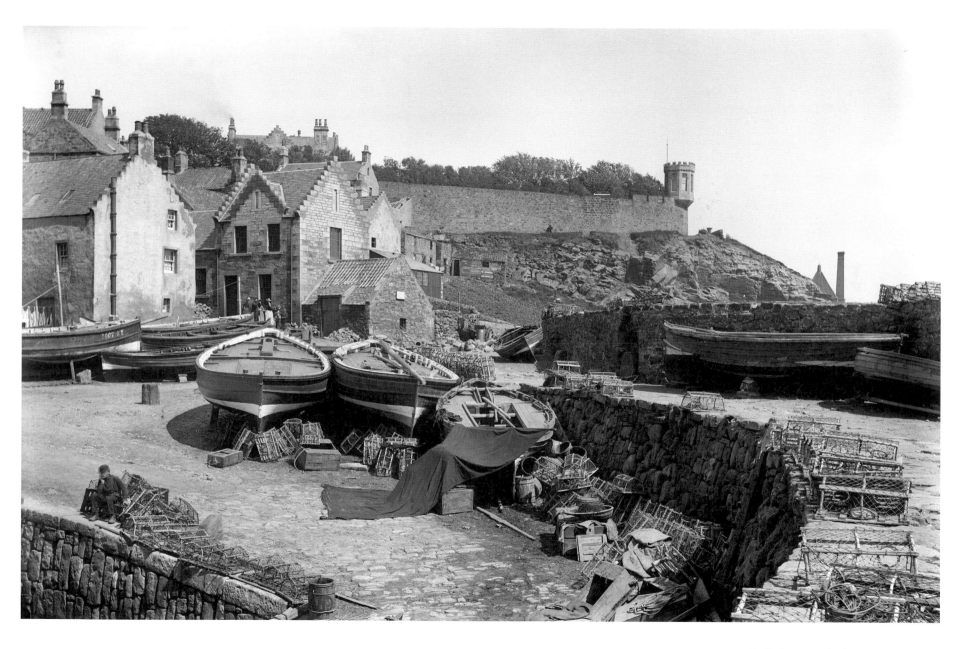

*Crail, Shoregate, harbour, 1890. Similar to
the previous view but taken a few years later.
An octagonal Victorian gazebo with crenellated top
has been built into the wall of Crail Castle. SC388584*

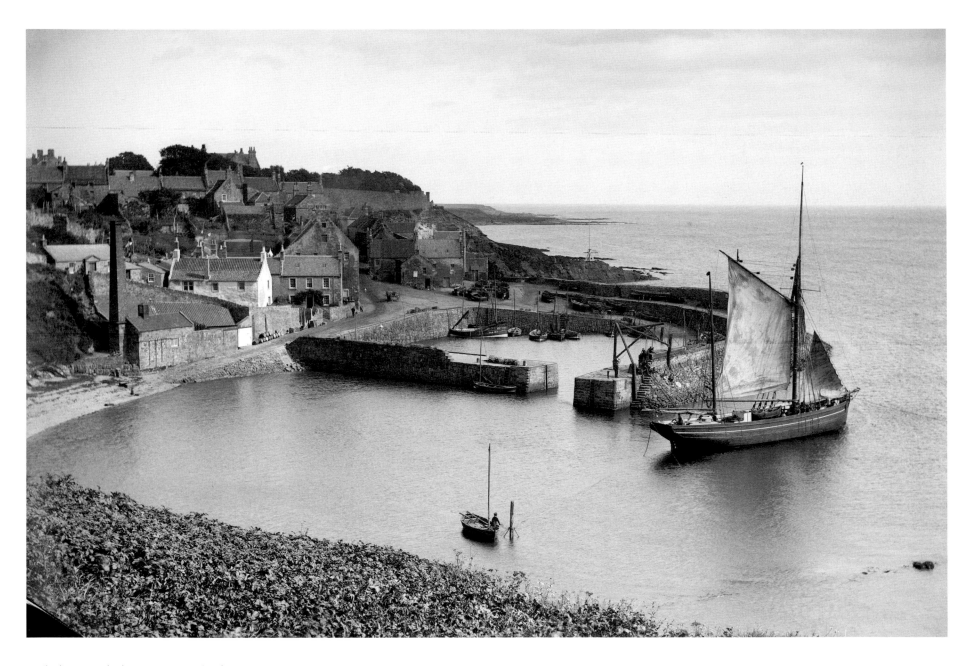

Crail, Shoregate, harbour, c.1890. Too big for the harbour, this trading ketch has dropped anchor outside the breakwater. SC388582

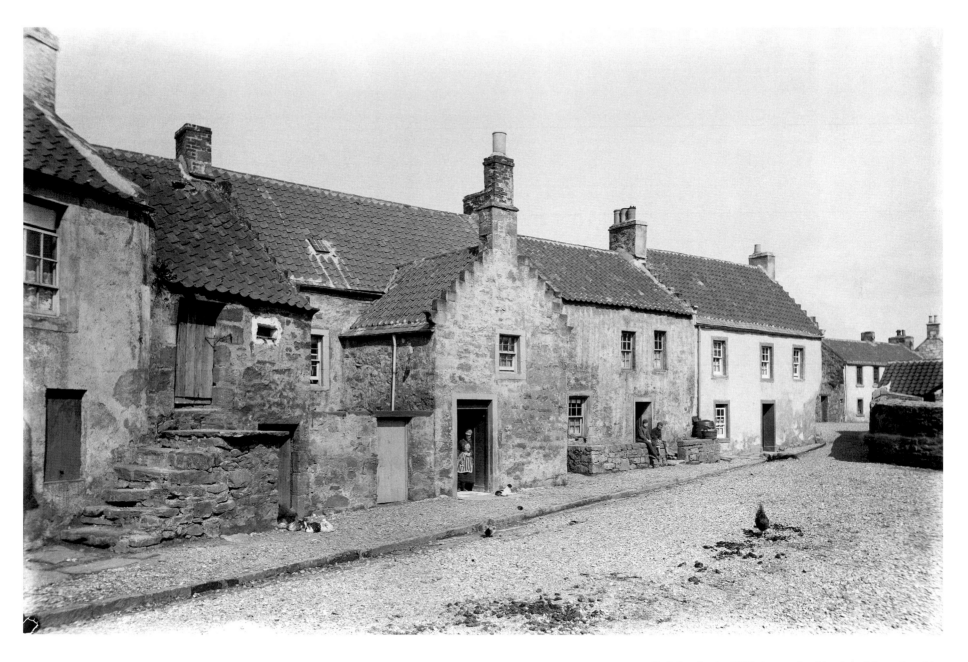

Crail, Rumford, c.1885. Attracted to historic buildings, Beveridge photographed these seventeenth- to eighteenth-century pantiled houses which have since been renovated and are occupied today. SC388539

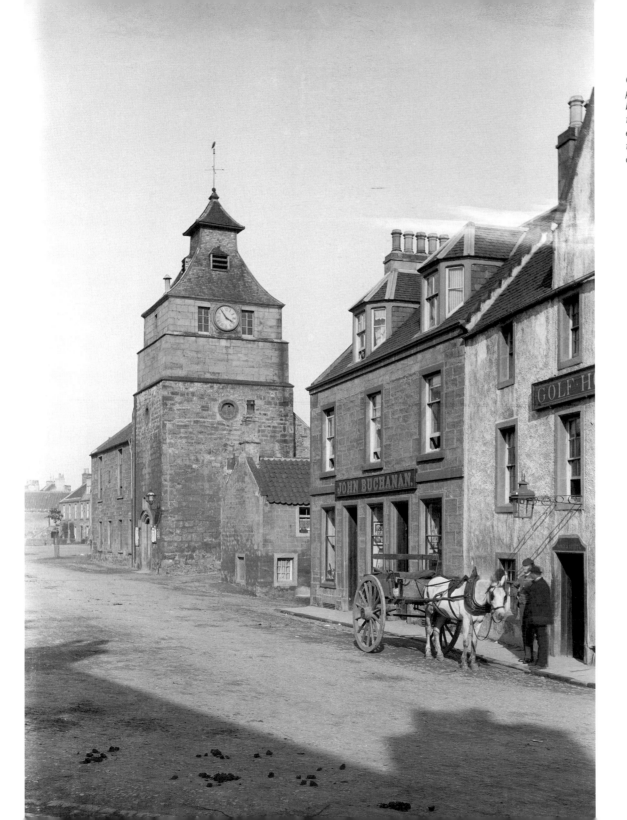

Crail, Tolbooth, 1885. This photograph was taken from beside the Golf Hotel, a former coaching inn. The eighteenth-century tower of the tolbooth dominates the centre of Crail. SC739247

Dunfermline, Hill House, 1889. Beveridge is known to have photographed around Dunfermline but this is one of few images of this area in the collection. With a view of Dunfermline to the north, Hill House is captured here in the autumn – stooks of straw often appear in Beveridge's photographs suggesting that he did much of his photography in September or October following the harvest. SC1113401

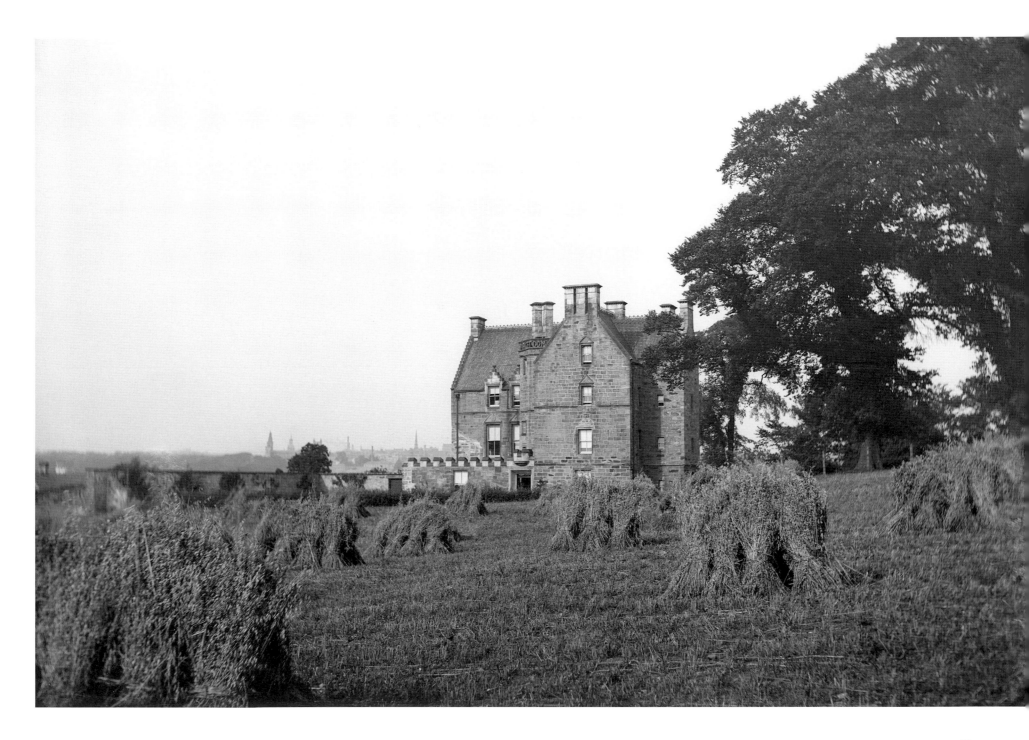

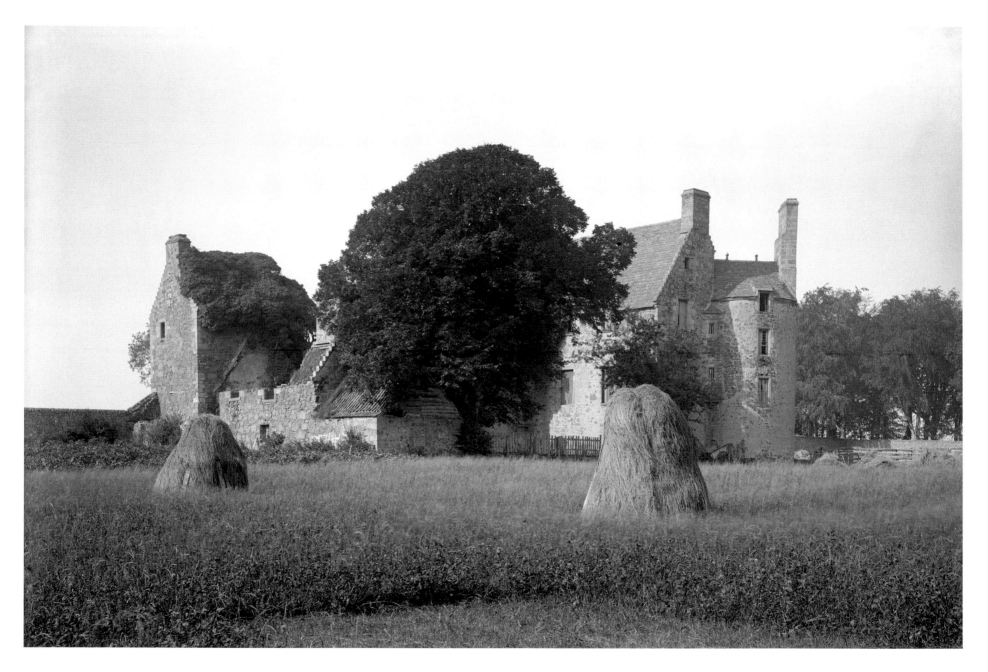

Earlshall, 1889. Earlshall was built by Sir William Bruce and dates to 1546. The house was in a ruinous state and was photographed by Beveridge just before Sir Robert Lorimer restored it in 1891–98. SC747702

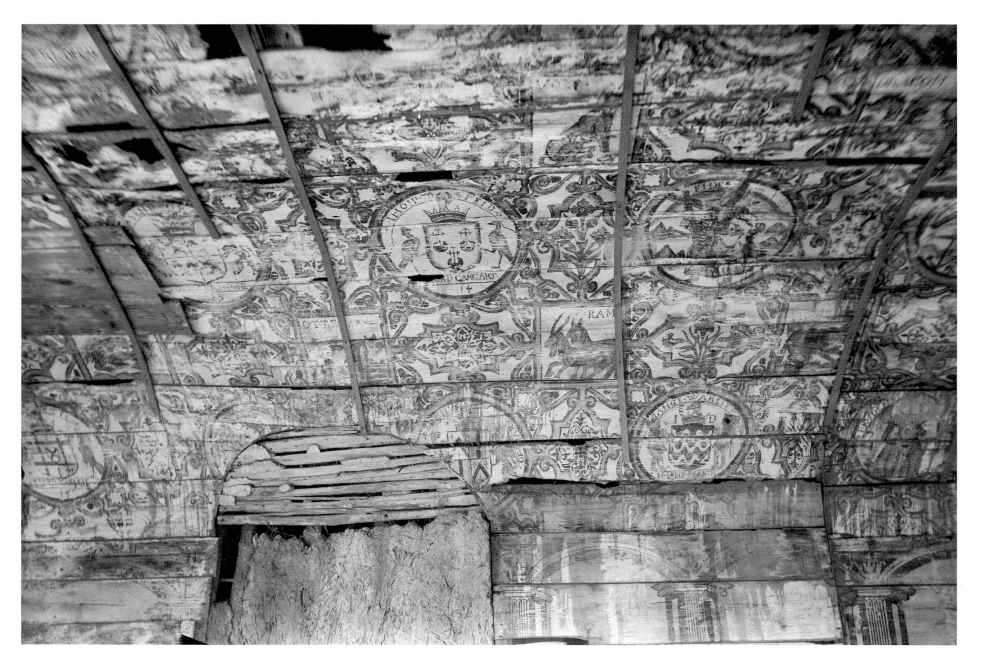

Earlshall, detail of painted ceiling in the long gallery, 1889. Beveridge photographed a section of the painted ceiling and wall frieze containing the coats-of-arms with mottoes of many Scottish families, surrounded by animals and flowers. SC747707

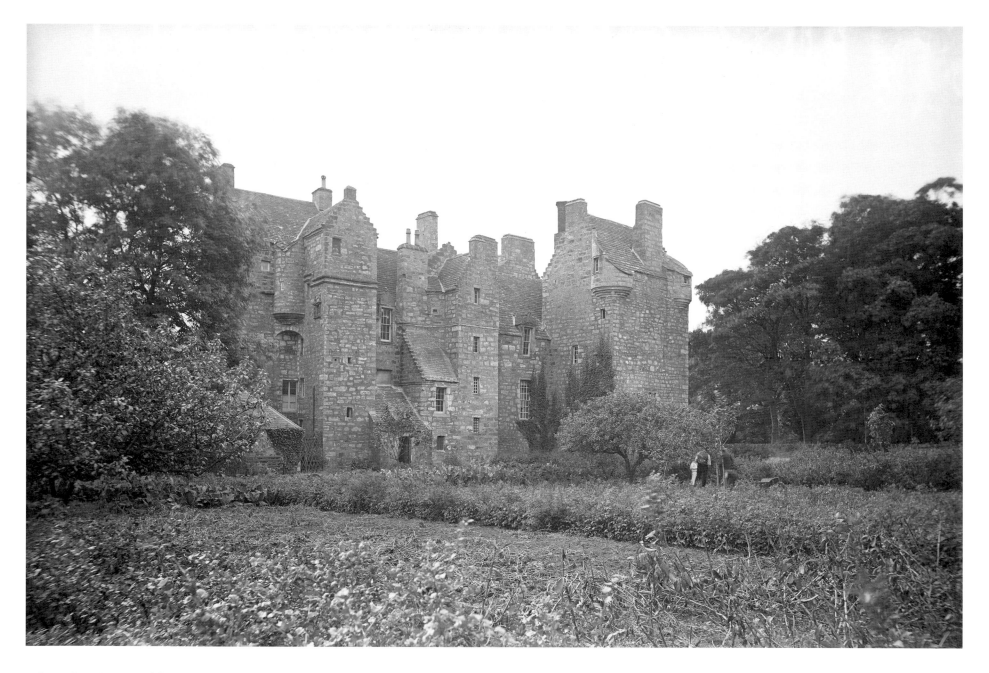

Kellie Castle, c.1890. One of the oldest castles in Scotland, Kellie was abandoned for a period of time in the nineteenth century but by the time of this photograph it was in the hands of Professor James Lorimer who was to lovingly restore it. SC740599

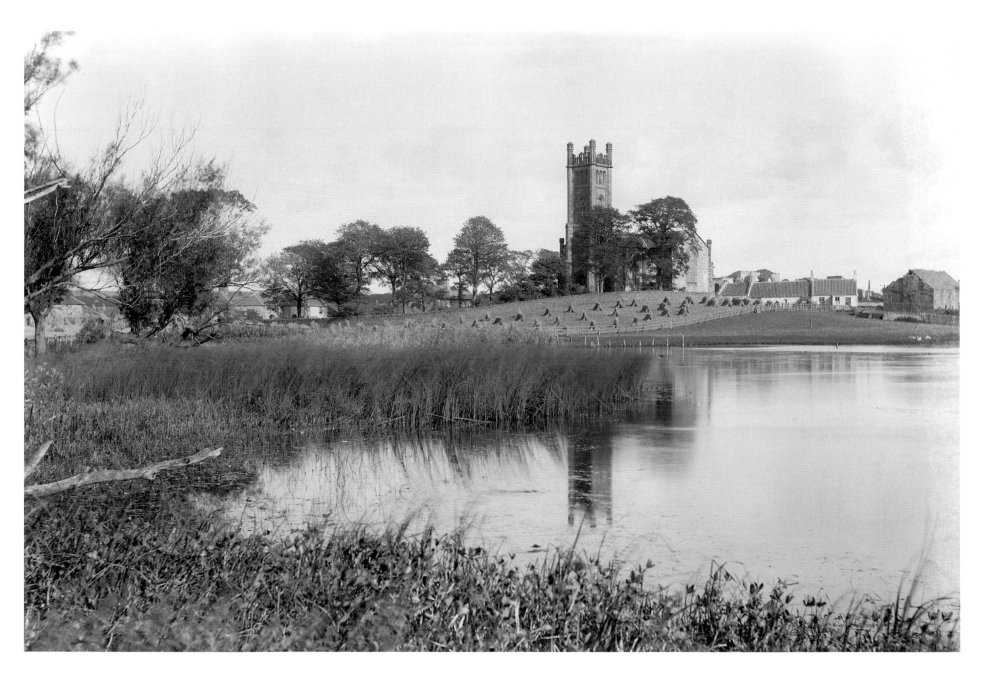

Kilconquhar Church, c.1885. Situated on a knoll overlooking the loch, the Parish Church was built in 1819–21. SC740608

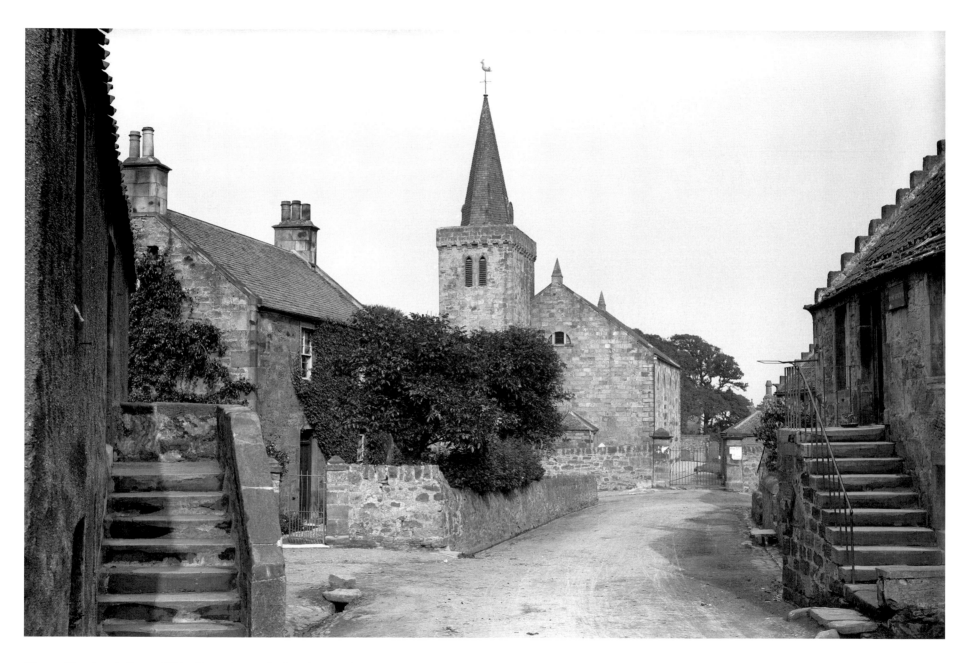

Kilrenny Church and village, c.1889. Kilrenny is a small village dominated by the fifteenth-century church tower. The crow-stepped houses with pantiled roofs and external stairs in the village date to the eighteenth century. SC740619

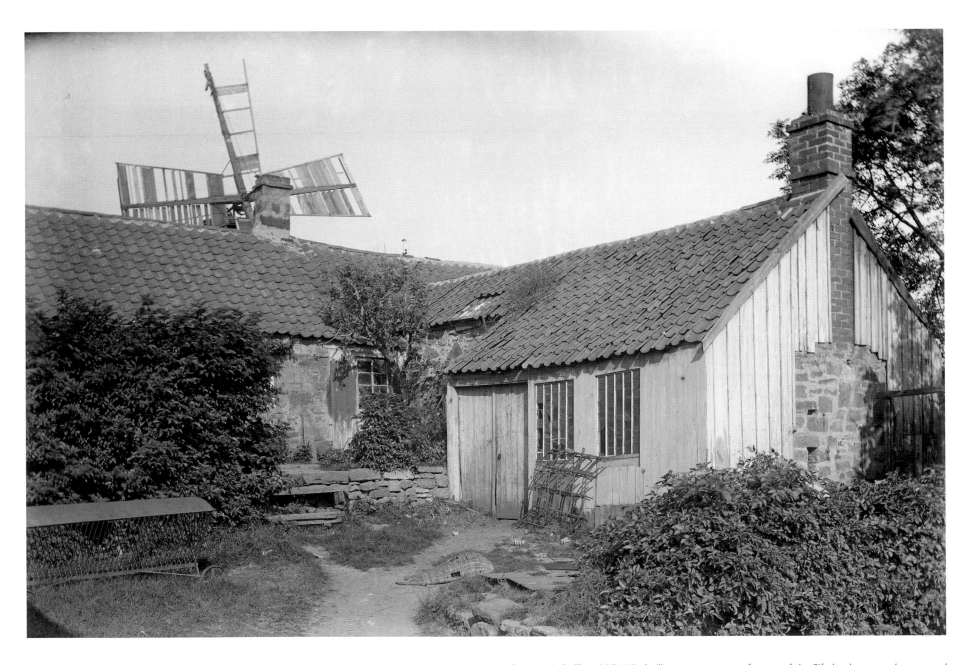

Kingsbarns, windmill, c.1885. Windmills were a common feature of the Fife landscape and were used for grinding or threshing grain. Many mill sites were abandoned or converted to other purposes in the late nineteenth century. This is possibly the only photographic record of this windmill. SC740624

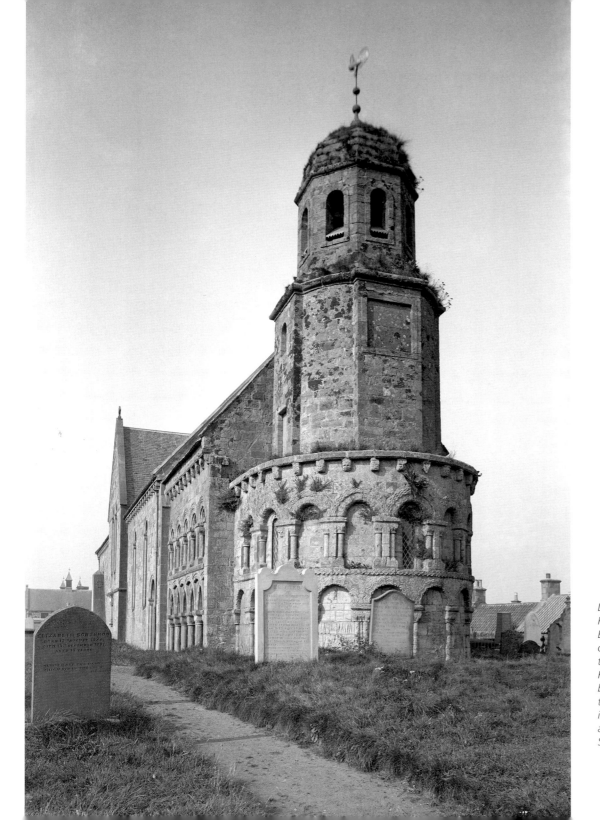

*Leuchars, St Athernase
Parish Church, c.1890.
Beveridge took a number
of photographs of the
twelfth-century St Athernase
Parish Church and may have
been planning to publish
the images. The church
is located on a slight hill
and dominates the village.
SC740631*

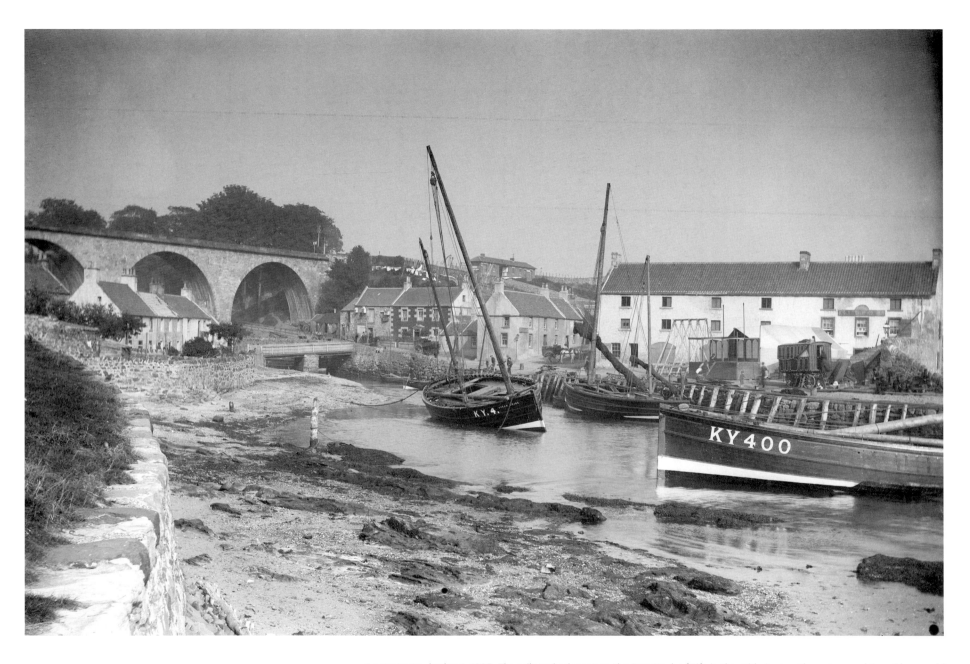

Lower Largo, harbour, 1885. The railway had come to the East Neuk of Fife in the mid nineteenth century and Beveridge would have used it to travel around the main towns, using a horse-drawn carriage for excursions elsewhere. The railway station is visible here beyond the viaduct over the Kiel Burn. Part of the granary building was converted into the Crusoe Hotel. SC740648

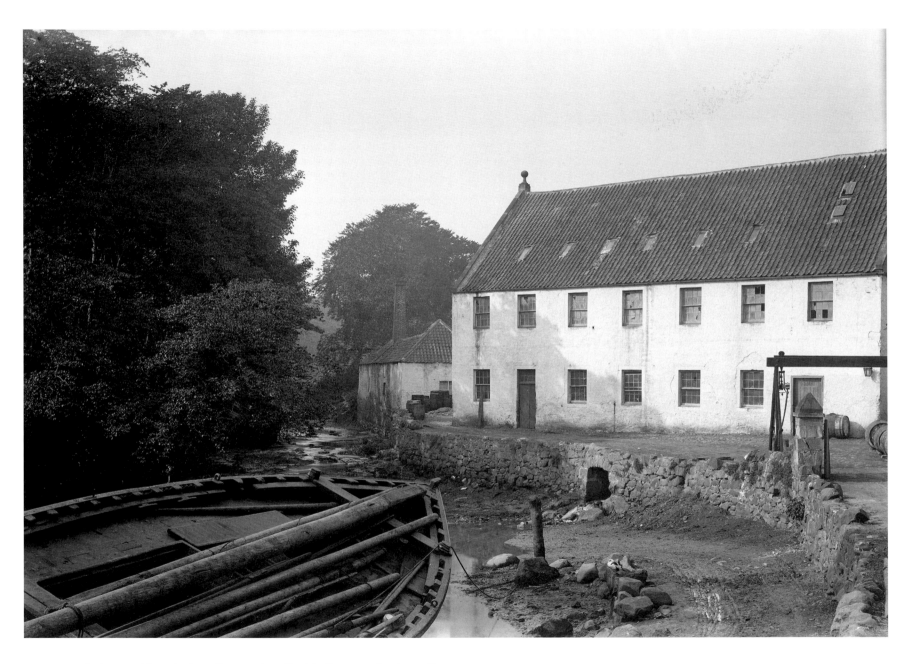

Lower Largo, harbour and flax spinning mill, 1890. The mill originally prepared and spun flax for linen manufacture but by the 1870s it was producing linseed oil. Situated beside the Kiel Burn, the mill has now been demolished and replaced with modern housing. SC740625

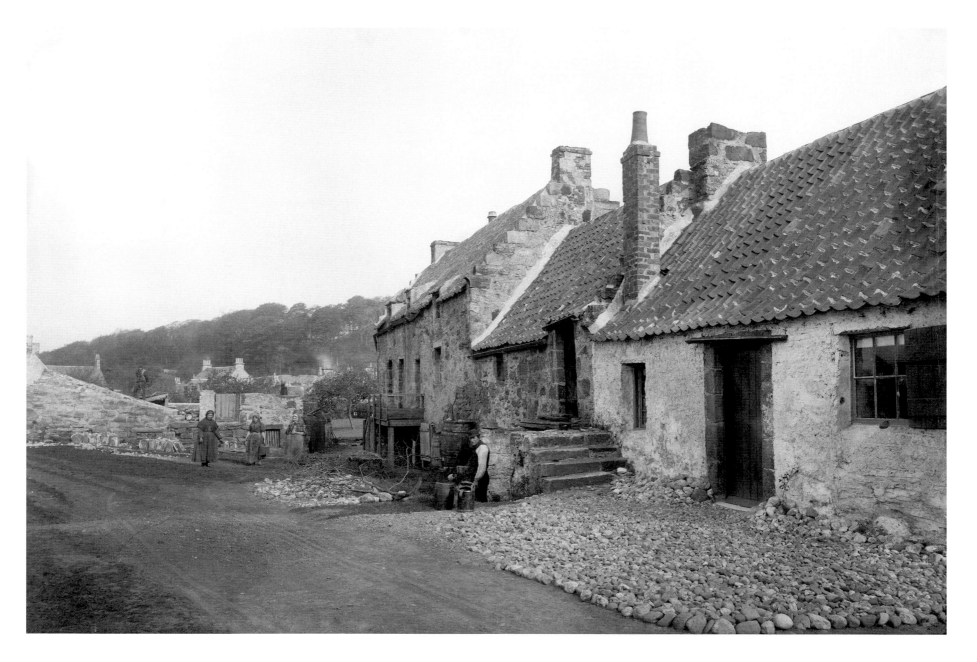

Newmills, c.1885. Beveridge has clearly photographed these cottages with the full co-operation of the people who are stationary and looking towards the camera. SC1115965

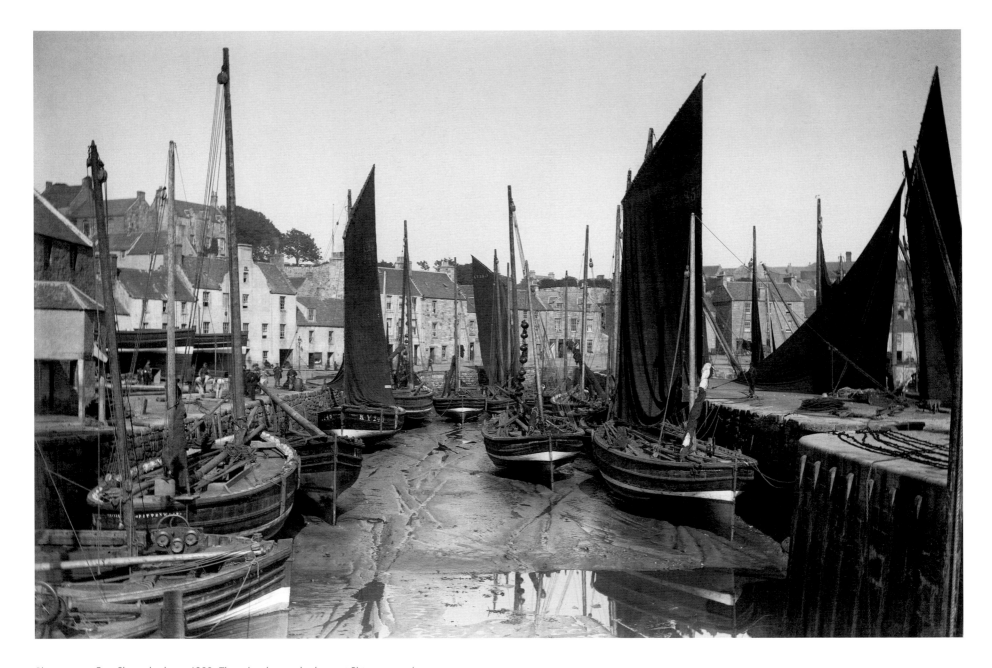

Pittenweem, East Shore, harbour, 1889. There has been a harbour at Pittenweem since medieval times and it is still used today for fishing. When Beveridge visited in 1889, most of the fishing fleet was out and only a few boats were in the inner harbour. SC396571

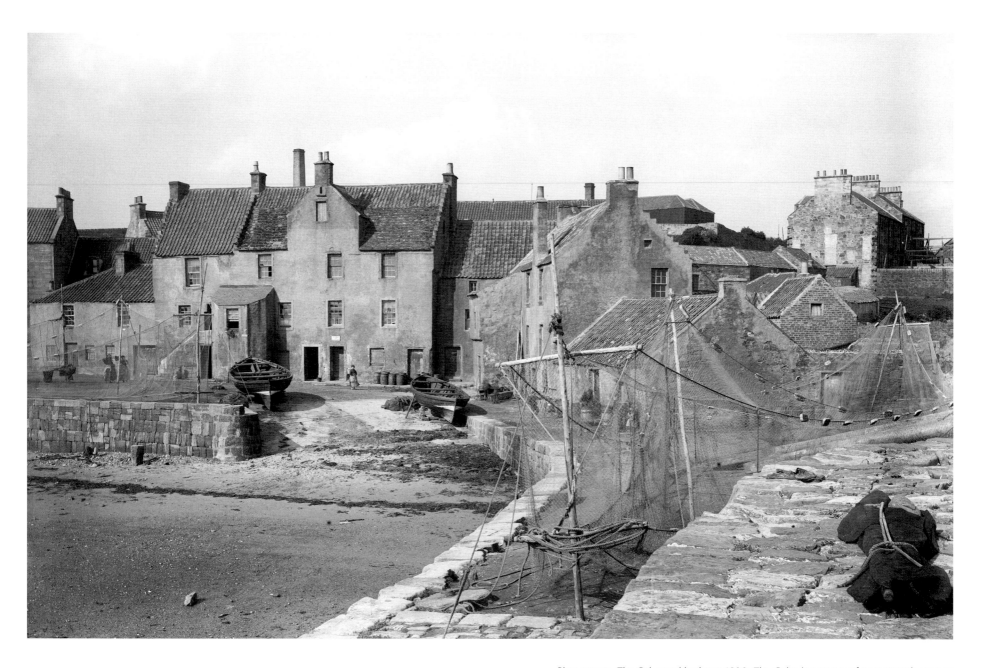

Pittenweem, The Gyles and harbour, 1890. The Gyles is a group of seventeenth-century buildings, built at a time when the wealth of Pittenweem was based on trade with the Low Countries. The buildings were restored by the National Trust for Scotland in 1962. SC747795

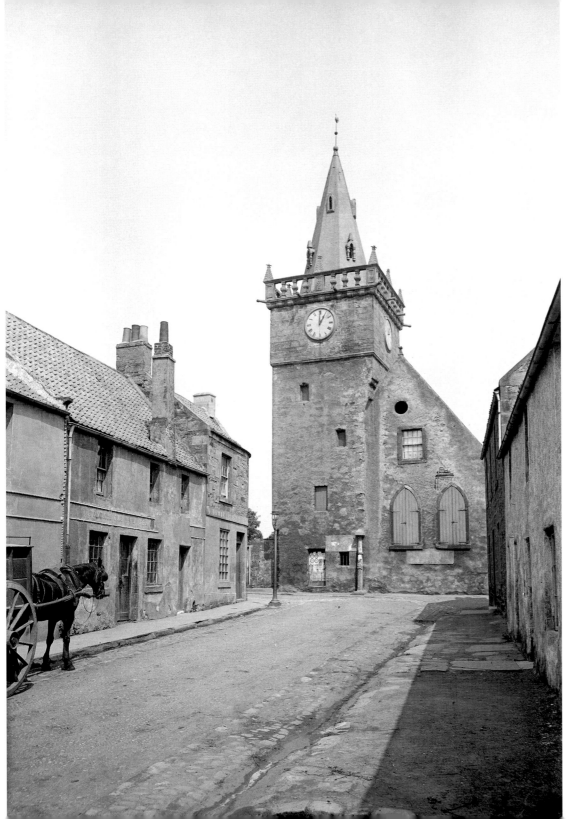

Pittenweem, tolbooth and church, c.1889. Situated at the end of the High Street, the tolbooth tower dates to 1588 and houses the council chamber. The church predates the tower by some fifty years and remnants of even earlier construction dating to the thirteenth century have been identified in the building. SC747809

St Andrews, viewed from St Rule's Tower, 1890. An unusual but rewarding viewpoint, it would have required considerable effort to climb to the top of St Rule's Tower with all his photographic equipment. SC1113429

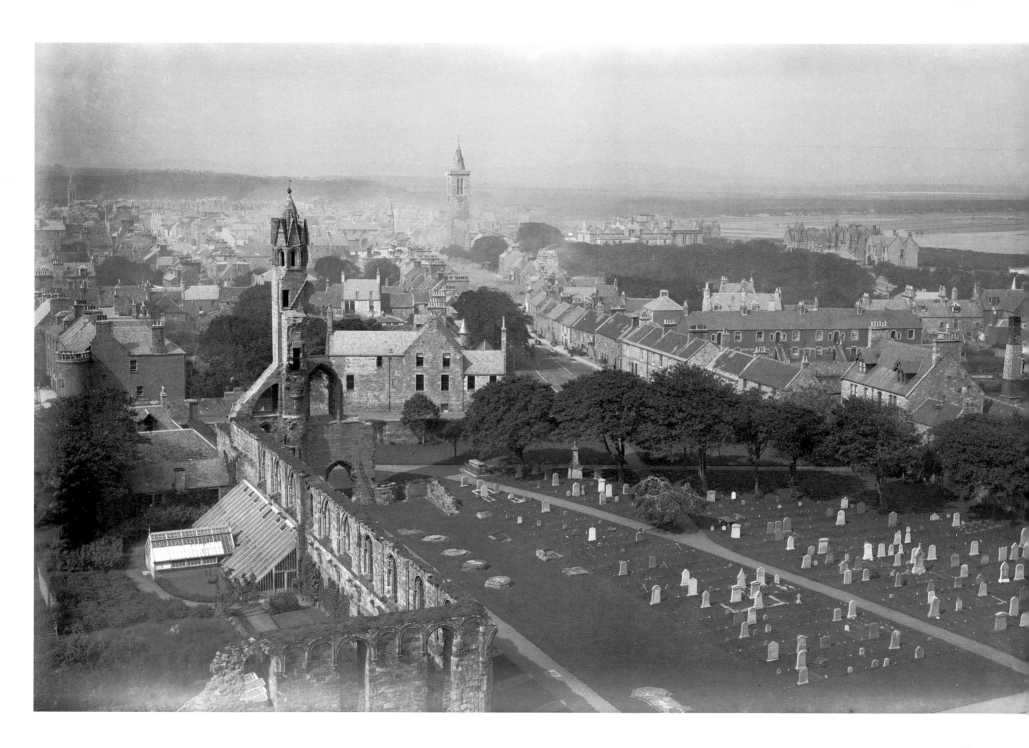

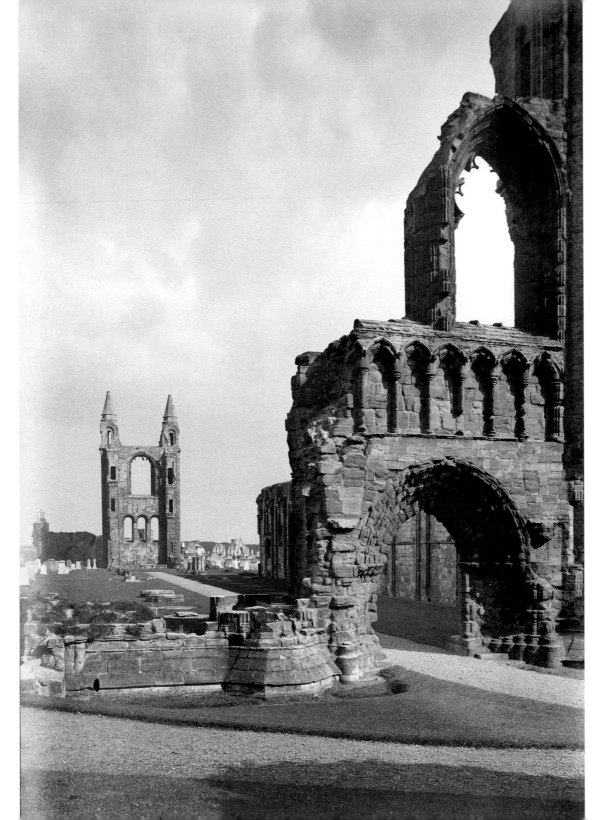

St Andrews Cathedral, 1890.
It was commonplace for
Victorian photographers to
illustrate the medieval ruins
of Scotland. St Andrews was
one of several cathedrals
or abbeys photographed
by Beveridge on his travels.
SC740651

St Andrews, harbour, 1890.
First mentioned as a fishing
port in 1226, the harbour at
St Andrews suffered storm
damage on a number of
occasions. In the seventeenth
century it was rebuilt using
stone from St Andrews
Castle. SC372141

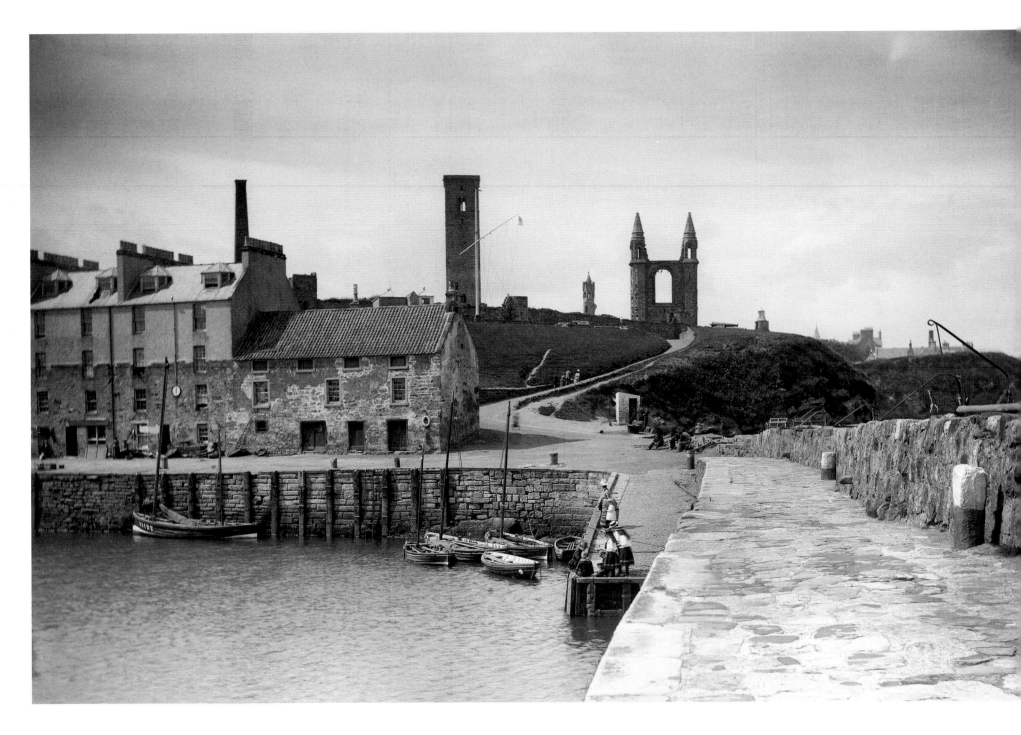

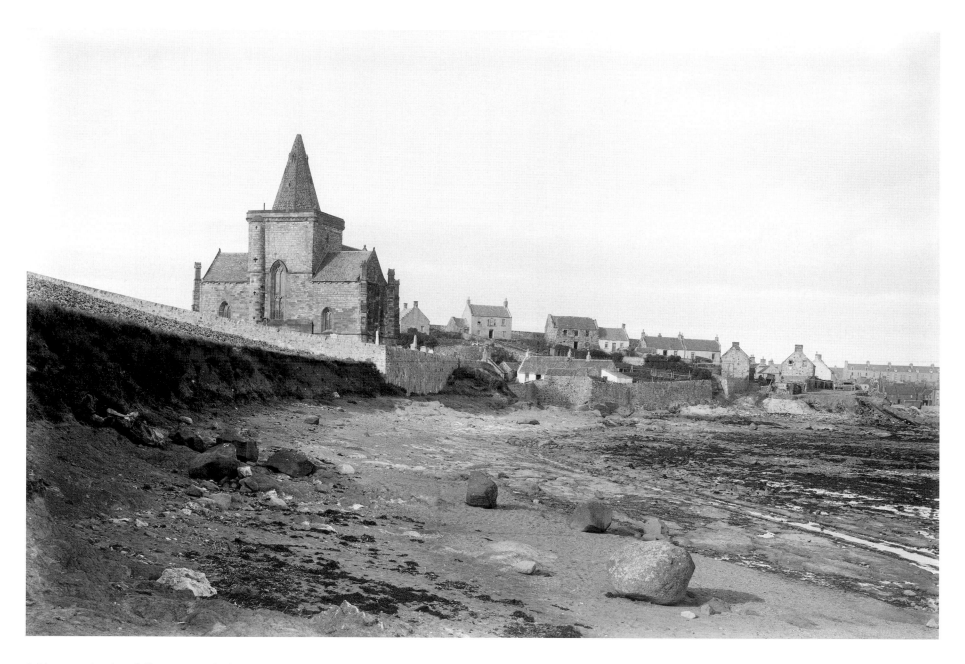

St Monance, church and village c.1890. The fourteenth century church of St Monance stands on the shore edge protected by a high wall. Adjacent, the fishing village was thriving at the end of the nineteenth century as were the boat builders. SC1111681

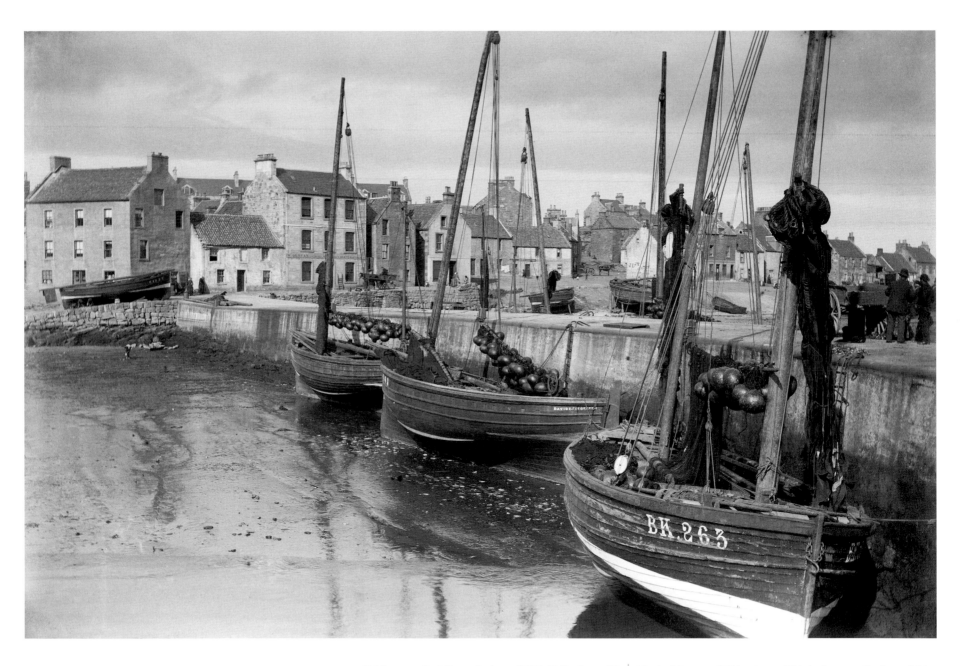

St Monance, East Shore, harbour, 1885. At the time of Beveridge's visit, some 100 boats used this harbour continuing a fishing tradition which dated back to the fourteenth century. The boats here are of the 'Fifie' type, a local two-masted design. Most boats were registered locally at Kirkcaldy and had a 'KY' number but the example in the foreground is from Berwick. SC747715

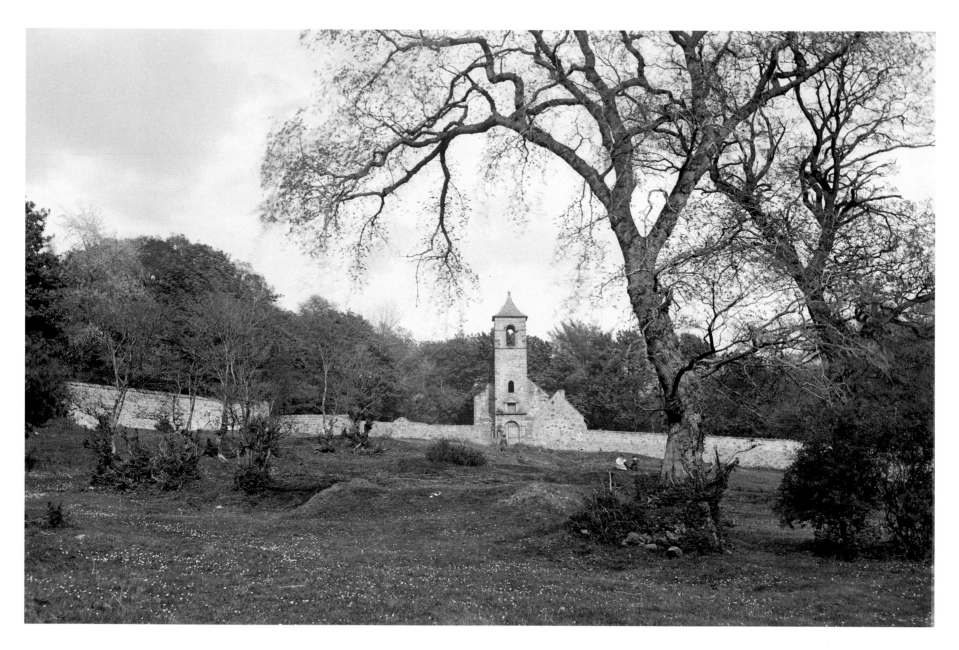

Tulliallan, Old Parish Church, c.1880. In the early 1880s Beveridge took a number of photographs for his cousin David, who was preparing a volume on Culross and Tulliallan published in 1885. This is one of several views of the seventeenth-century Old Parish Church. SC1113506

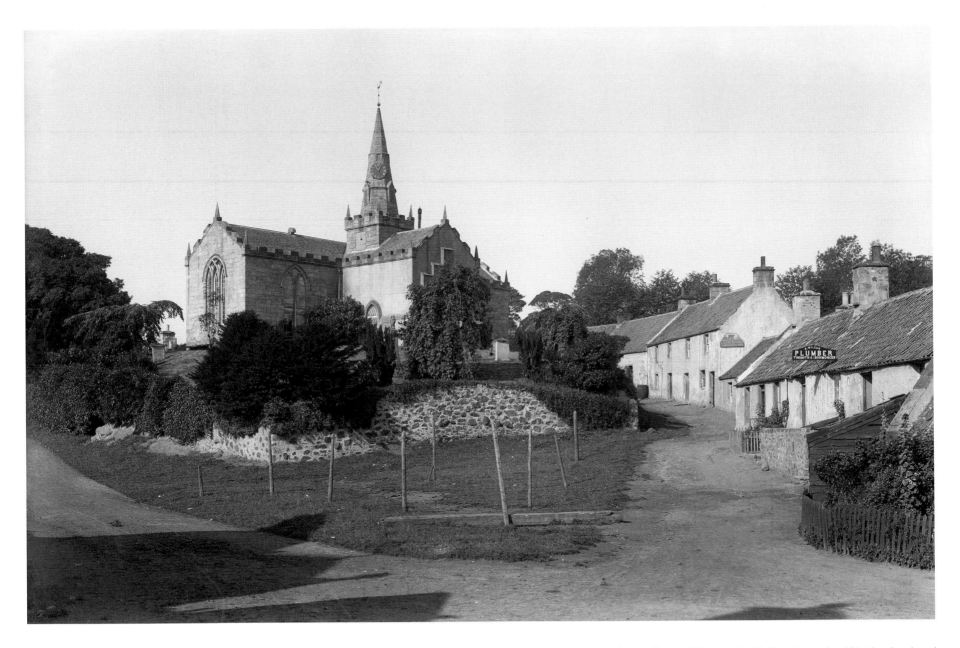

Upper Largo, church and village, 1890. Largo Parish Church stands within the churchyard surrounded by the village. It was rebuilt between 1816 and 1817 incorporating the seventeenth-century tower and chancel. Shop signs on the houses are for 'A Wilson Plumber, Tinsmith and Ironmonger', and 'A Baird, Butcher. Carriage Hire'. SC740628

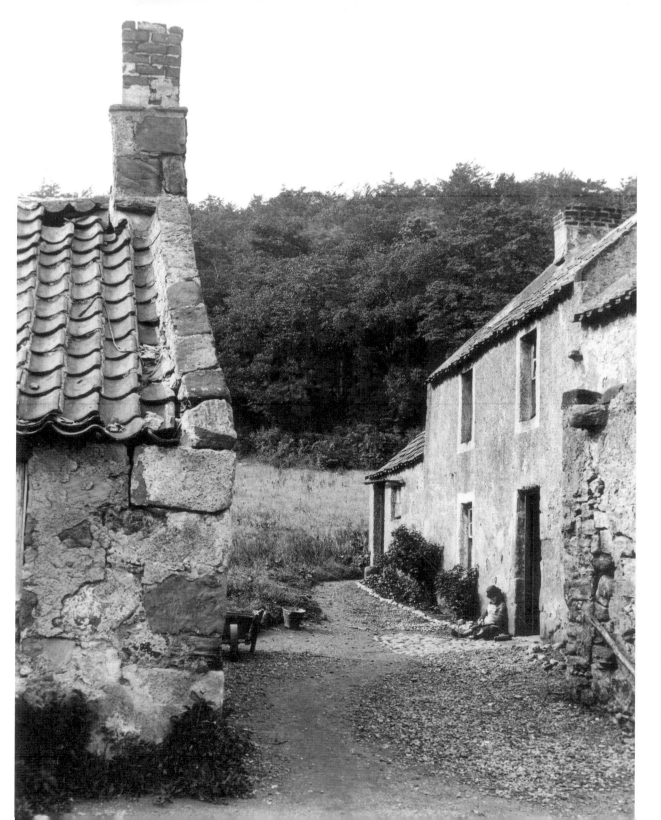

Unidentified house, c.1885. Beveridge has captured a delightful domestic scene: a bare-footed figure sits on the doorstep of a house enjoying the sunshine, probably in Fife. This is one of a number of photographs which has not yet been identified. SC1115964

South Scotland

There are only a small number of photographs for Southern Scotland and these illustrate a number of different excursions to popular historic buildings in Edinburgh, Midlothian and the Borders.

However, a number of photographs date to April 1884, suggesting that Beveridge spent Easter week touring the island of Arran. With daily steamers from Ardrossan, Wemyss or Glasgow, Beveridge was able to visit the sights recommended in the popular tourist guides of the time, including the castles at Kildonan and Lochranza, the standing stones at Tormore, the 'King's Cave' and Holy Island.

Glasgow

Edinburgh

Crichton Castle

Lochranza Castle

Corrie

Arran

Glen Cloy

Machrie Moor

Melrose Abbey

Dryburgh Abbey

Dumfries

Ruthwell Cross

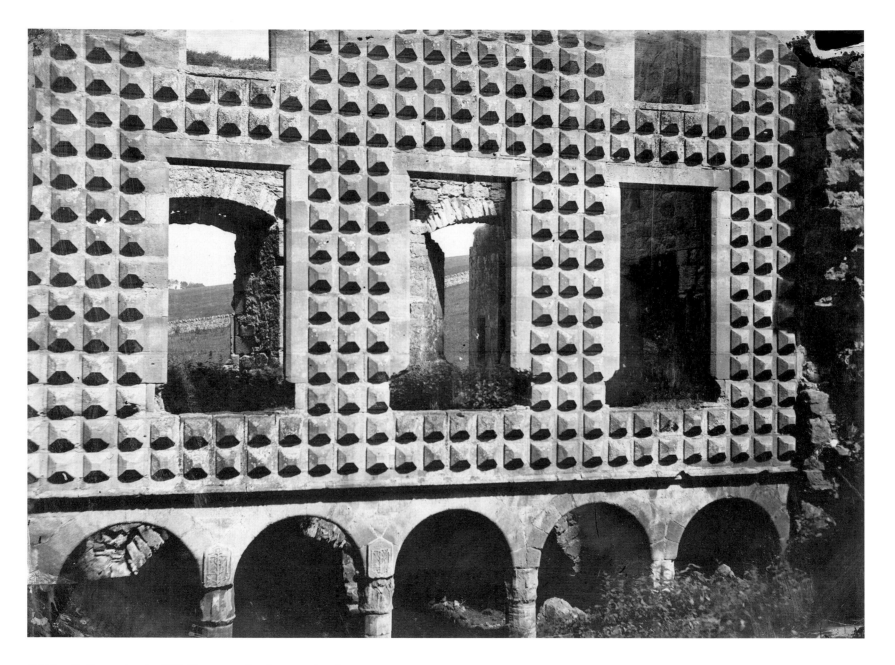

Crichton Castle, courtyard, c.1890. There are only a few examples of photographs by Beveridge of Edinburgh or Midlothian. Here he was visiting Crichton Castle with its unique and elaborate courtyard. SC1113128

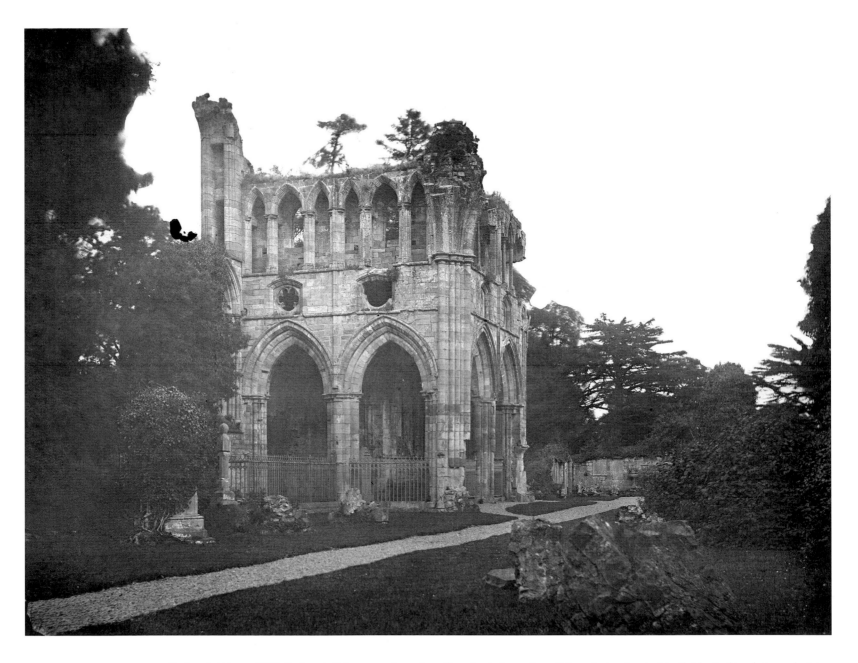

Dryburgh Abbey, c.1880. Dryburgh Abbey was a favourite with early photographers. This particular view is virtually identical to photographs taken by other tourists as well as the commercial photographers George Washington Wilson (1823–1893) and Valentines of Dundee. While a student at Edinburgh University, Beveridge joined the Edinburgh Photographic Society where Wilson often gave illustrated talks on his work. SC798819

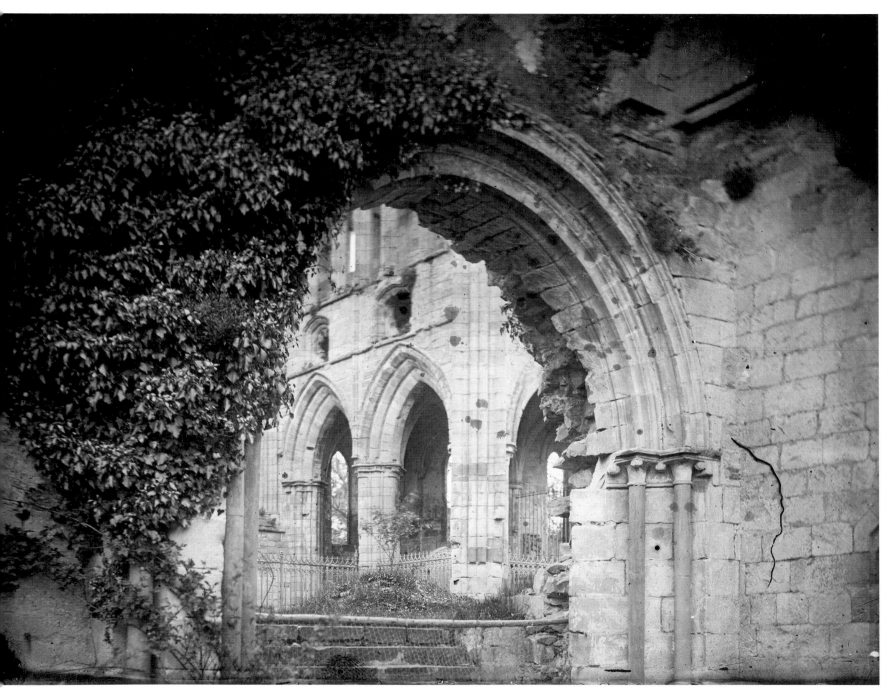

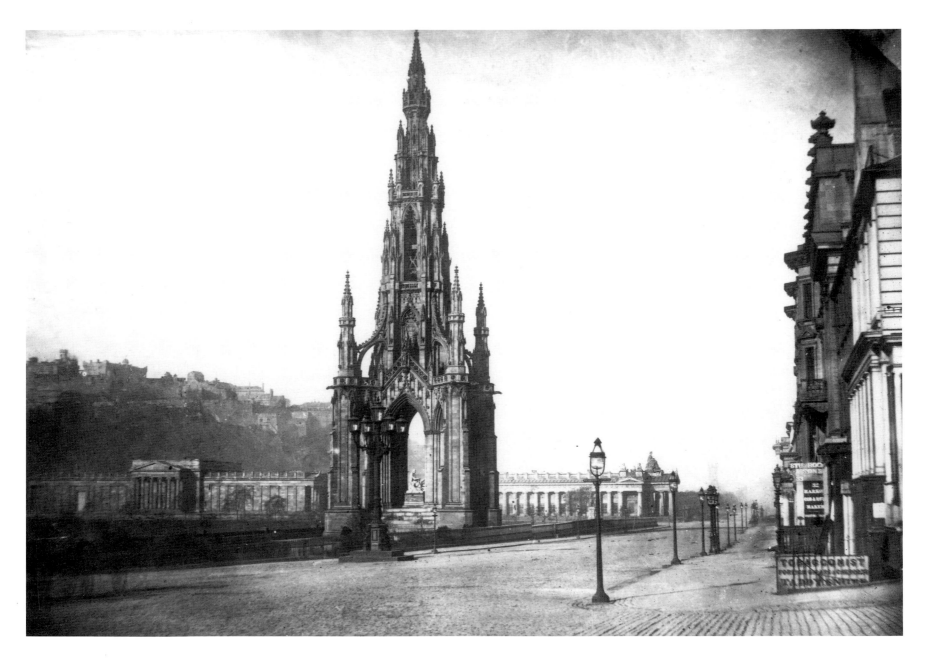

Edinburgh, Scott Monument and Princes Street, c.1890. This is one of only a few photographs of Edinburgh taken by Beveridge. Princes Street is surprisingly empty suggesting that this photograph was taken early in the day. Viewed from the corner of St David's Street, there are a number of identifiable business premises, including the gunmaker Joseph Harkom (at number 32 Princes Street) and Sturrock and Sons perfumers (at 33). The buildings on this corner were demolished prior to the construction of R W Forsyth's in 1906. SC1113101

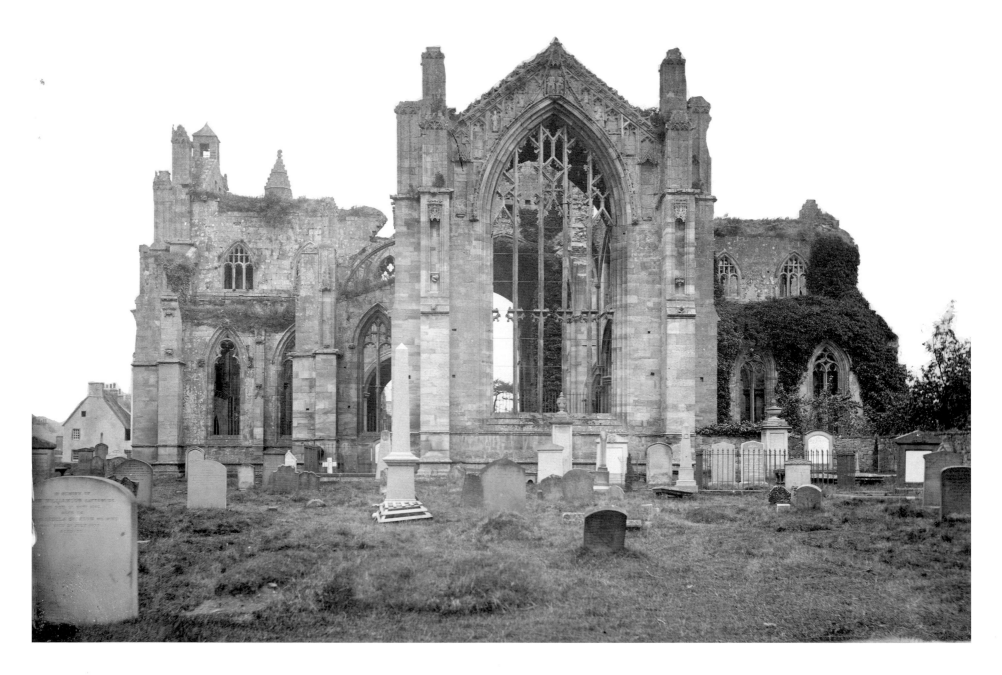

Ruthwell Cross, 1896. This is the only monument in the south-west of Scotland included in the Beveridge collection in RCAHMS. The cross had only been in the purpose-built apse in Ruthwell Church for nine years when it was photographed by Beveridge. Dating to the eighth century and standing to a height of 5.2m, the cross was smashed into pieces in the early seventeenth century but was brought together in 1802 by the minister of the church. New arms were created and in 1887 the restored cross was moved into the church. SC747876

Melrose Abbey, c.1890. Melrose Abbey was another favourite subject for early photographers, from William Henry Fox Talbot (1800–1877), the creator of photography, to George Washington Wilson (1823–1893), Thomas Annan (1830–1887) and William Donaldson Clark (1816–1873). Clark was also active in the Edinburgh Photographic Society and spoke on his photography of Melrose while Beveridge was a member. SC1115892

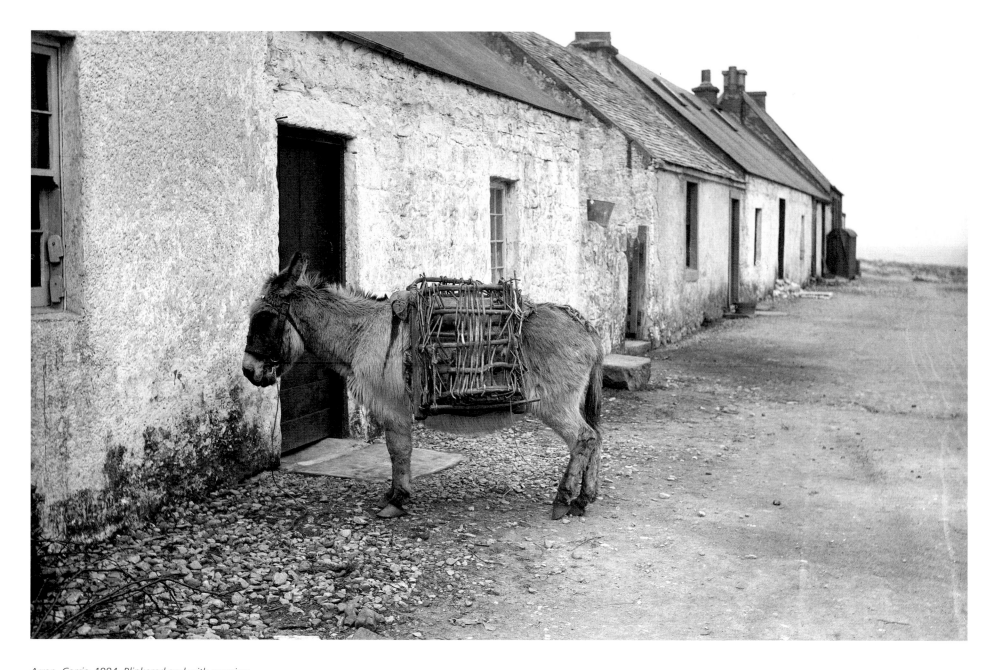

*Arran, Corrie, 1884. Blinkered and with panniers,
the donkey was probably used to transport goods
to and from the small harbour at Corrie. SC747888*

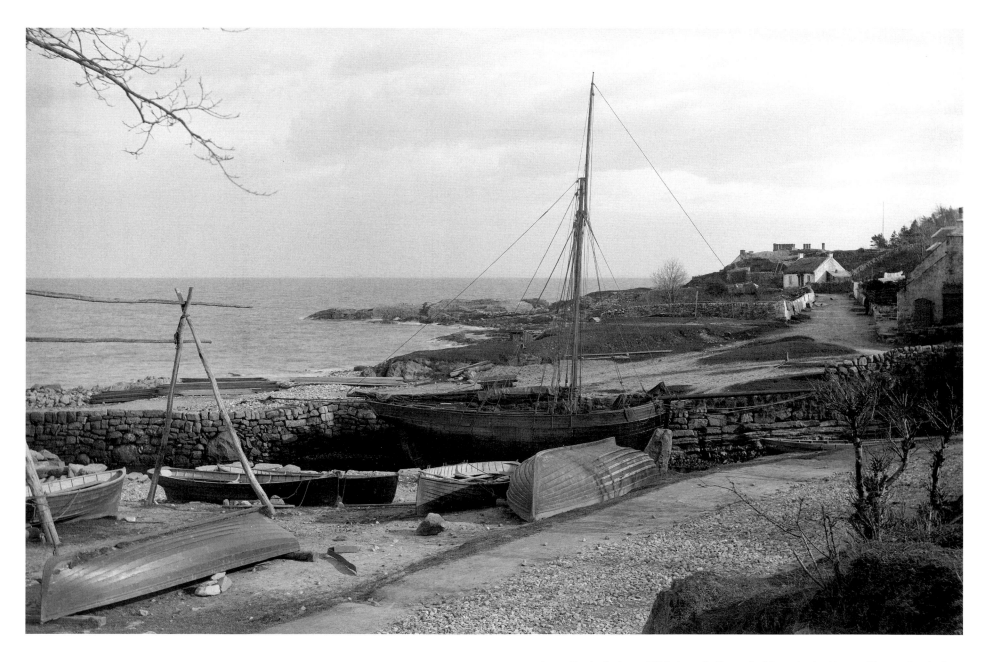

Arran, Corrie, harbour, 1884. A small village of whitewashed cottages with a modest harbour used for fishing boats. The harbour was originally built for the shipment of quarried sandstone, some of it used in the construction of the Crinan Canal between 1794 and 1809. SC747879

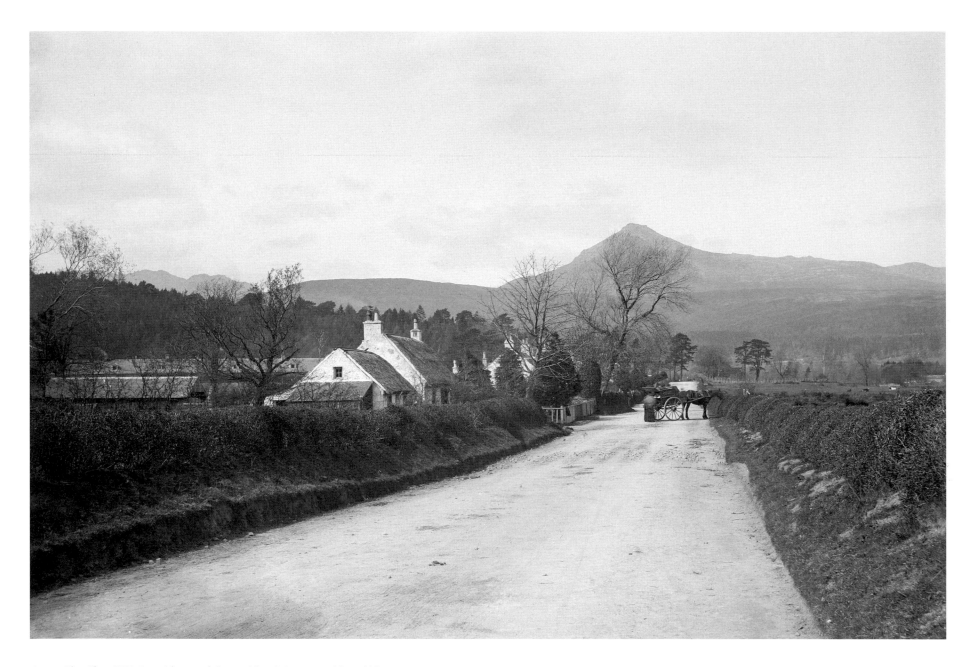

Arran, Glen Cloy, 1884. Beveridge carefully considered the composition of his photographs and this is an example of where he took two virtually identical views: this one with the horse and cart and another one without. SC747904

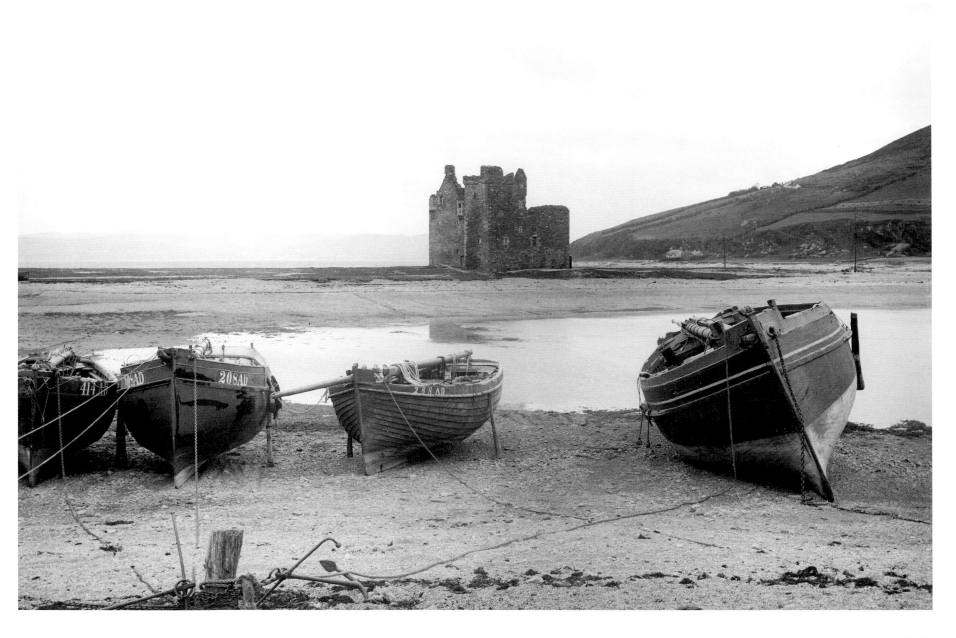

Lochranza Castle,
Arran, 1884.
SC1092509

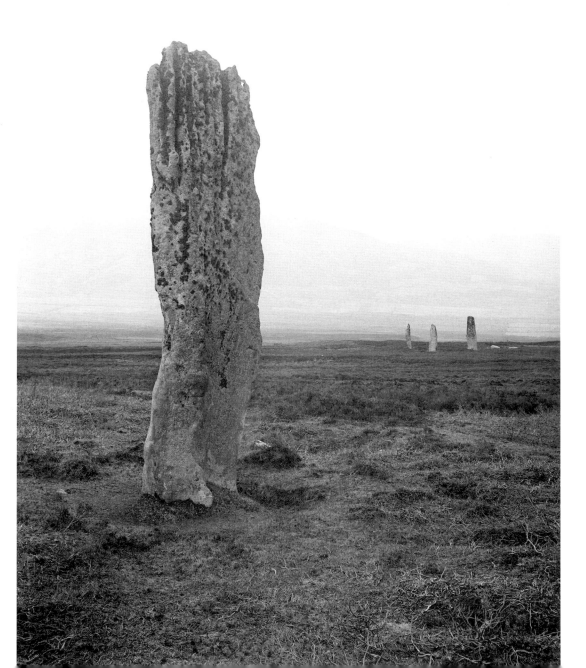

*Machrie Moor, Arran,
standing stones, 1884.
There are at least six stone
circles on Machrie Moor
dating to the Neolithic and
Bronze Age. SC1113092*

Argyll

The photographs of Argyll reflect the holidays and leisure time of a wealthy Victorian businessman with a fascination for the past and the picturesque. In the summer months of 1882 and 1883 Beveridge travelled extensively on the west coast of Scotland visiting places along the coastal fringes and the islands of Staffa, Iona, Colonsay, Oronsay, Eigg and Lismore. He photographed the early Christian crosses and buildings, the harbours, rural housing and beautiful landscapes witnessed on his travels. He revisited many of these islands following a visit to Canna, Pabbay and Barra in 1895 but, from 1896 onwards, holidays were spent on Coll and Tiree where Beveridge began his detailed research into the archaeology and history of those islands.

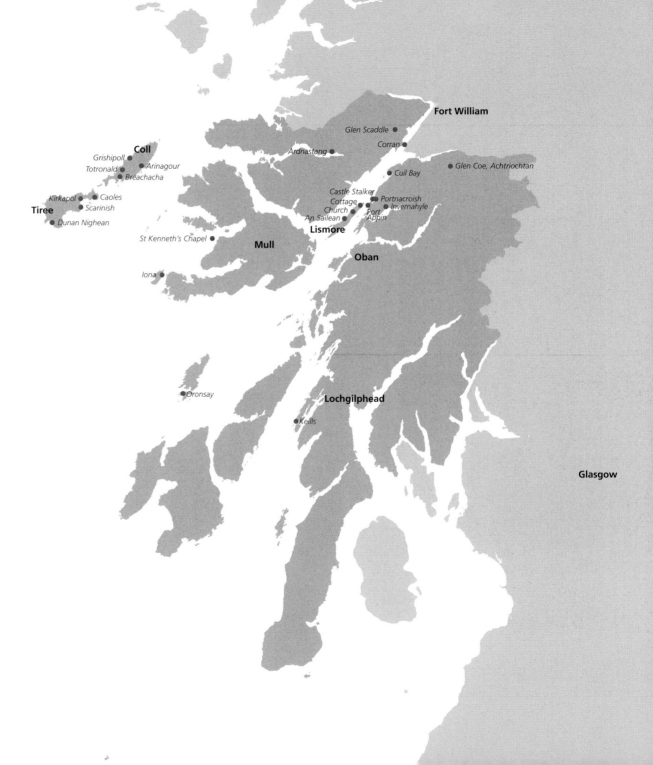

Ardnastang, c.1900. Situated to the west of Strontian, the village of Ardnastang overlooks Loch Sunart. SC1115961

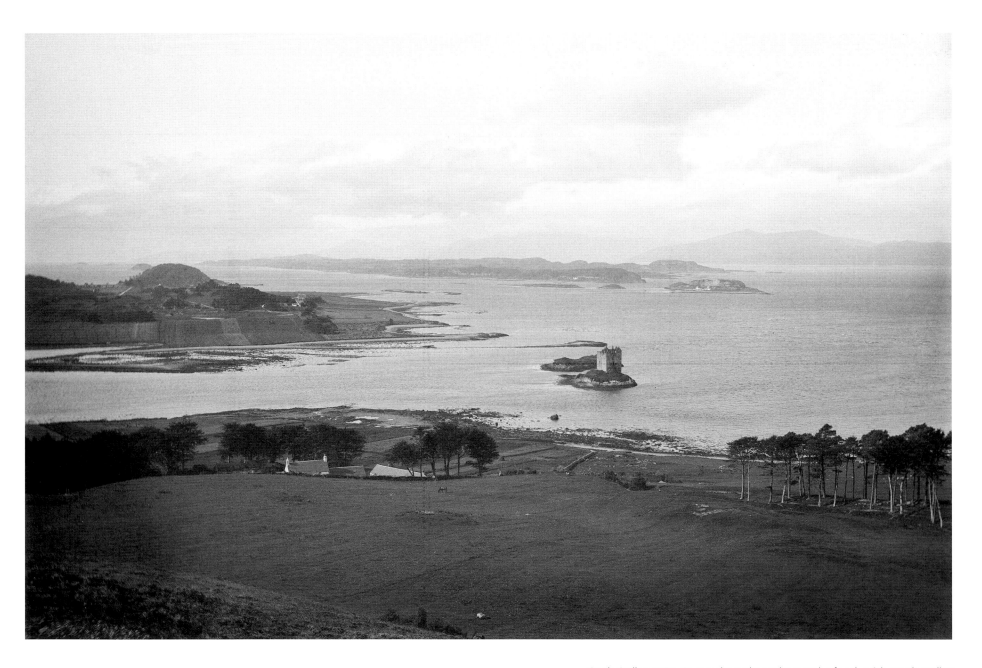

Castle Stalker, 1882. On a rocky outlet at the mouth of Loch Laich, Castle Stalker commands extensive views of Loch Linnhe and the Strath of Appin. Built in c.1541, the castle is roofless in this photograph but has since been reconstructed. SC1112918

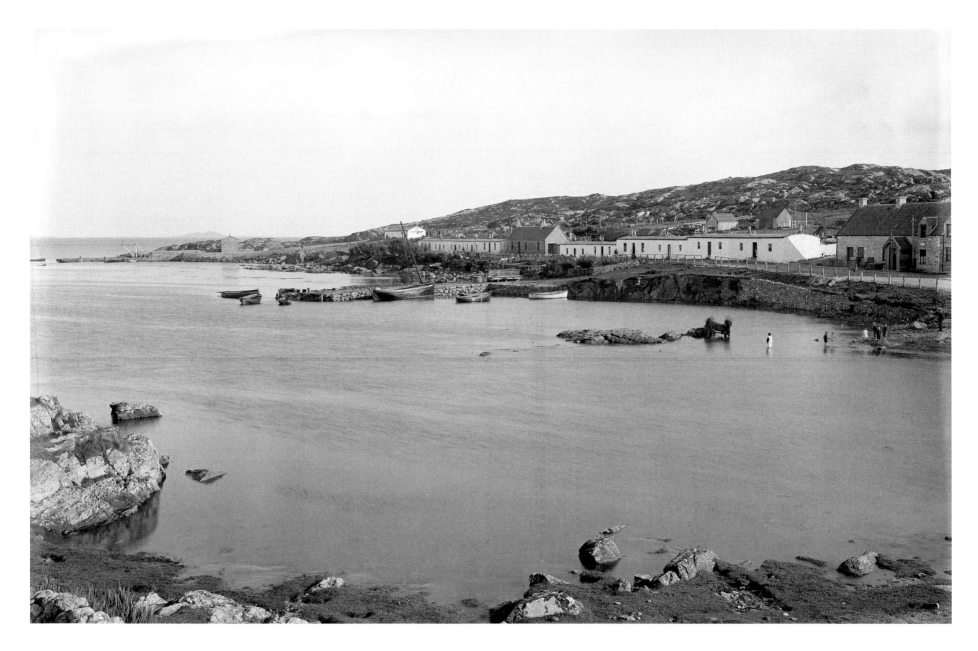

Coll, Arinagour, 1898. Arinagour is the main village and harbour on Coll. The cottages were built c.1814 by the Laird of Coll and the pier was constructed in 1843. The village provided a vital communication link for small boats transporting goods, mail and passengers from steamers anchored offshore. The Ordnance Gazetteer of Scotland by F H Groome, 1882, notes that on Coll 'the manufacture of butter and cheese is carried out extensively and successfully, some dairies keeping upwards of eighty Ayrshire cows'. SC740711

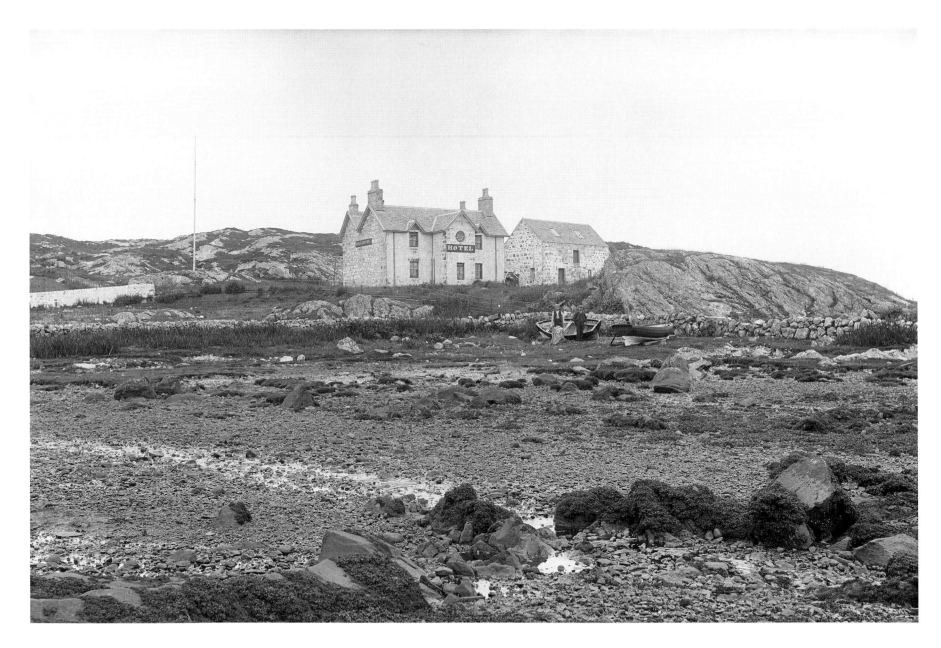

Coll, Arinagour, hotel, 1898. The Coll Hotel was extended in the 1880s and could accommodate up to 12 guests. To the front was a vegetable garden. As it was the only hotel on the island, Beveridge may have been one of the many Victorian guests who stayed here and enjoyed fishing. SC740708

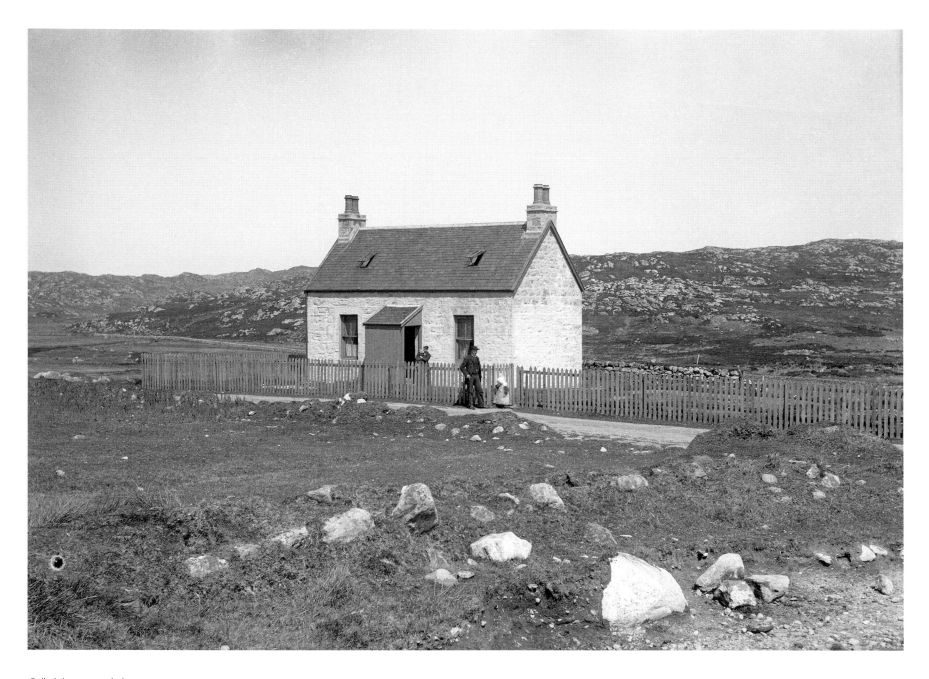

*Coll, Arinagour, mission
house, 1898. SC740706*

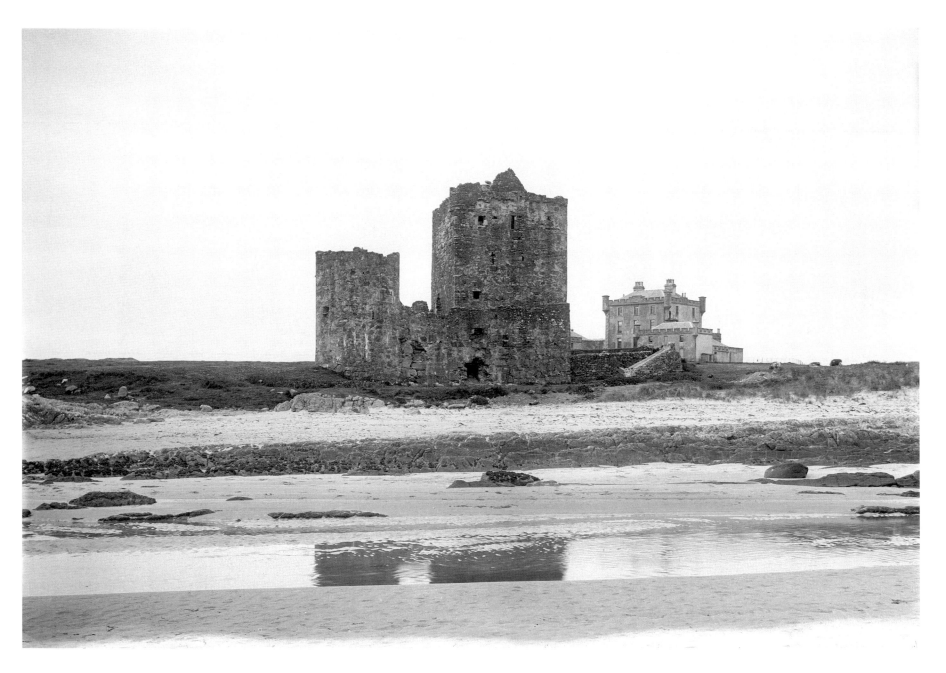

Coll, Breachacha Castle, c.1895. Dating to the early fifteenth century, the tower-house is the oldest surviving portion of the castle. It was extensively altered in the following two centuries until 1750 when Breachacha House was constructed where the Laird of Coll entertained Dr Johnson in 1773. SC1115956

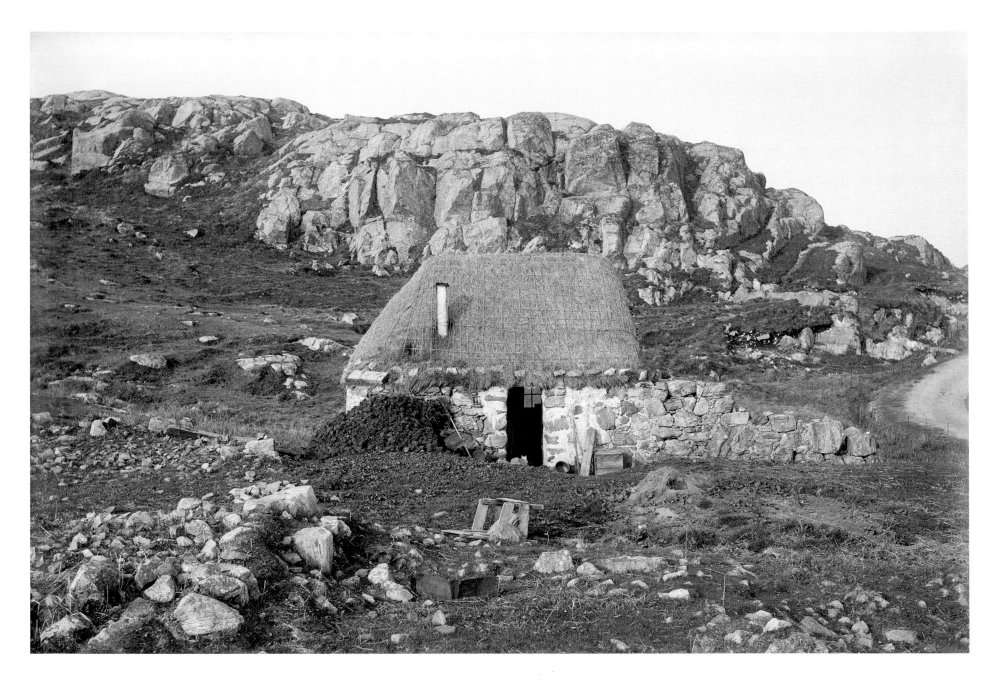

Coll, Grishipoll, 1898. With peat stacked against the wall and a cat in the doorway, this small single-roomed house, adjacent to the beach at Grishipoll, is clearly occupied. SC740707

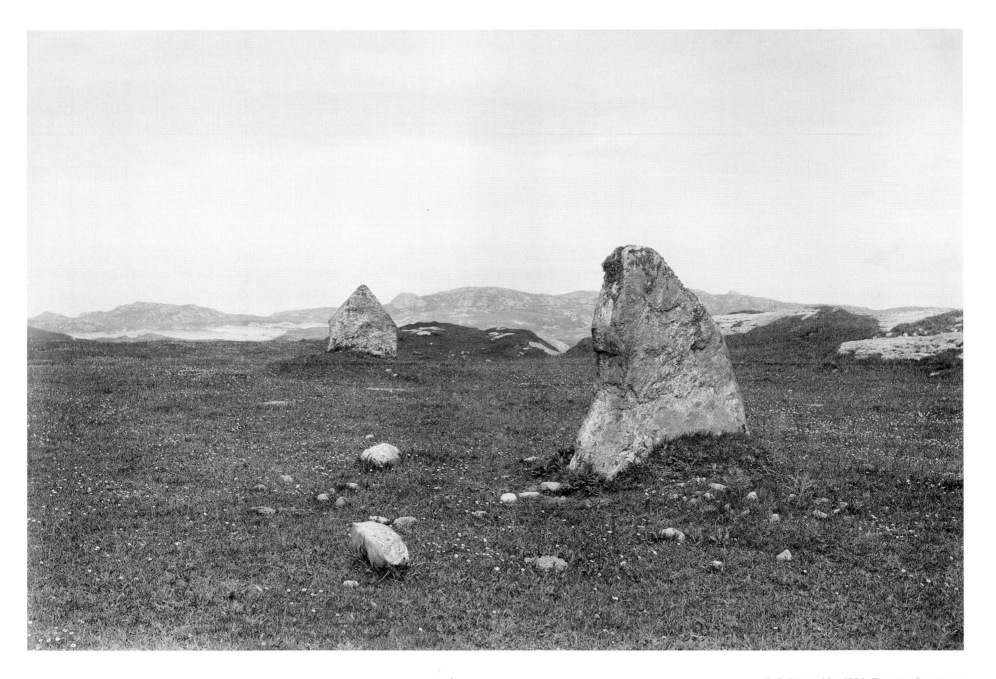

*Coll, Totronald, c.1890. Two standing stones
located on the crest of a ridge. SC1106066*

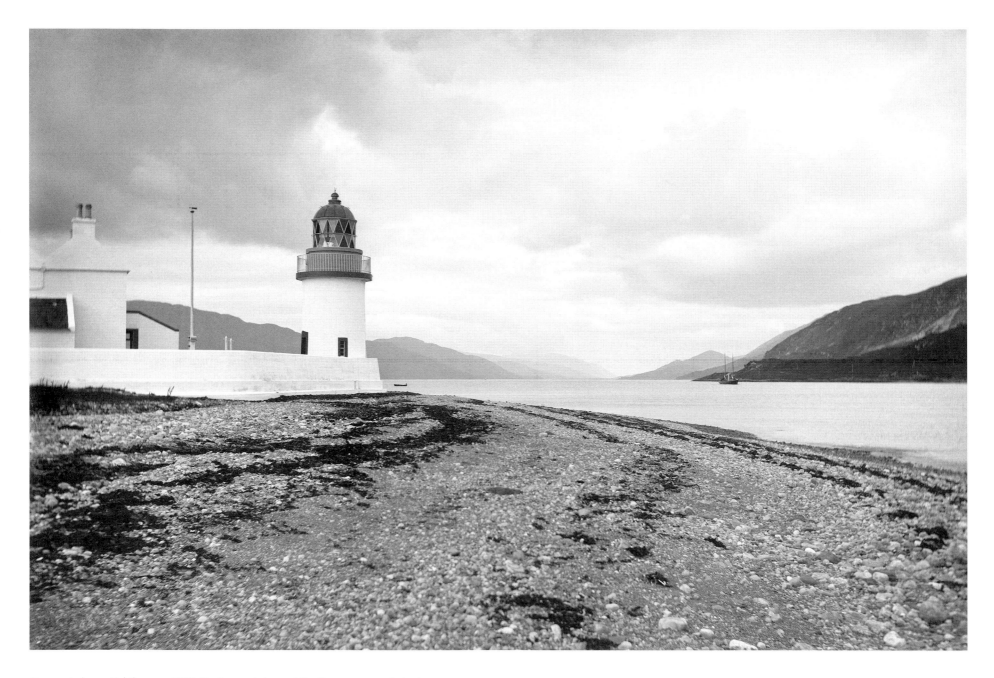

Corran, Ardgour, Lighthouse, c.1886. On the west shore of the Corran narrows in Loch Linnhe, this lighthouse was built in 1860 by David and Thomas Stevenson. SC746284

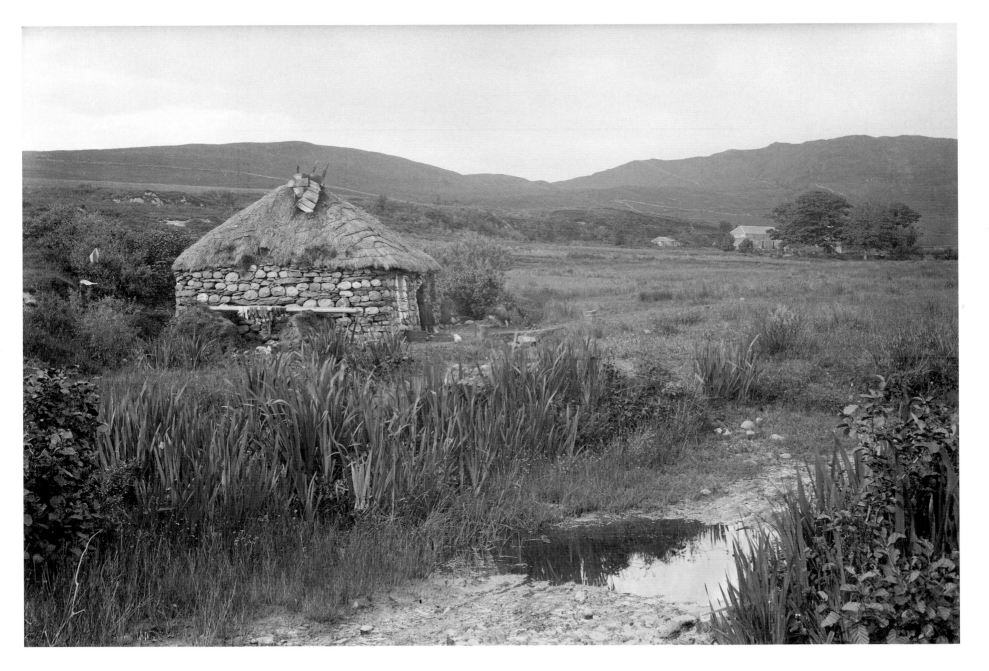

Cuil Bay, Duror, 1883. A beautifully composed view of a cottage with children, chickens and a dog outside. A row of socks is drying on the horizontal pole on the side of the house. SC746089

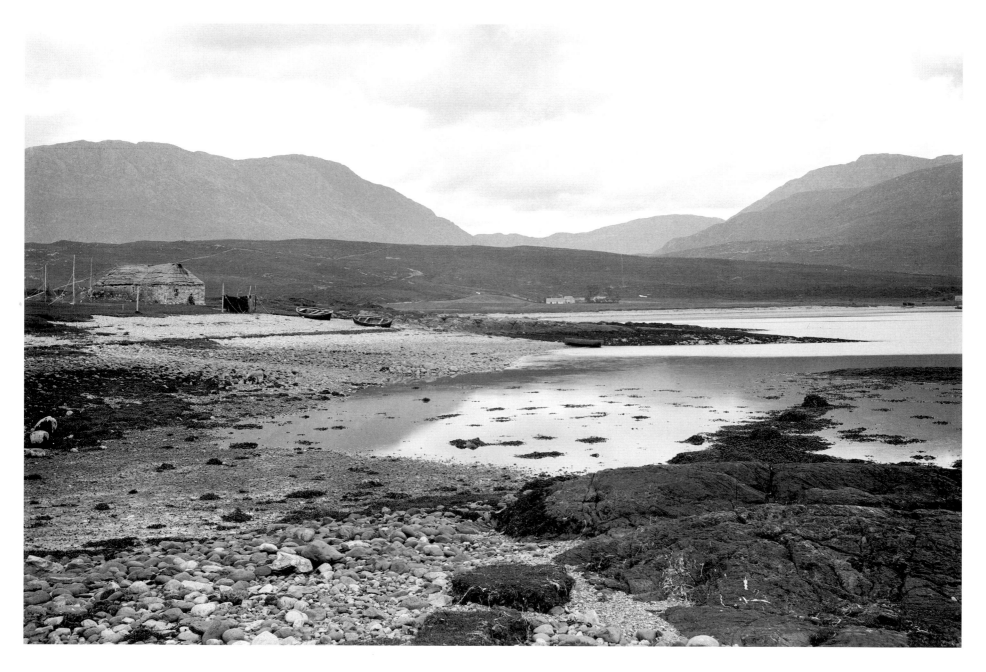

*Cuil Bay, Duror, 1883. Looking inland
from the shore of Cuil Bay. SC1115954*

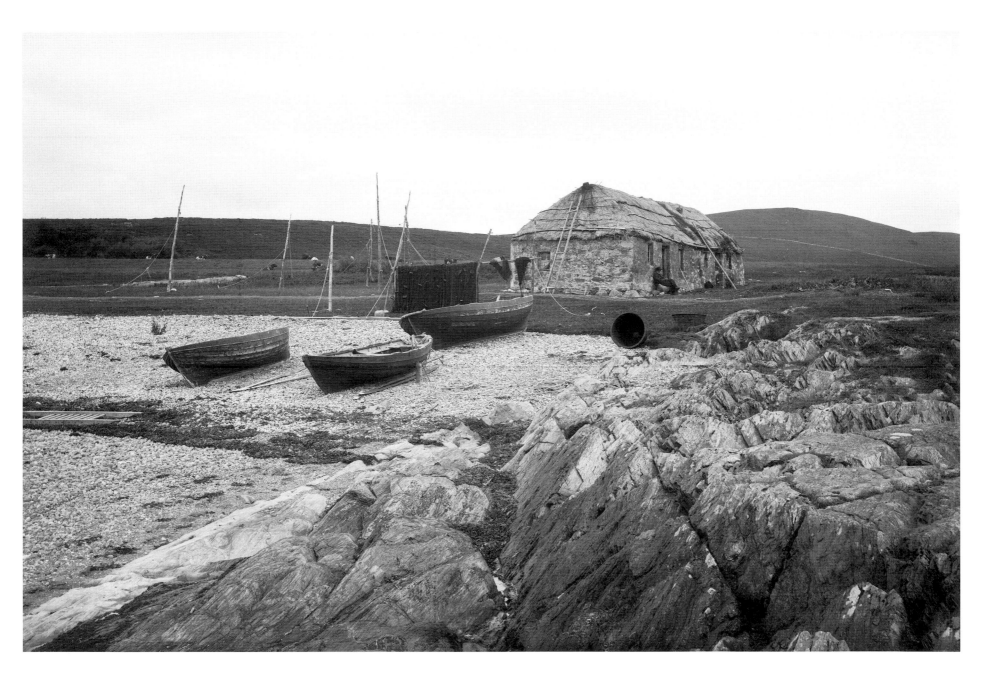

Cuil Bay, Duror, 1883. This traditionally built cottage has thick stone walls and a thatched roof. Fishing nets are drying on the upright poles and, in the absence of a pier, the boats have been dragged up on the shore. SC746287

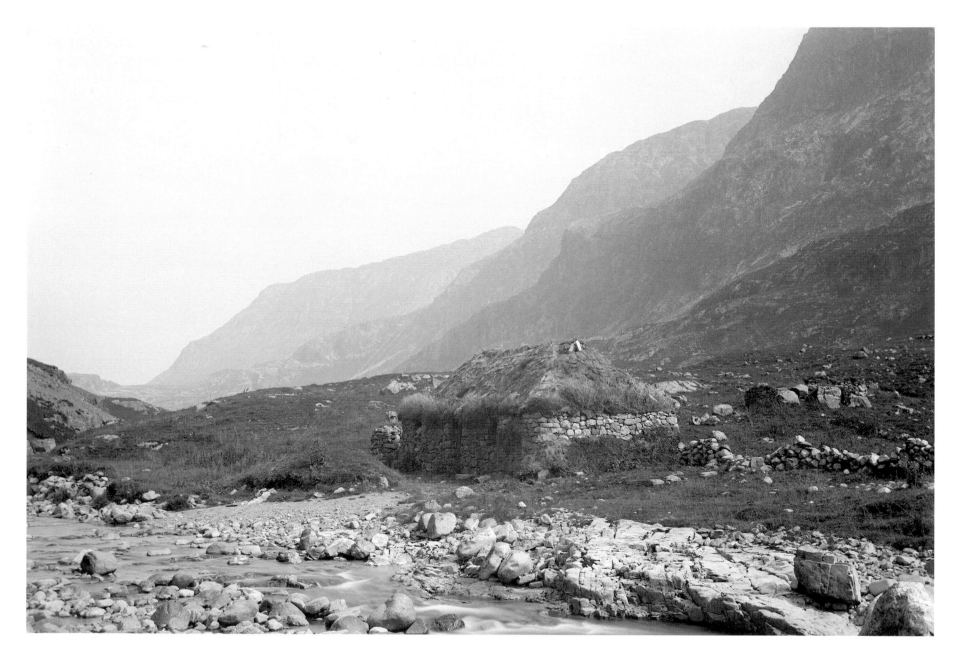

Glen Coe, Achtriochtan, 1882. Beveridge was no different from other Victorian tourists who visited popular historic places or beauty spots. From the steamer pier at Ballachulish, carriages took visitors to the Ballachulish Slate Quarries and into Glen Coe, passing this farmstead at Loch Achtriochtan. SC746099

Glen Scaddle, 1883. A farmstead in Glen Scaddle in the Ardgour peninsula. The house and byre are to the left and the building to the right is a cart-shed: the handles of the cart are sticking out. A large peat stack is visible just beyond the cart-shed. This image is another example of Beveridge's autumn photography with the fields of stooks. SC742964

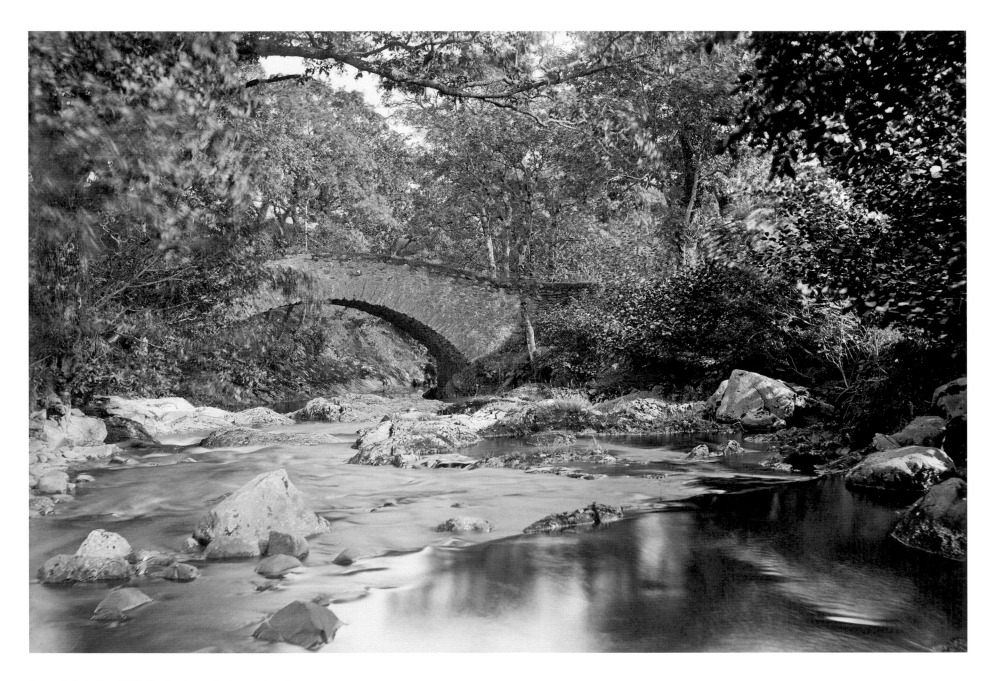

*Invernahyle Bridge, 1883. The bridge carried the old road
across the Iola river in the Strath of Appin. SC746112*

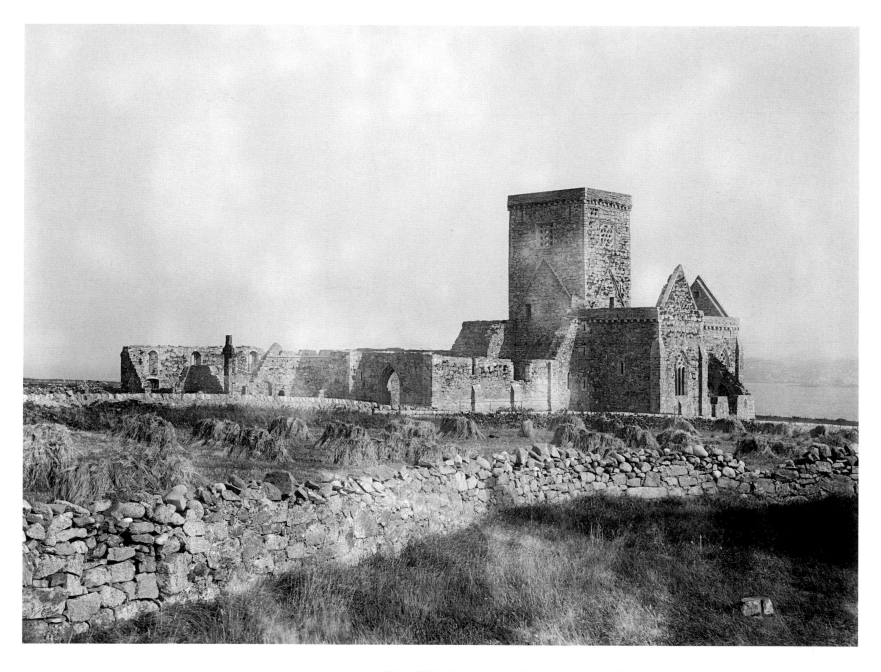

Iona Abbey, 1895. The abbey was still a ruin when visited by Beveridge in 1895. Built around 1200, restoration began in 1938 and was completed in 1965. St Martin's Cross is visible to the left of the photograph. SC743228

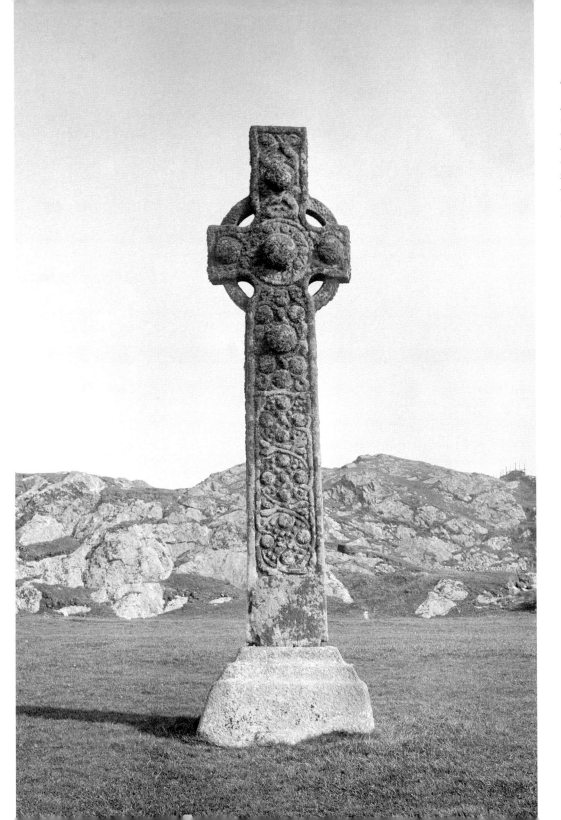

Iona, St Martin's Cross, 1895. Carved from a single block of stone, St Martin's Cross is one of four surviving crosses on Iona. Carved between AD700 and 800, it still stands in its original granite base. The carvings show serpents encircling cross-shaped sets of bosses. SC1115945

Iona, cross fragments, 1895. These cross fragments are from St John's Cross, now restored and displayed in the Iona Abbey Museum. Beveridge also photographed an upright cross shaft which was not identified as the shaft for St John's Cross until the early twentieth century. SC413949

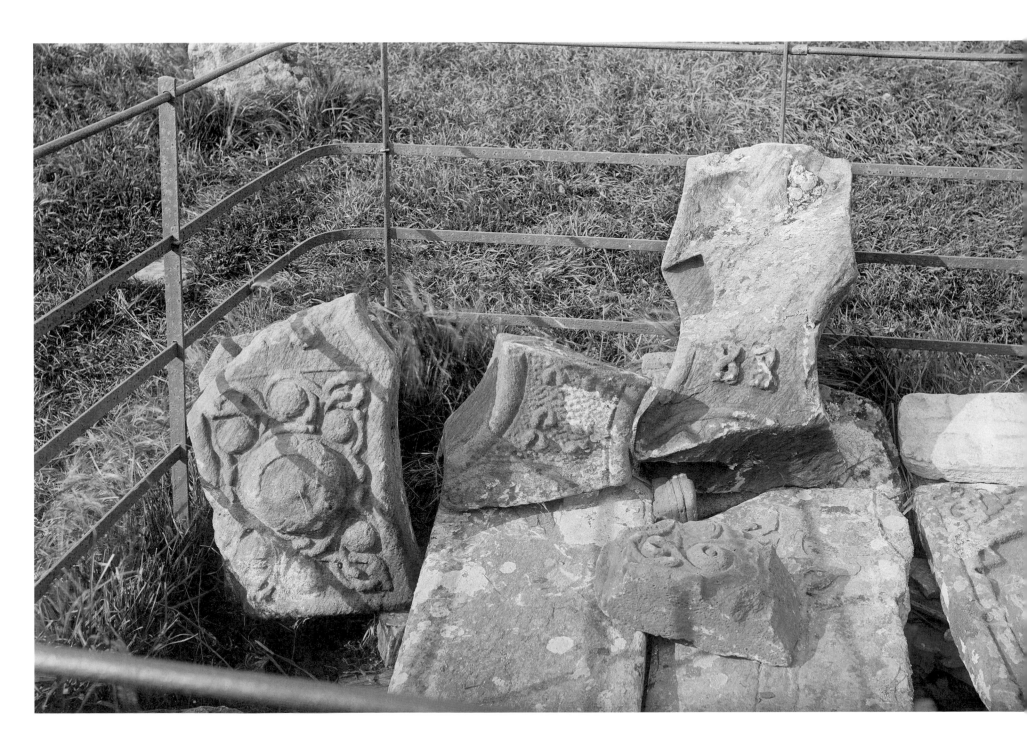

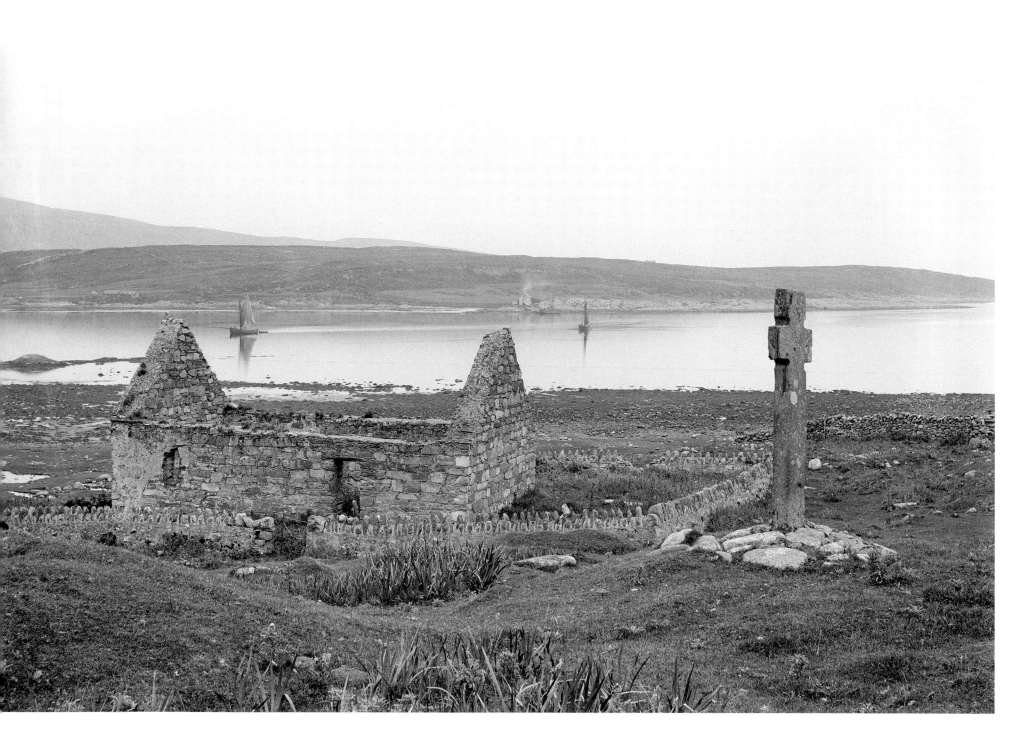

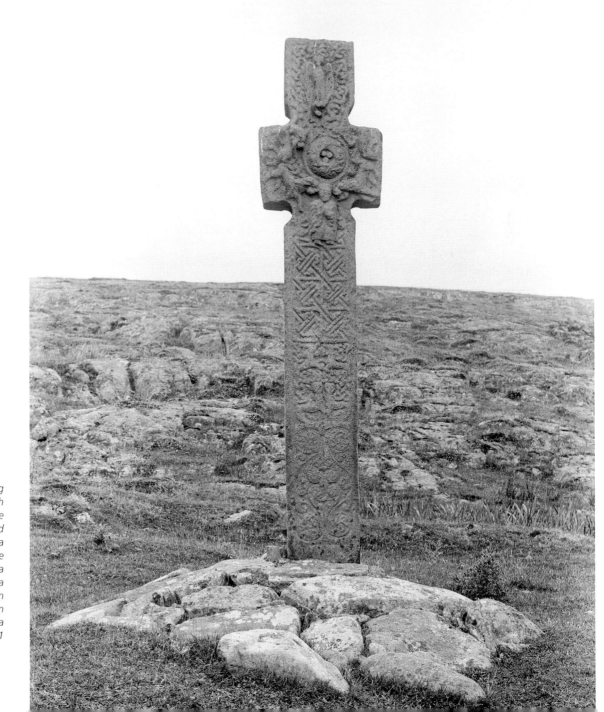

Keills Chapel, 1898. The chapel dates from the last quarter of the twelfth century and was reroofed in 1978 to house an important collection of Early Christian and medieval carved stones. The Keills Cross is now housed in the chapel. SC414820

Keills Cross, 1898. Dating from the eighth or ninth century, this cross is made from local stone. Created by a mason from the Iona school of sculpture, the cross is ornately decorated: a figure of Daniel is holding a book and raising his arm in blessing; his head is between two pairs of lions with a central boss. SC748661

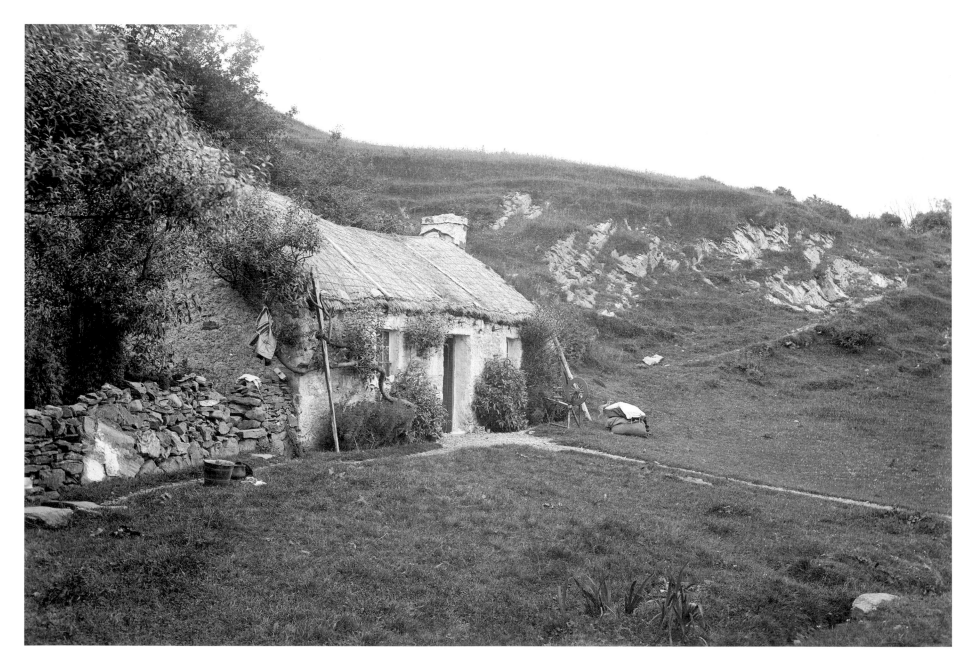

Lismore, Cottage, 1883. A typical island cottage dating from the early nineteenth century.
Spinning was traditionally undertaken outside to get the best light. SC743178

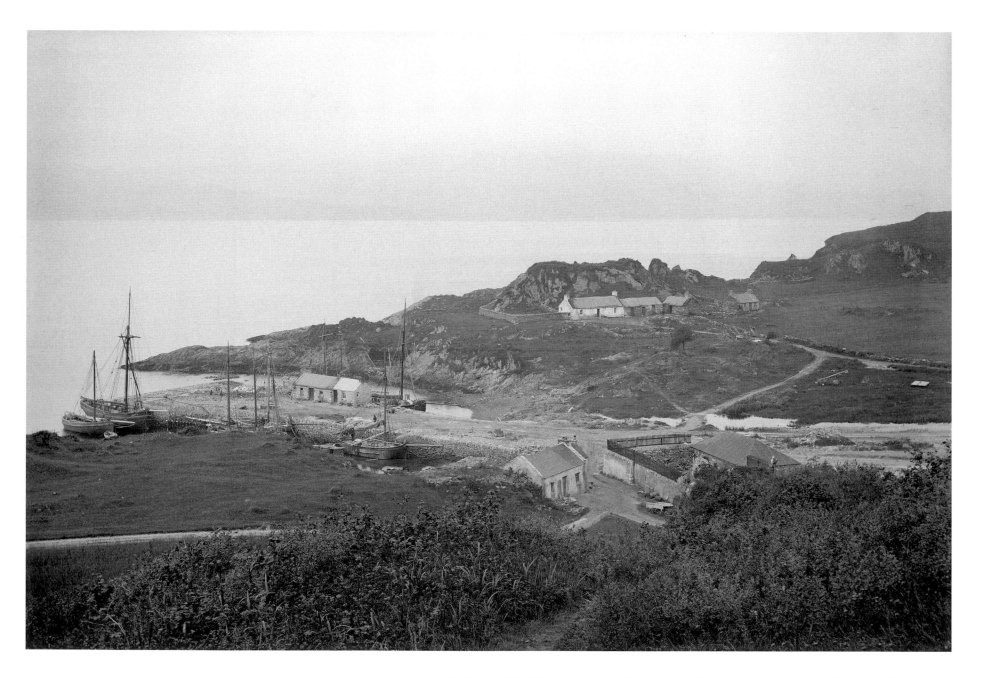

Lismore, An Sailean, 1883. This was once one of the centres for limestone quarrying and lime-burning on Lismore in the nineteenth century. The houses are grouped round the stone-built quay from where the lime was shipped. SC743164

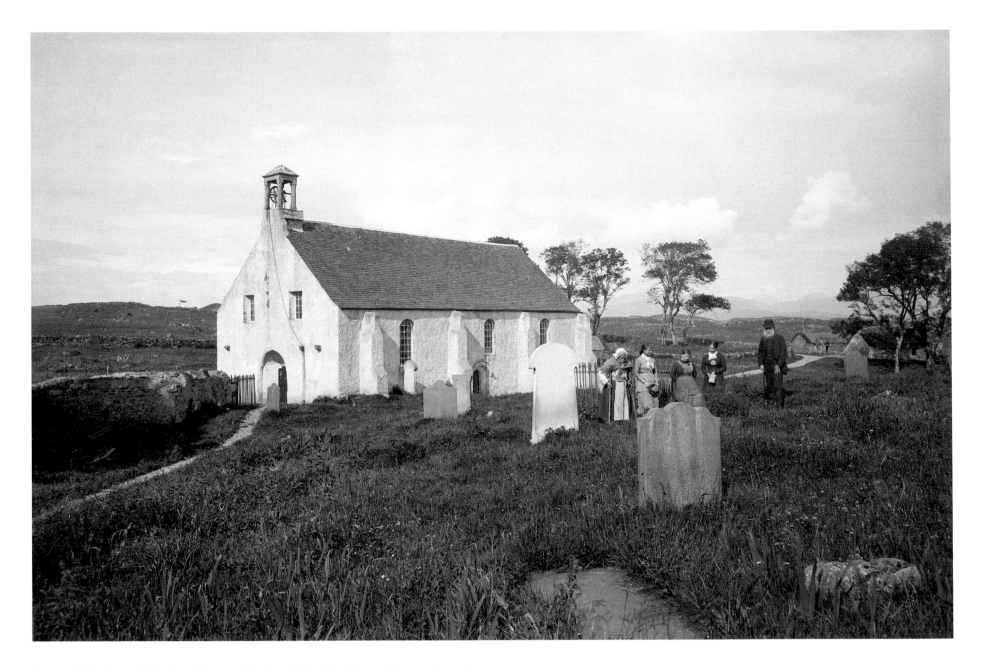

Lismore Parish Church, 1882. One of the most significant historic buildings on Lismore. The parish church was built in 1749 from the ruins of the early-fourteenth-century cathedral dedicated to St Moluag. The external buttresses on the wall are original fourteenth-century features. SC500617

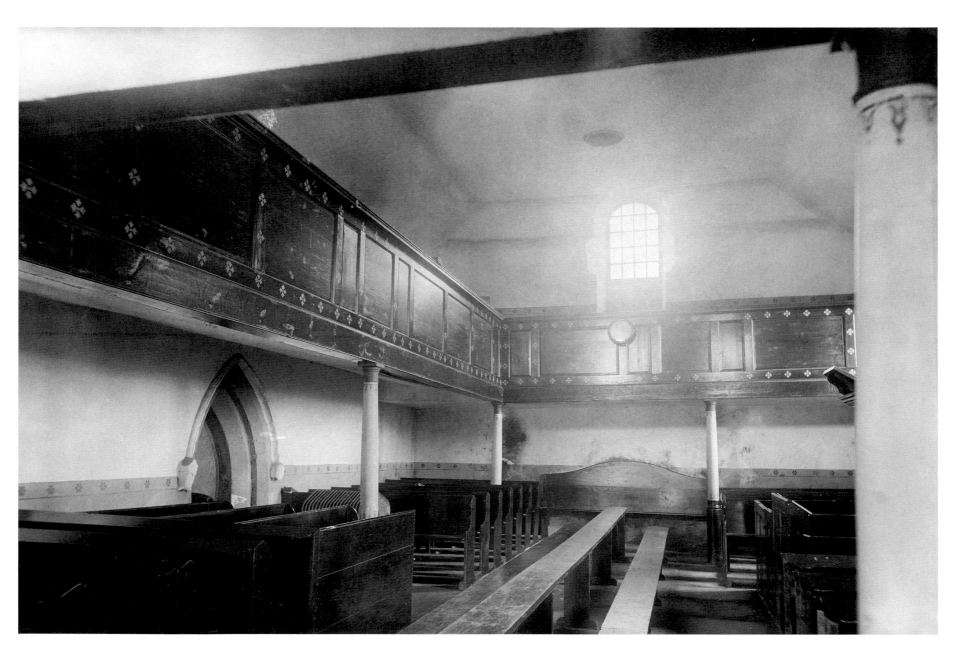

Lismore Parish Church, interior, 1882. In a rare interior view, Beveridge has photographed the mid-eighteenth-century layout of the church. A long central communion table with benches runs down the length of the church. Plans for the restoration of the church were prepared in 1894, not long after this photograph was taken, and the work was carried out c.1900. SC742999

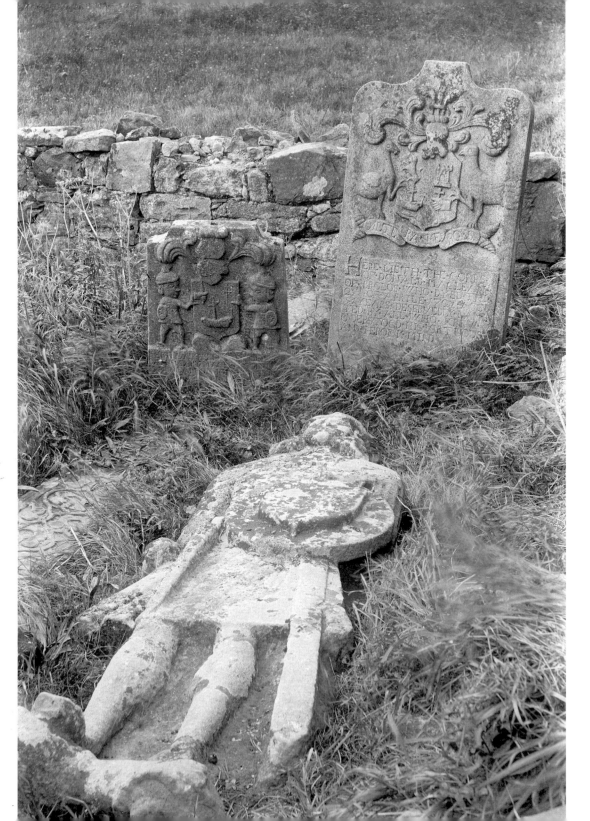

Mull, Loch na Keal, St Kenneth's Chapel, 1895. The ruins of a thirteenth-century chapel stand on Inch Kenneth, an islet off the west coast of Mull. Two eighteenth-century gravestones and a seventeenth-century effigy are within a burial enclosure built against the south wall of the chapel. SC748672

Oronsay Priory, West Highland Gravestones, 1895. Beveridge visited Oronsay on at least two occasions – in June 1895 and August 1898 – photographing the priory and many of the grave-slabs. These late medieval grave-slabs date from the fourteenth to sixteenth centuries and are decorated with plant scrolls, intertwined stems, galleys or swords. There are three distinct styles of grave-slab depending on whether the mason trained at Iona, Loch Sween or Oronsay. SC740727

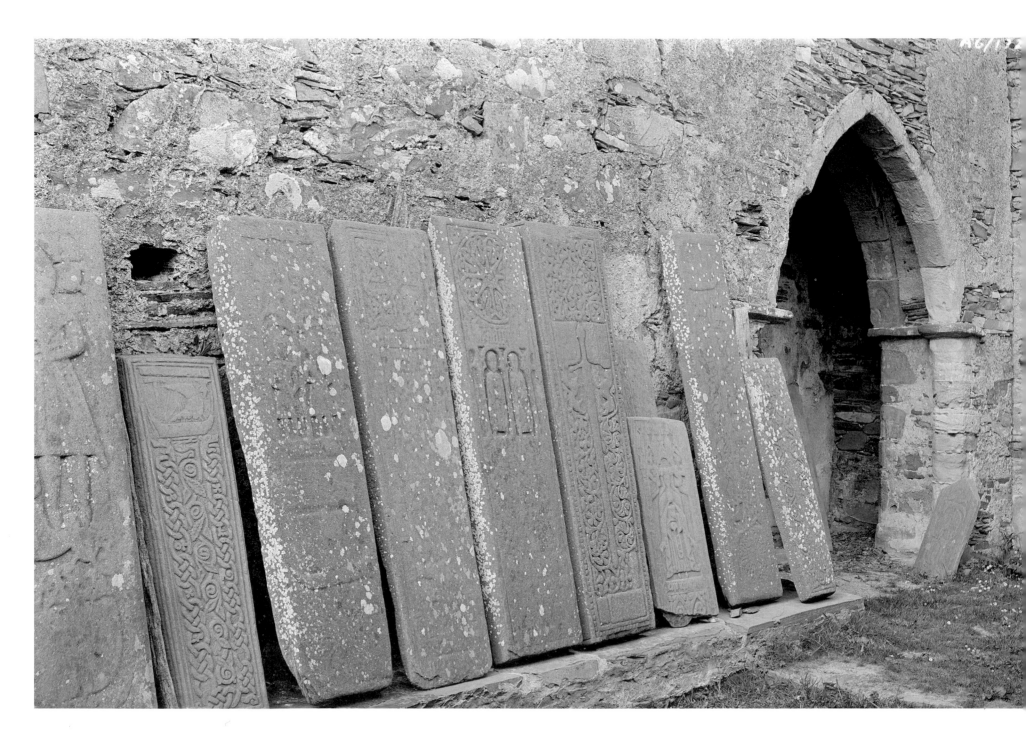

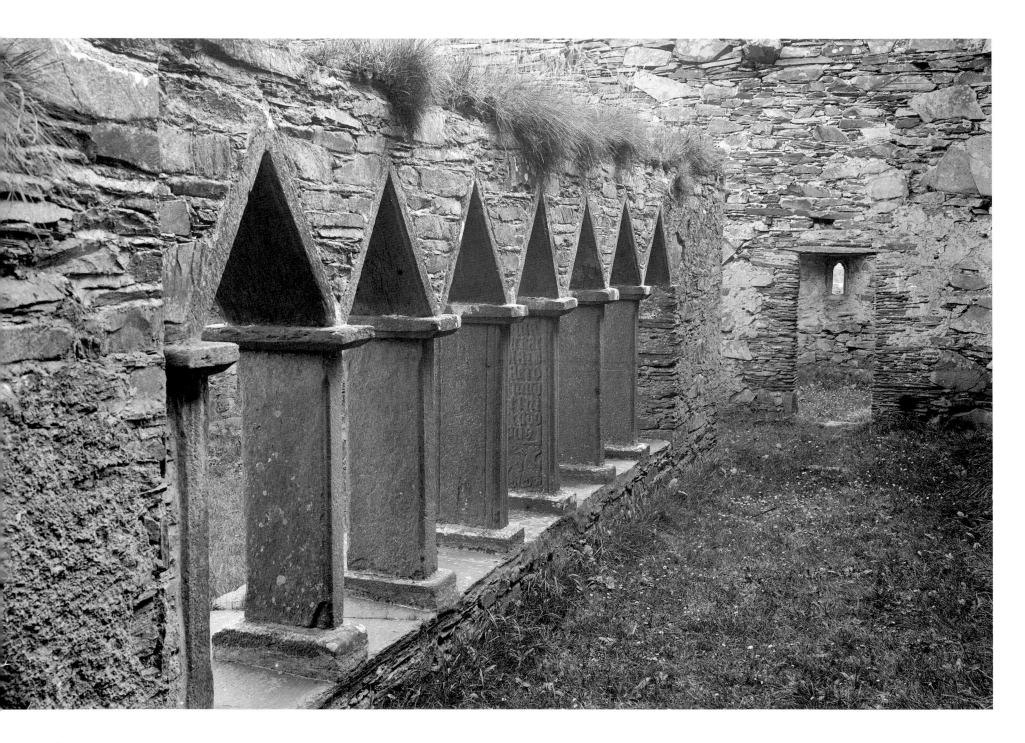

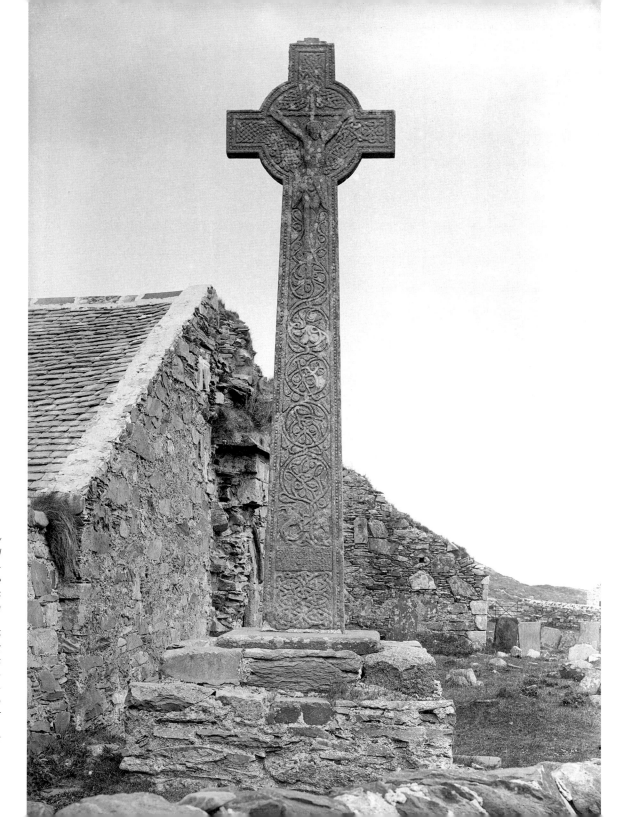

Oronsay Priory, west cloister arcade, 1898. Founded between 1325 and 1353 by John I, Lord of the Isles, as an Augustinian community, the priory buildings were in ruin by the seventeenth century. This cloister arcade was reconstructed in 1883. SC740720

Oronsay Priory, Cross, 1895. The late-fifteenth-century cross stands in its original socket-stone upon a three-tiered pedestal beside the ruins of the priory. The cross commemorates Malcolm MacDuffie, Lord of Colonsay, who died between 1506 and 1509. An inscription at the foot of the cross reveals that the sculptor was Mael-Sechlainn O Cuinn, an Iona-trained mason who may also have been responsible for rebuilding the priory c.1500. SC740705

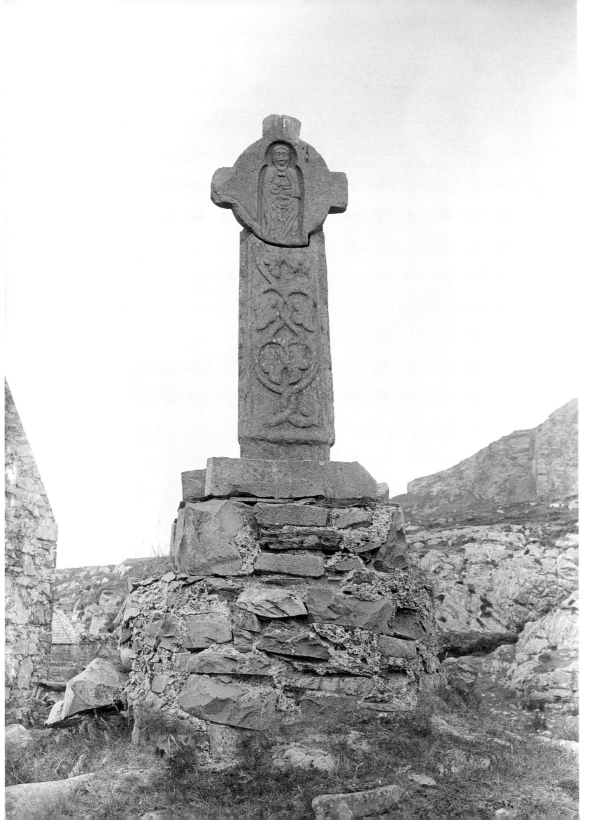

Oronsay, Abbot's Cross, 1895. This looks as if it is one monument but, at some time before 1870, the head of one cross was joined to the lower part of another and erected on a circular base. SC1115960

Port Appin, 1883. An important ferry port for the island of Lismore. SC742963

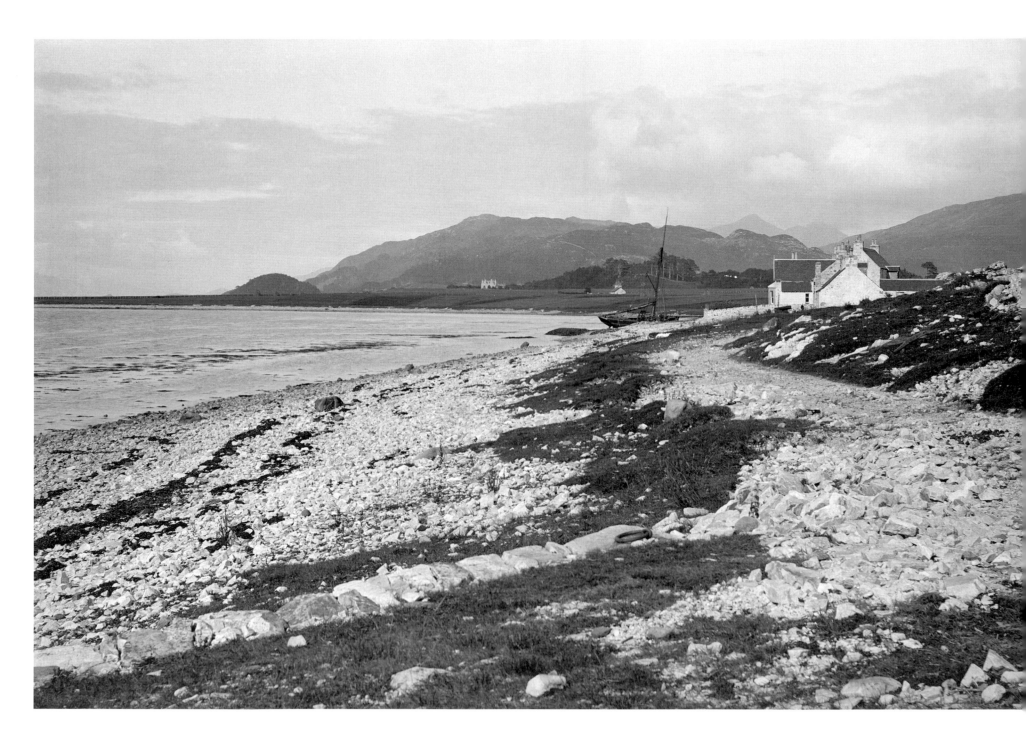

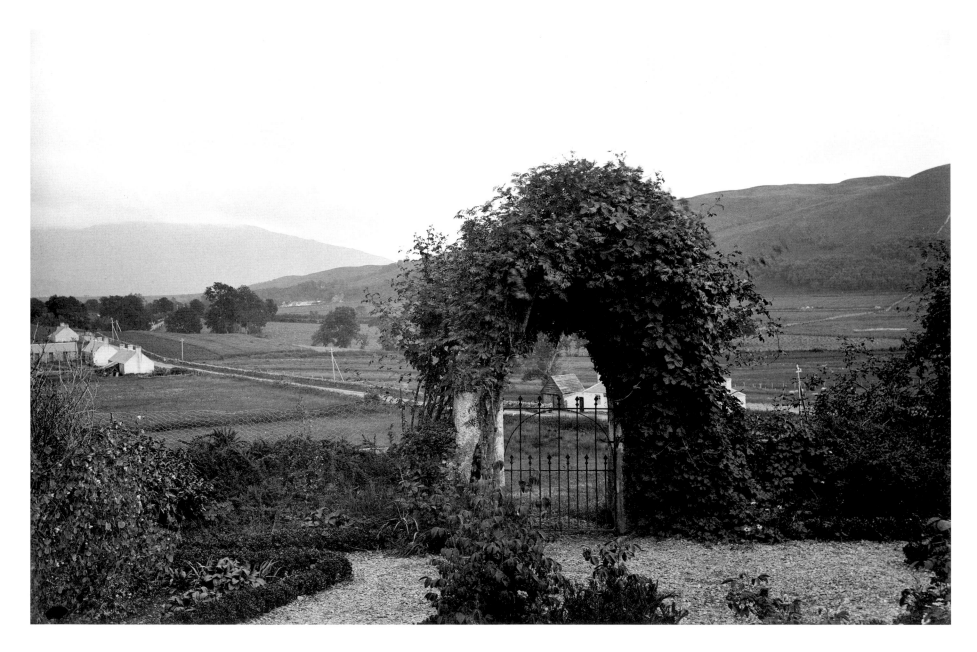

Portnacroish, Strathappin House, 1882.
This arch at the foot of the garden looks
across the valley from Strathappin House,
which was the parish manse. SC743025

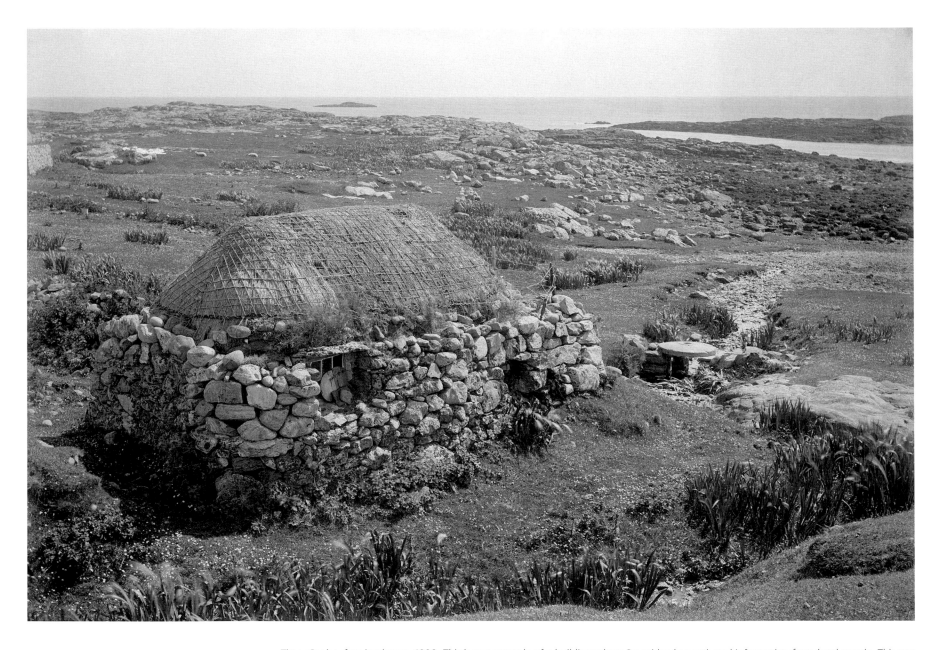

Tiree, Caoles, fanning house, 1899. This is one example of a building where Beveridge has gathered information from local people. This was probably originally a mill which was adapted for use as a fanning house for grain processing. Local knowledge suggested that the fanning house was in operation until 1885 and that the millstone came from Coll. When visited by Beveridge, the building was occupied by a disused loom and he comments that there were fewer than twelve looms in use in the townships of Tiree at that time. SC743218

Tiree, Dunan Nighean, 1898. Described by Beveridge as a 'curious long and narrow passage which runs through the rocks', he was 'assured by a neighbouring cottar that this was a roofed-in passage'. The house photographed here has been built over this natural feature. SC743231

Tiree, Kirkapol, church and chapel, 1898. The roofless remains of the Old Parish Church stand in a small enclosed burial ground. Dedicated to St Columba it first appears on record in 1375. The chapel to the right has no recorded history, and its dedication is unknown. SC743232

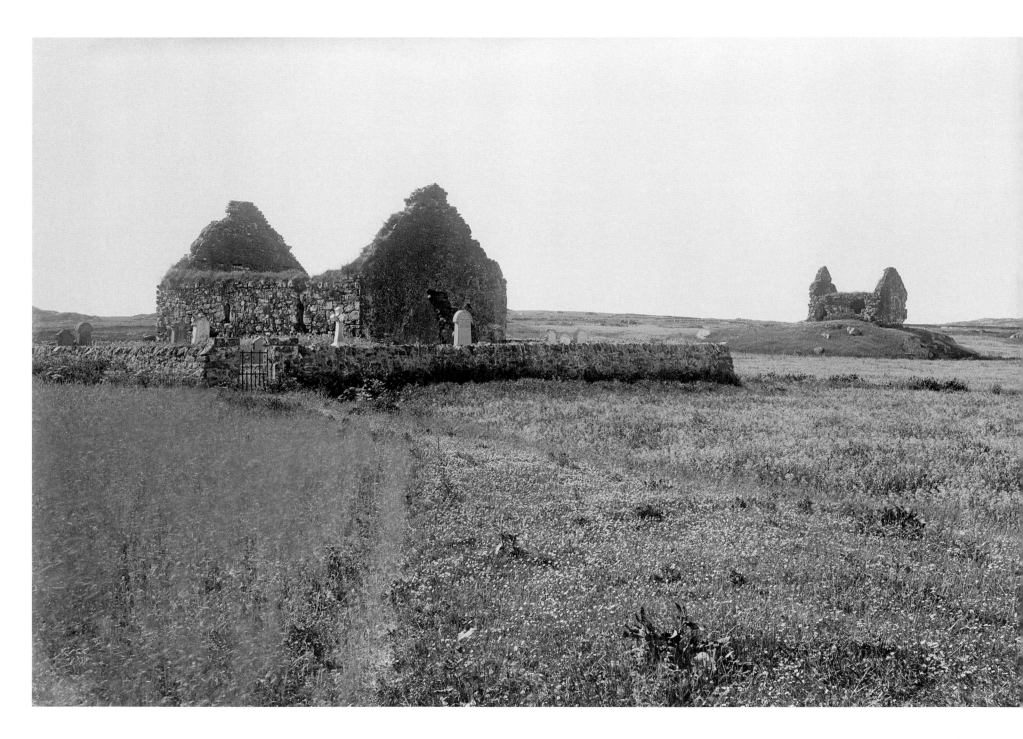

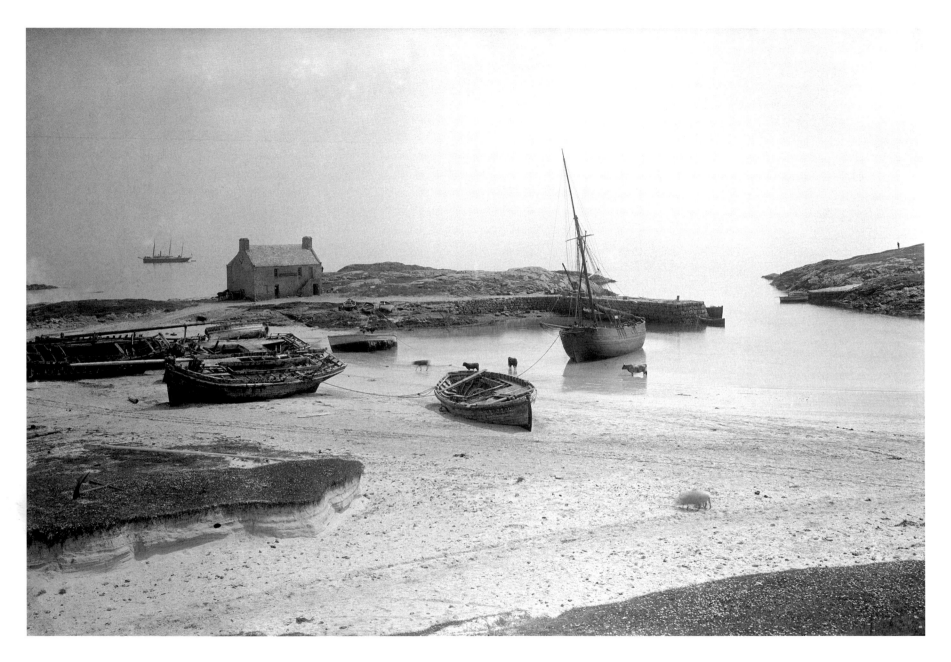

Tiree, Scarinish harbour, 1898. Scarinish was developed in the mid-eighteenth century by the Duke of Argyll as a fishing village and harbour. Small steamers could pull alongside the drystone L-shaped pier, built in 1771, but larger vessels had to anchor outside the harbour and their passengers or goods were ferried ashore. SC743238

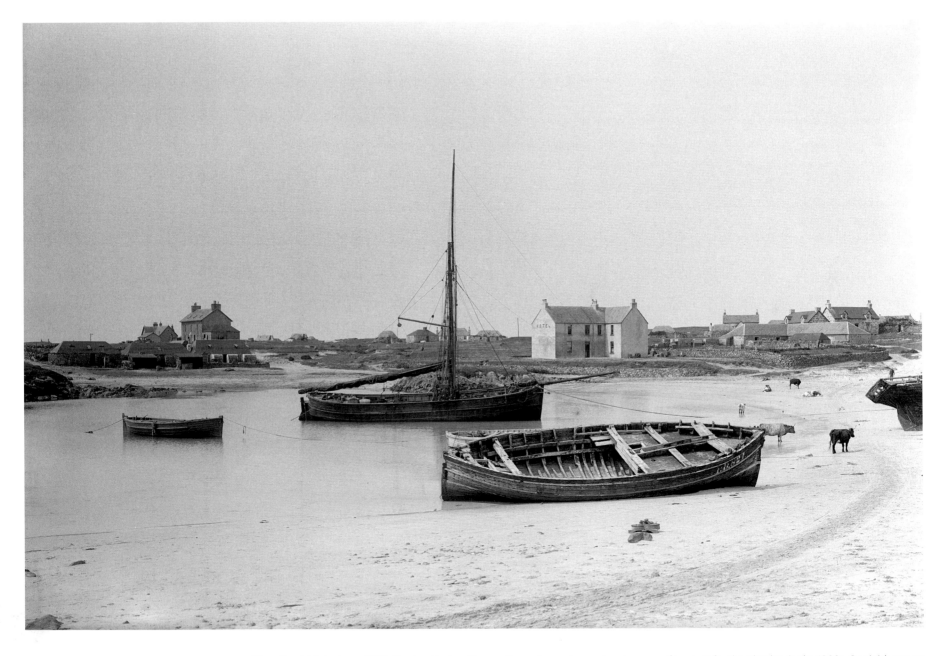

Tiree, Scarinish harbour, 1898. Rearing black cattle was the main employment and means of support for the islanders in the 1880s. Scarinish was an important port in the late nineteenth century for the transport of the island's cattle to market, as well as for ferrying animals from neighbouring islands of Coll, Muck, Canna and Rum. It remained the island's main harbour until a steamboat pier was constructed at Gott Bay in 1908–14. SC743237

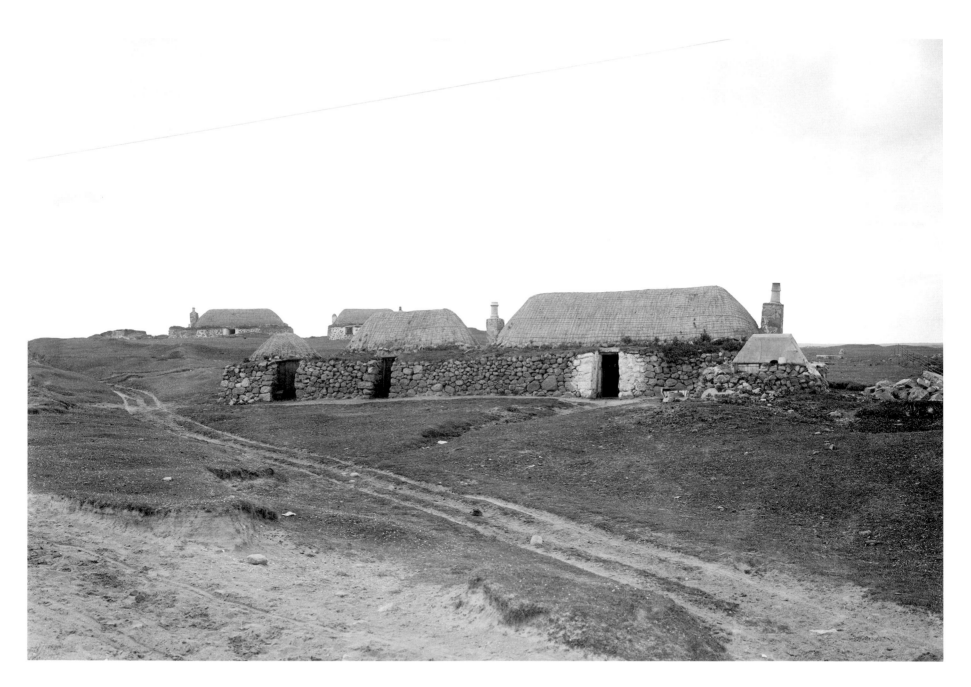

Tiree, Scarinish, 1898. When Beveridge visited Scarinish, the township was quite dispersed to the west of the harbour, with a mixture of later-nineteenth-century and traditionally built houses, as here. SC743245

Inverness-shire

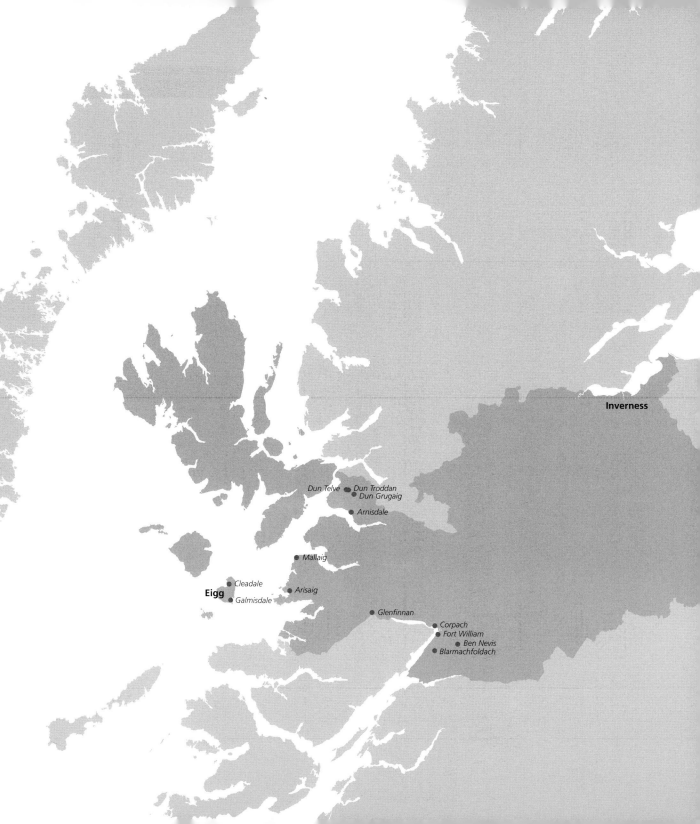

An area of mountains and stunning scenery, Inverness-shire is one of many areas where Beveridge is known to have photographed the wider Scottish landscape. Sadly, few of these views have survived in this collection but those that do illustrate the quality of his landscape photography.

With his interest in brochs, it was inevitable that Beveridge would visit the well-preserved examples in Glenelg. Contemporary tourist guides note that the steamer from Oban called at Glenelg and recommended the excellent inn there where an excursion could be made to the village of Arnisdale and the 'Pictish forts'.

Inverness

Dun Telve Dun Troddan
 Dun Grugaig

Arnisdale

Mallaig

Cleadale

Eigg Arisaig

Galmisdale

Glenfinnan

Corpach
Fort William
Ben Nevis
Blarmachfoldach

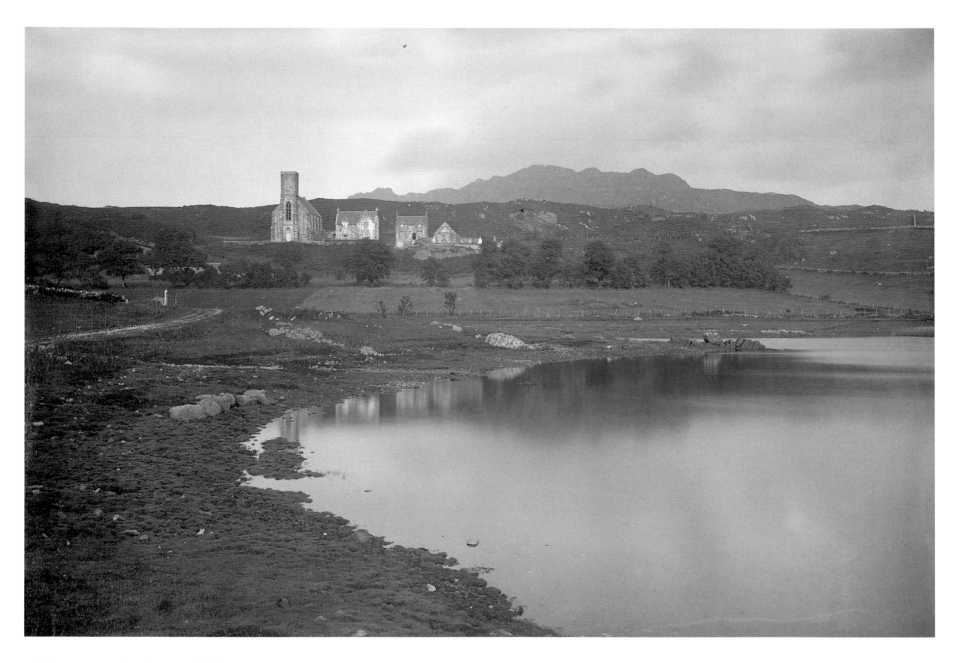

Arisaig, 1883. Located at the east end of the village of Arisaig,
St Mary's Roman Catholic Church was completed in 1849 to
designs by the architect William Burn. SC746318

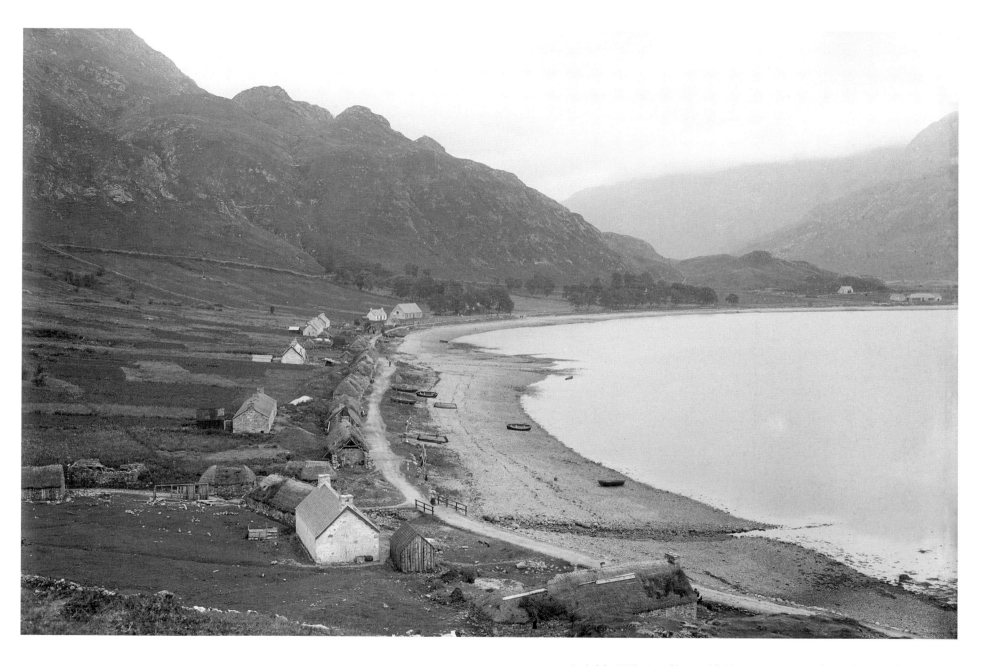

Arnisdale, 1898. A crofting and fishing community on the north shore of Loch Hourn.
The older thatched houses beside the shore were inundated by high tides in 1881.
All new houses have been constructed behind the line of the original village. SC748658

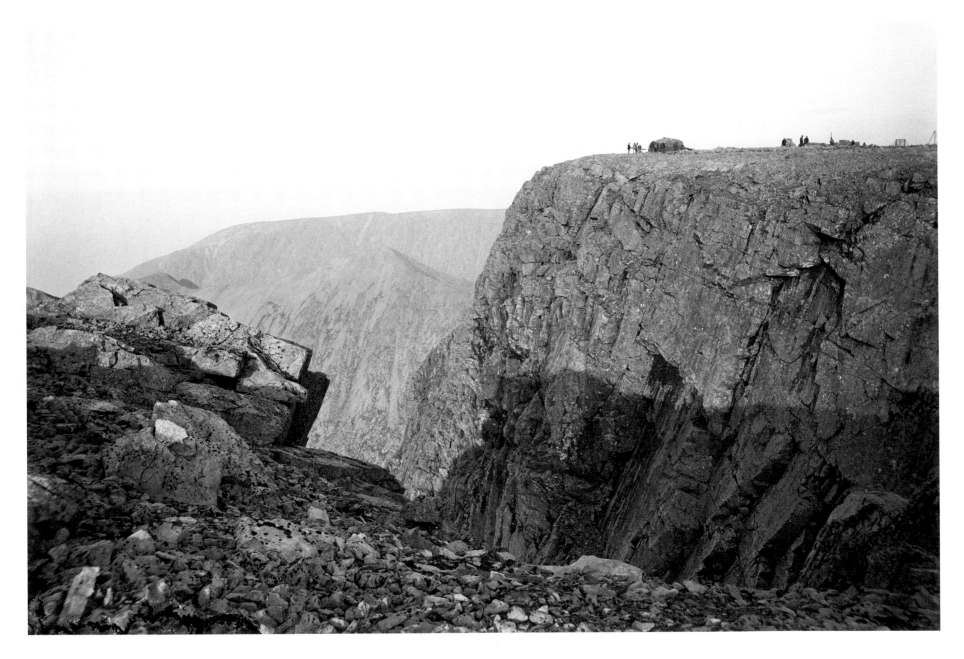

Ben Nevis, 1883. In 1883 a path was constructed to the summit of Ben Nevis to improve access to the weather observatory. Beveridge climbed to the summit that year with his camera and glass plate negatives. This view is from the top of Tower Ridge looking across Gardyloo Gully to the summit. SC746125

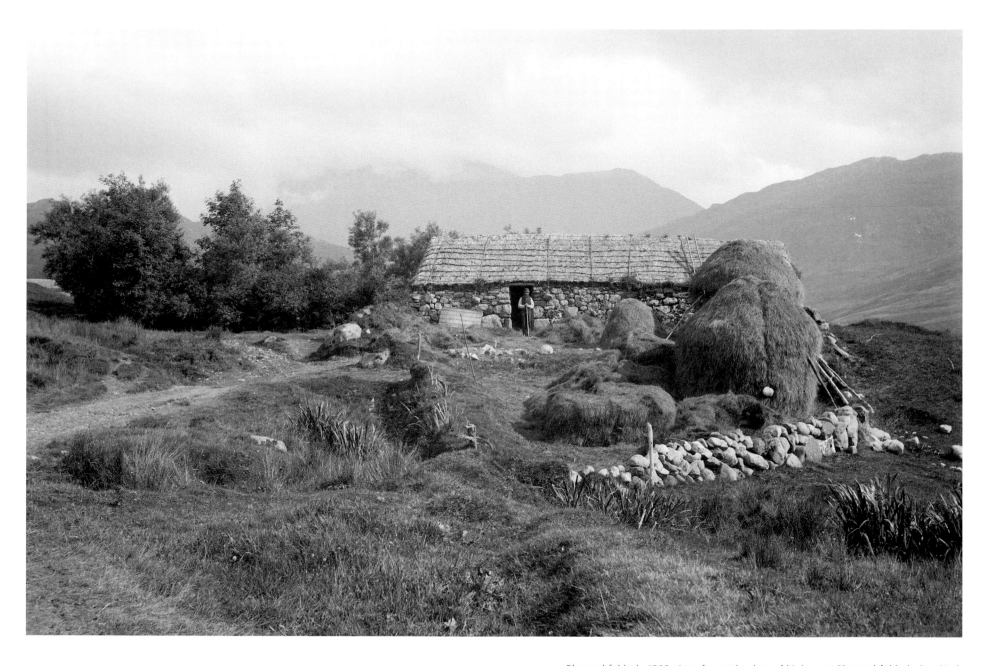

Blarmachfoldach, 1883. A crofter at the door of his barn at Blarmachfoldach. Ben Nevis is in the background. Built from irregularly shaped hill stones, the barn has a turf and thatch roof and a partially enclosed yard at the front for the hay-stacks. SC746281

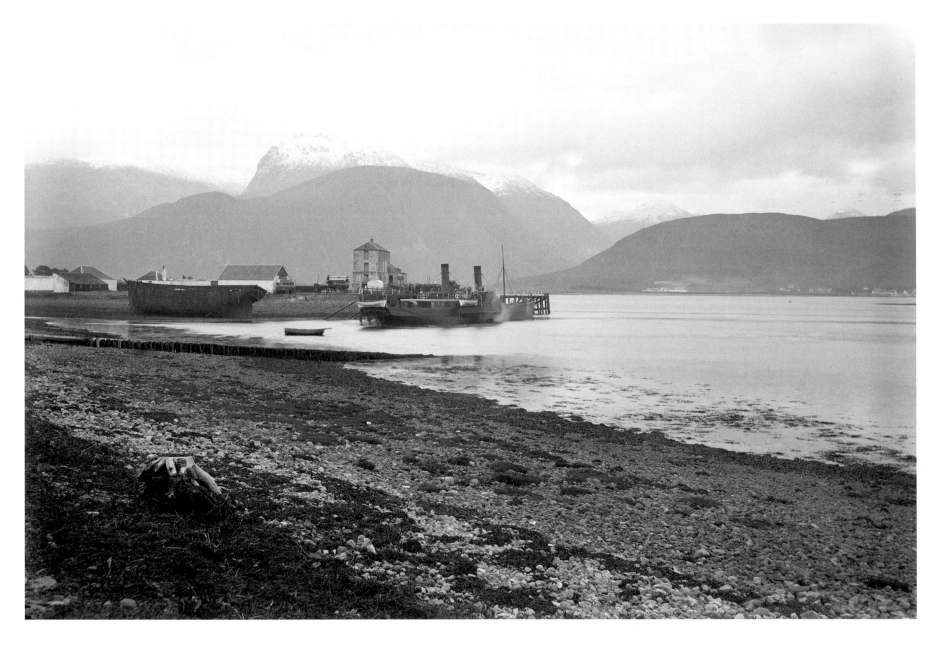

Corpach, 1883. Dominated by the snow-covered peak of Ben Nevis, the pier at Corpach was constructed in 1804–06 for ships entering the Caledonian Canal from Loch Linnhe. As today, tourists could enjoy day trips along the canal. On the pier, a horse and carriage provide transport for passengers to and from the paddle steamer. SC746161

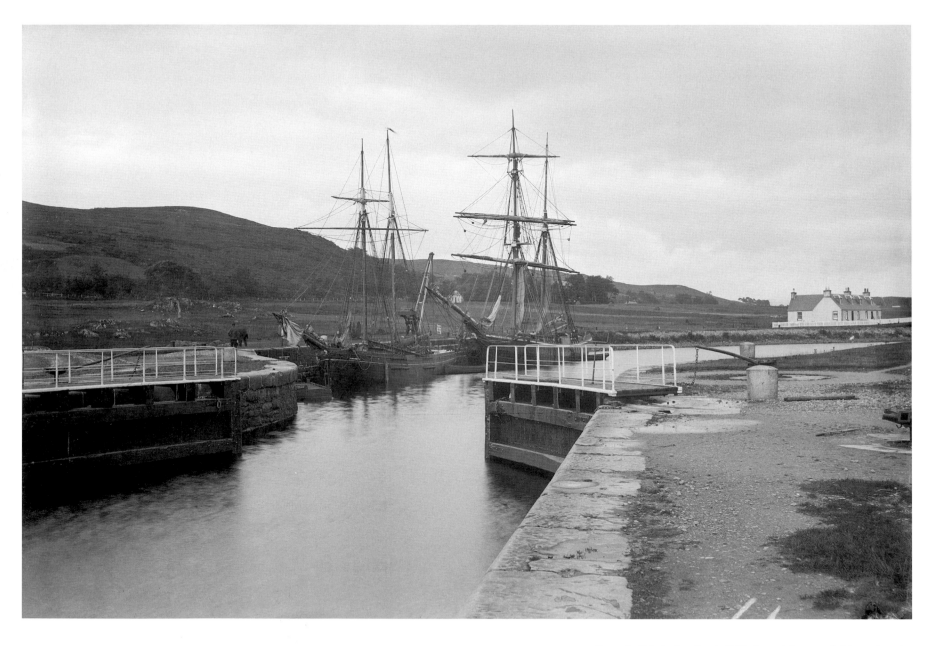

Corpach, Caledonian Canal, 1883. One of the remarkable engineering achievements of Thomas Telford, the Caledonian Canal was completed in 1822, and ran from Inverness through the Great Glen. The final locks are at Corpach before the canal flows into Loch Linnhe. SC1112920

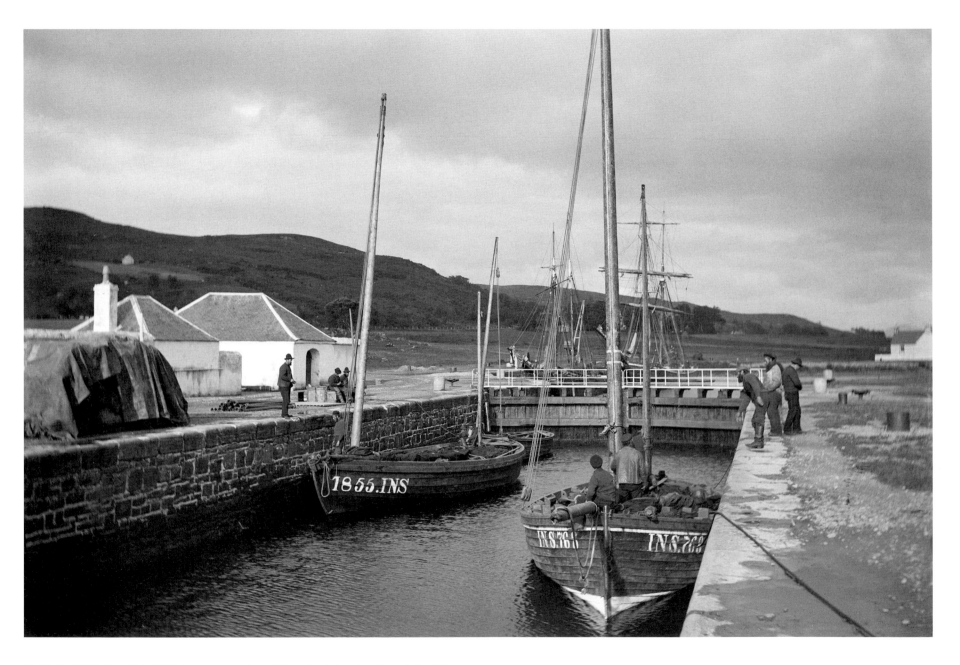

Corpach, Caledonian Canal, 1883. Inverness registered fishing boats heading through the locks into Loch Linnhe. The construction of the Caledonian Canal opened up access from the north-east to the west of Scotland, avoiding the treacherous waters of the Pentland Firth. SC1112919

Dun Grugaig, Glenelg, broch, 1897. Beveridge began to take an active interest in archaeological monuments, particularly brochs and duns, following holidays in Coll, Tiree and North Uist. He travelled extensively round Scotland and Ireland to visit similar monuments, going to Glenelg in 1897. SC1113131

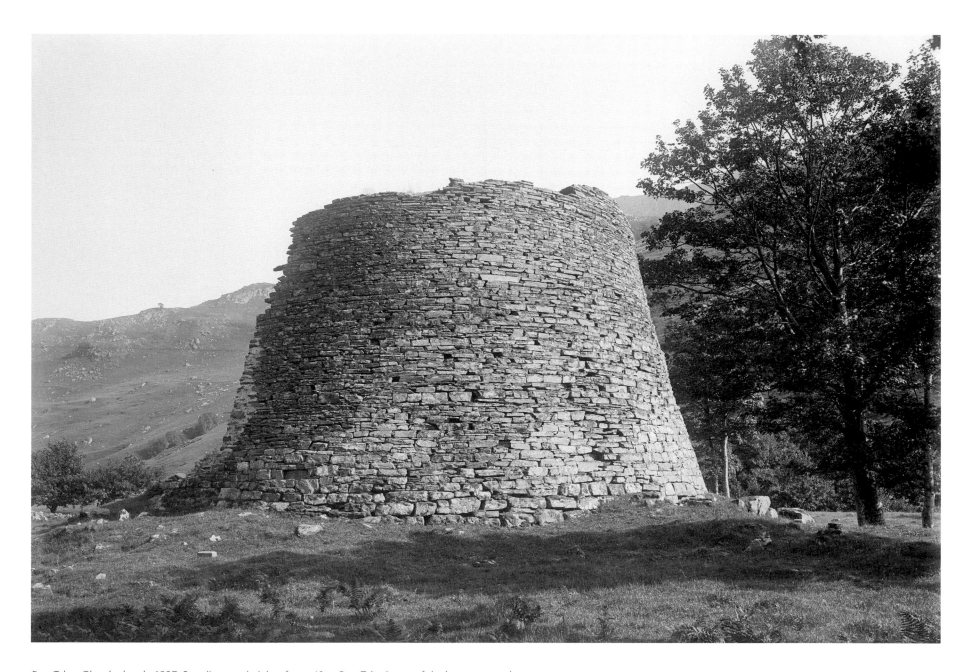

Dun Telve, Glenelg, broch, 1897. Standing to a height of over 10m, Dun Telve is one of the best preserved brochs in Scotland. Between the outer double walls a staircase of seventeen surviving steps led to an upper floor. Stone lamps were discovered in the interior when it was excavated in 1914. SC336810

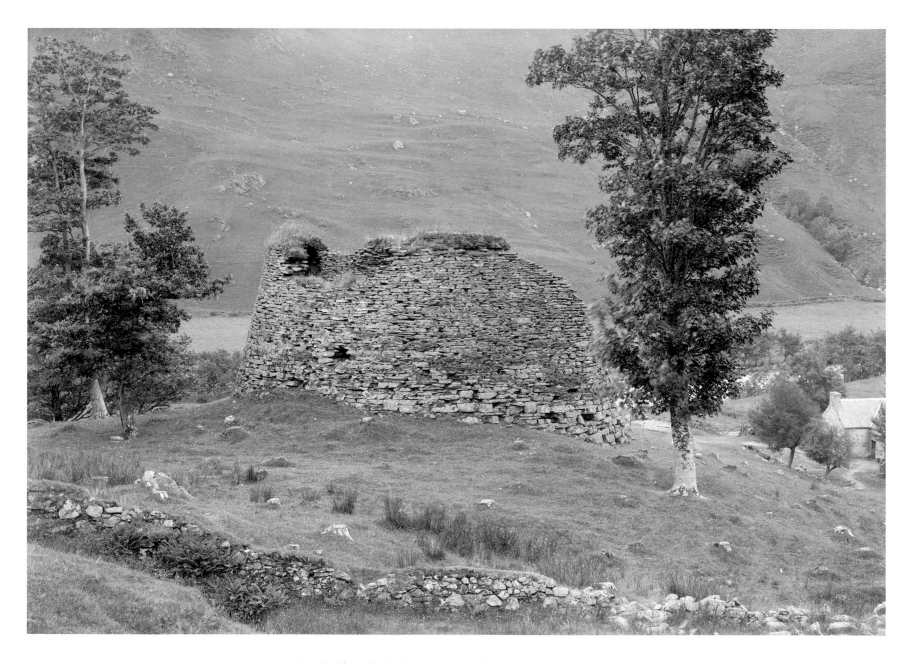

Dun Troddan, Glenelg, broch, 1897. Looking down on the neighbouring broch of Dun Telve, Dun Troddan is one of the other best preserved brochs in Scotland. Standing to a height of some 7.6m, it too has the partial remains of a staircase leading upwards. Excavations in the interior in 1920 revealed a hearth and ring of postholes which would have held timbers supporting an upper floor. SC1113122

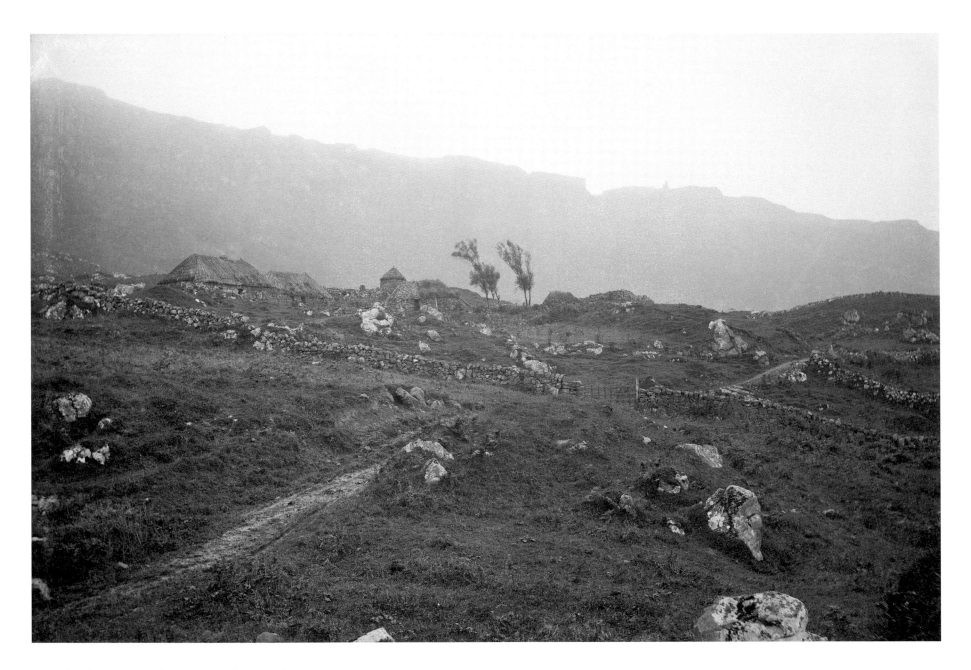

Eigg, Cleadale, 1883. One of three large crofting townships on Eigg. Clearly, when Beveridge visited, weather conditions were far from ideal for photography. SC743147

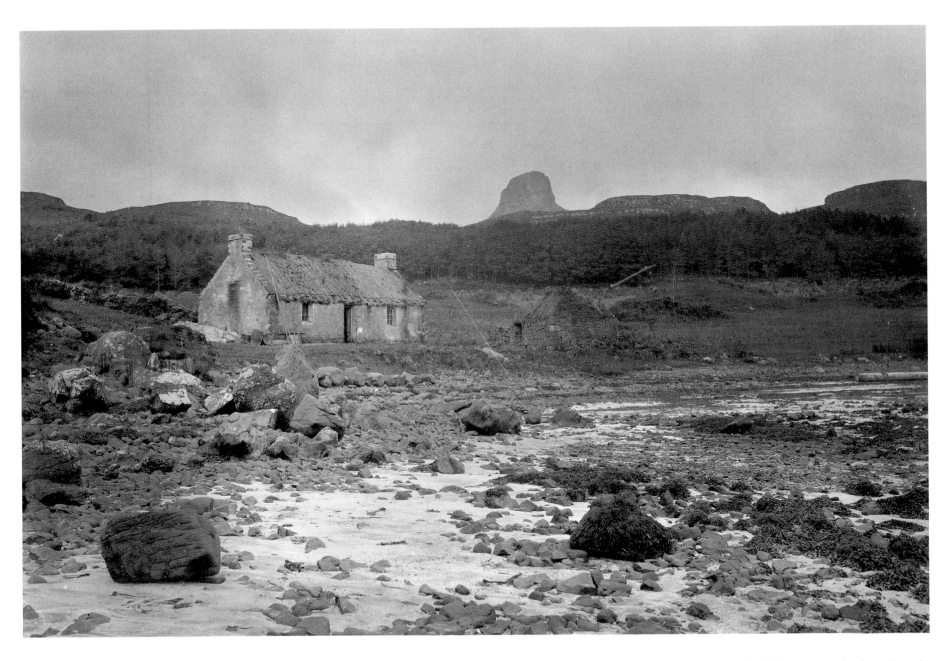

Eigg, Galmisdale, 1883. This photograph of a thatched cottage on the shore shows the Sgurr of Eigg in the distance. This is another example of Beveridge's autumn travels – there are stooks in the field behind and to the right of the house. SC743154

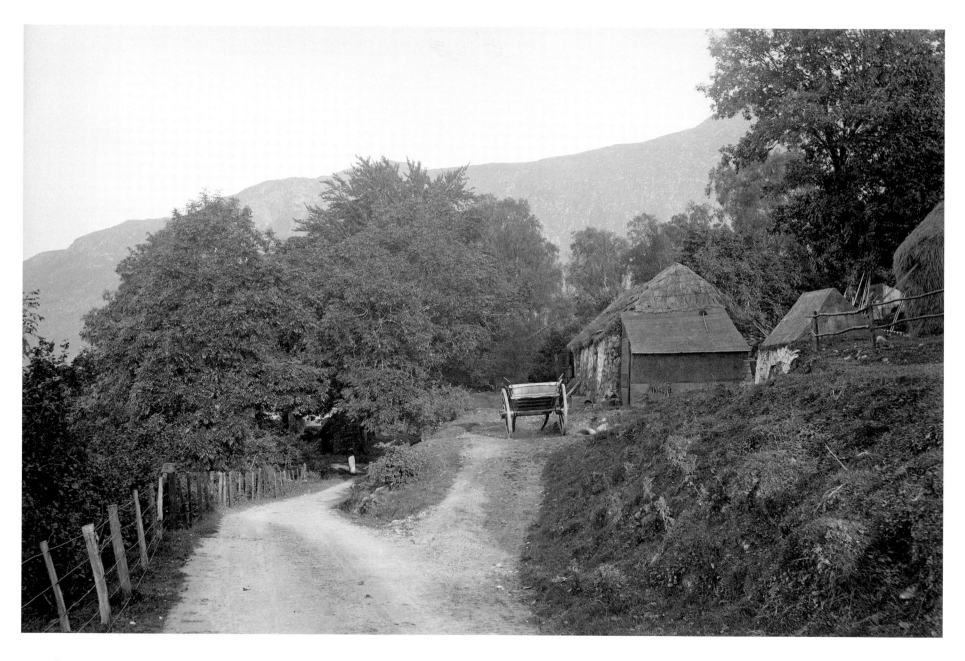

Fort William, A'Choille Bheag,
1883. A farmstead on the road
into Glen Nevis. SC746289

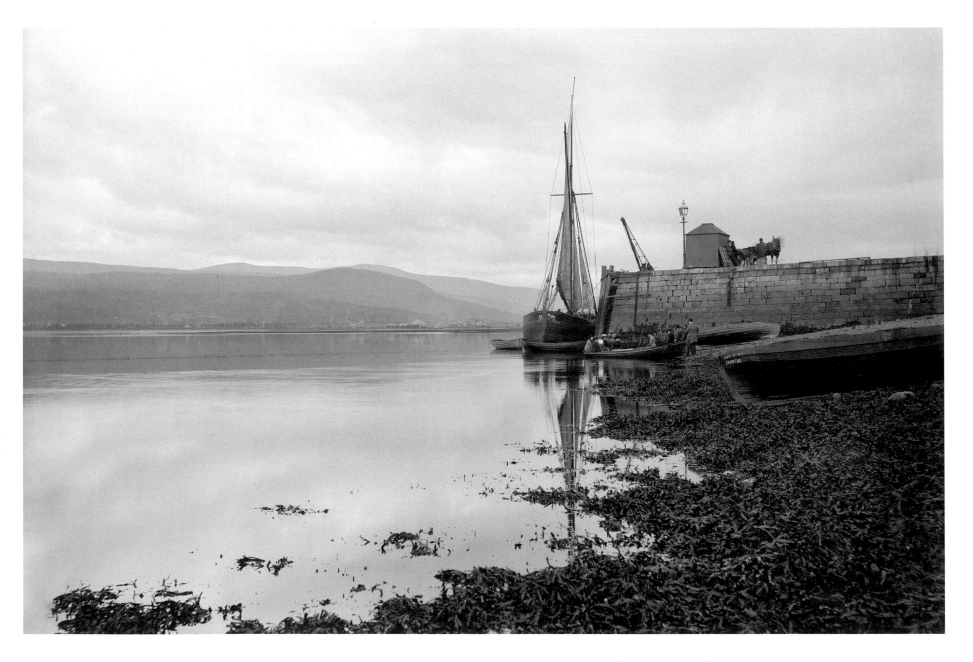

Fort William, c.1883. A large rowing boat is full of passengers being ferried across the loch or to a larger vessel anchored offshore. On the eastern shore of Loch Linnhe, the pier probably dates to the early nineteenth century. Before the arrival of the railway in 1894, it was the main transport and communication route for passengers and goods. SC746279

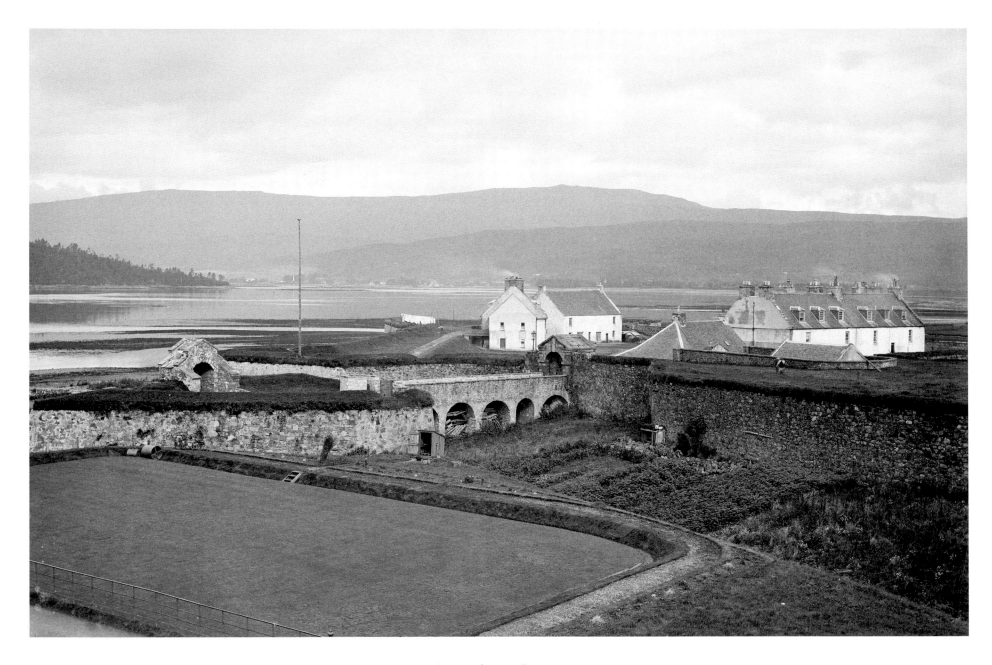

Fort William, fort, 1883. The fort was originally known as Inverlochy and was renamed in honour of King William III in 1690. Beveridge photographed the fort in the years before it was bought by the West Highland Railway and largely demolished. This view is looking across the ramparts into the fort interior. The former parade ground is in the foreground. SC746274

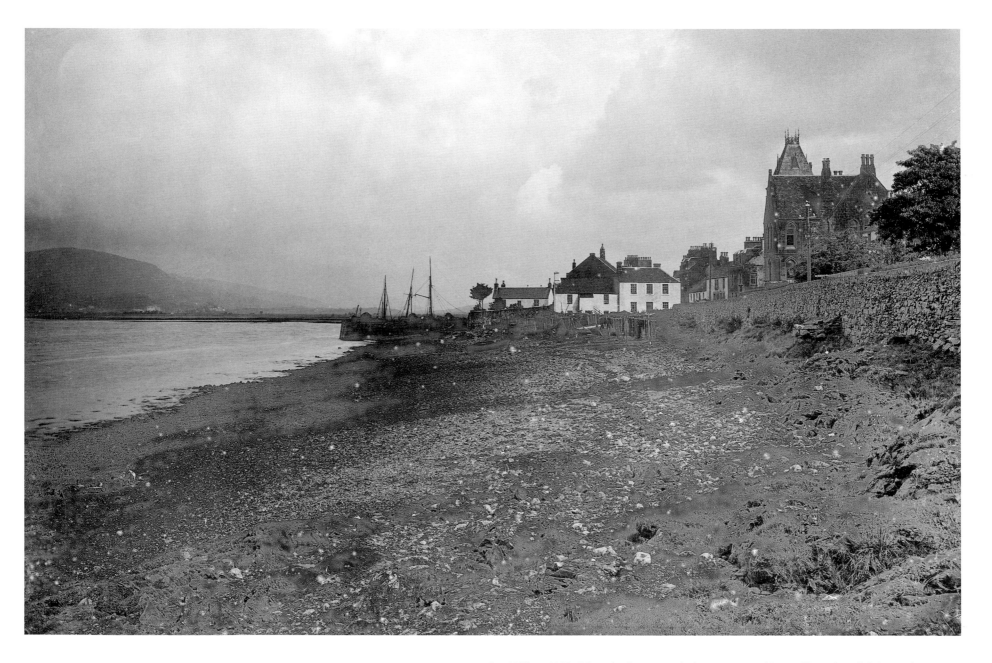

Fort William, 1883. When the fort at Inverlochy was renamed Fort William, the adjoining settlement was renamed Maryburgh, after the Queen. Later known as Gordonsburgh, and renamed as Duncansburgh in 1834, the name of the town as Fort William was finally established in 1874. SC746273

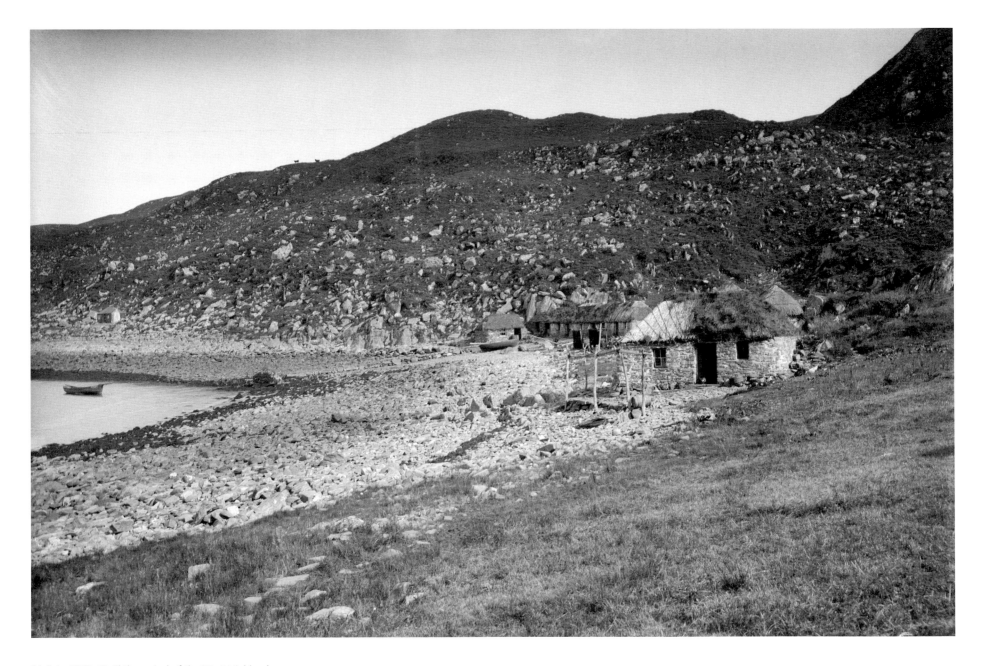

Mallaig, 1883. Until the arrival of the West Highland Railway in 1900, there were only a few houses and a small stone pier at Mallaig. SC746291

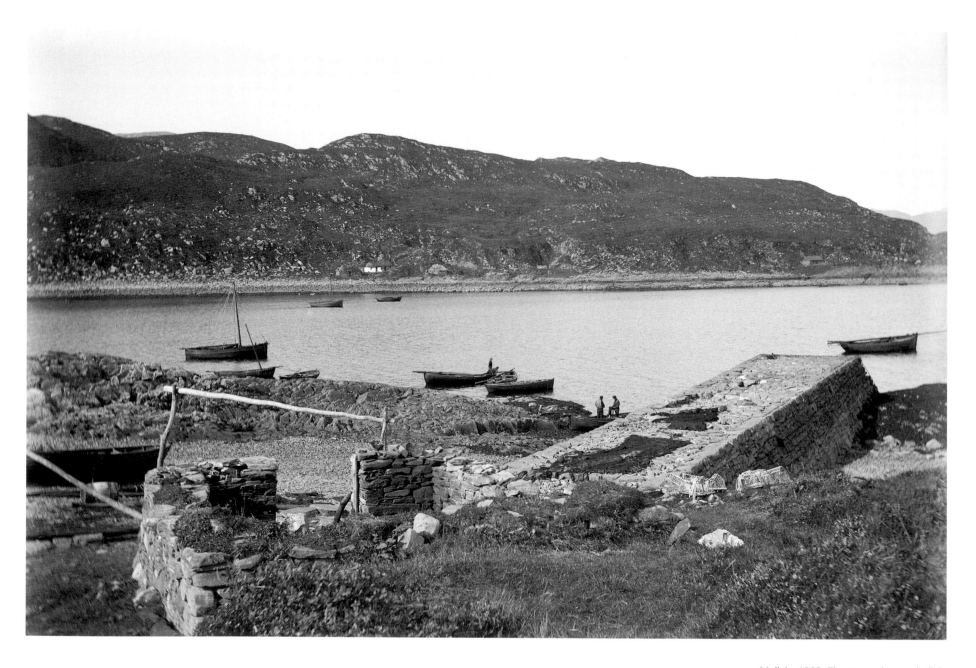

*Mallaig, 1883. The stone pier was built in
1846–47 by Lord Lovat, who had hoped
to develop a fishing port. SC746290*

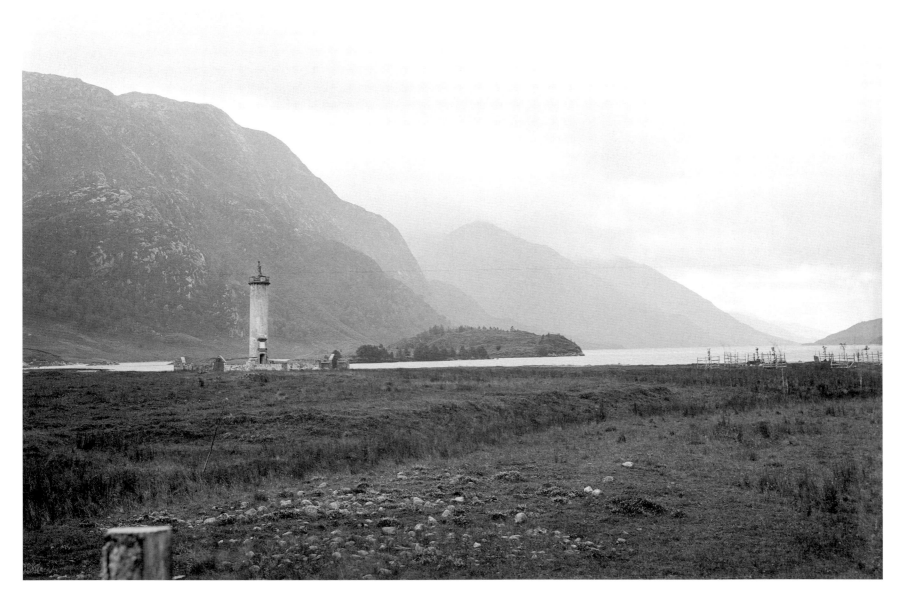

Glenfinnan Monument, 1883. Built in 1815 to commemorate where Prince Charles Edward Stuart is supposed to have raised the Jacobite standard in 1745, the Glenfinnan Monument has been restored since this photograph was taken. The rendering has been removed and the marble plaque above the door has been placed in the surrounding wall. SC1113136

Western Isles

Beveridge visited most areas of the Western Isles, but it was on North Uist that he purchased land and built his second home. All surviving photographs from 1900 until his death in 1920 are from North Uist. Many illustrate the archaeological excavations he undertook to get a better understanding of the sites he encountered. Other photographs document whole communities and their way of life at the start of the twentieth century which Beveridge must have contrasted with the industrial town of Dunfermline he left behind each summer.

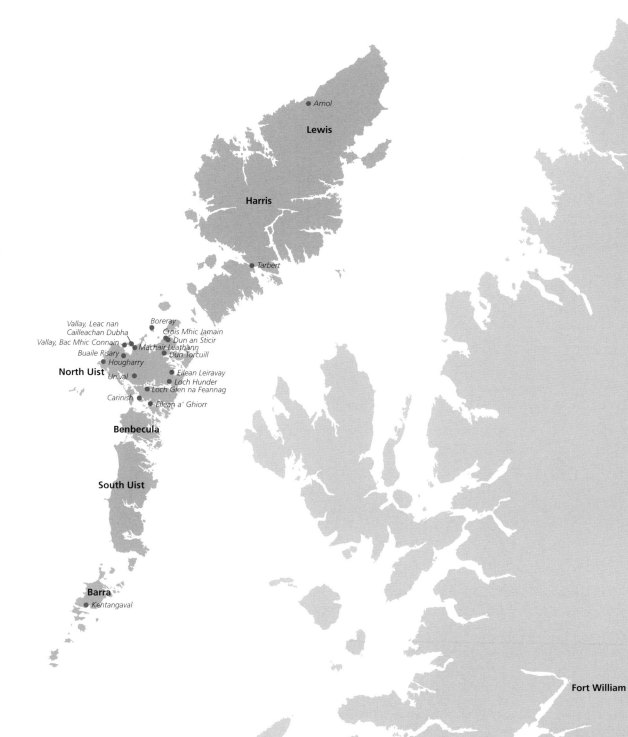

Arnol

Lewis

Harris

Tarbert

Boreray

Vallay, Leac nan
Cailleachan Dubha

Crois Mhic Jamain
Dun an Sticir

Vallay, Bac Mhic Connain
Buaile Risary

Machair Leathann
Dun Torcuill

Hougharry

North Uist
Unival

Eilean Leiravay
Loch Hunder
Loch Glen na Feannag

Carinish

Eilean a' Ghiorr

Benbecula

South Uist

Barra
Kentangaval

Fort William

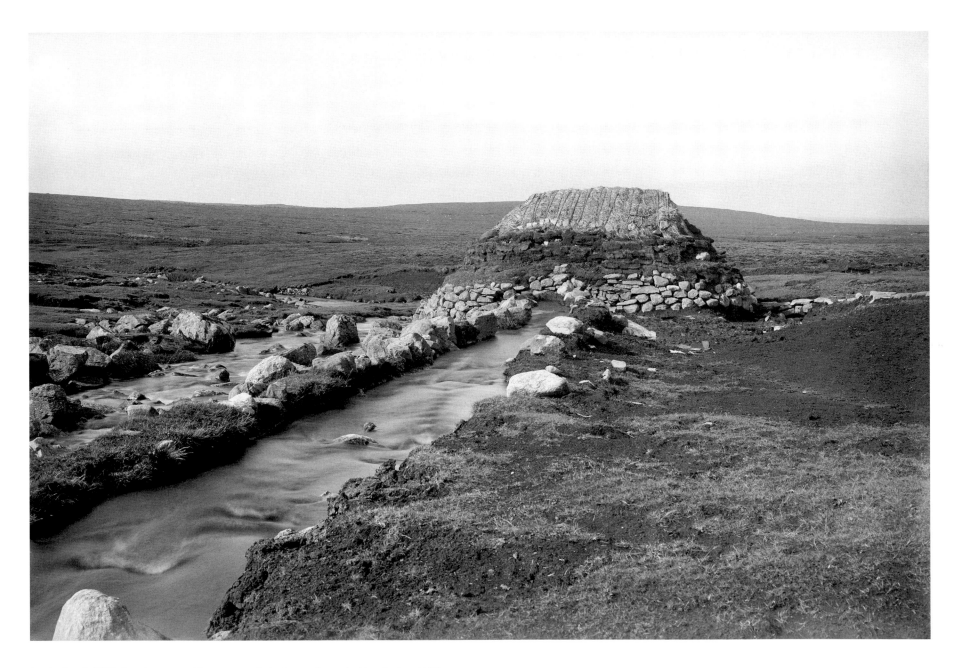

Lewis, Arnol, 1900. Arnol was a crofting community in the north-west of Lewis; Arnol Mill was the last horizontal mill in the area. Water from the lade was channelled onto the blades of a horizontal waterwheel which was linked to one of two millstones. SC695945

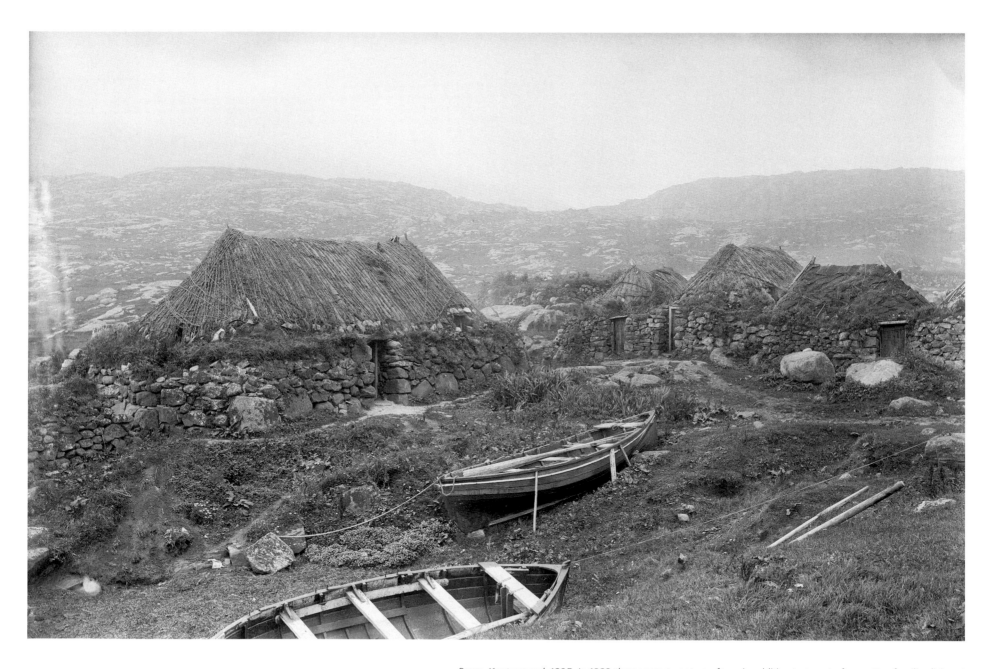

Barra, Kentangaval, 1895. In 1883 there were twenty crofters, in addition to twenty-four cottar families living at Kentangaval. Fishing had long been the main industry of the community and the agriculture survey of 1811 noted that the 'fishermen of Barray are the most active and prosperous now to be found in the Hebrides'. SC684175

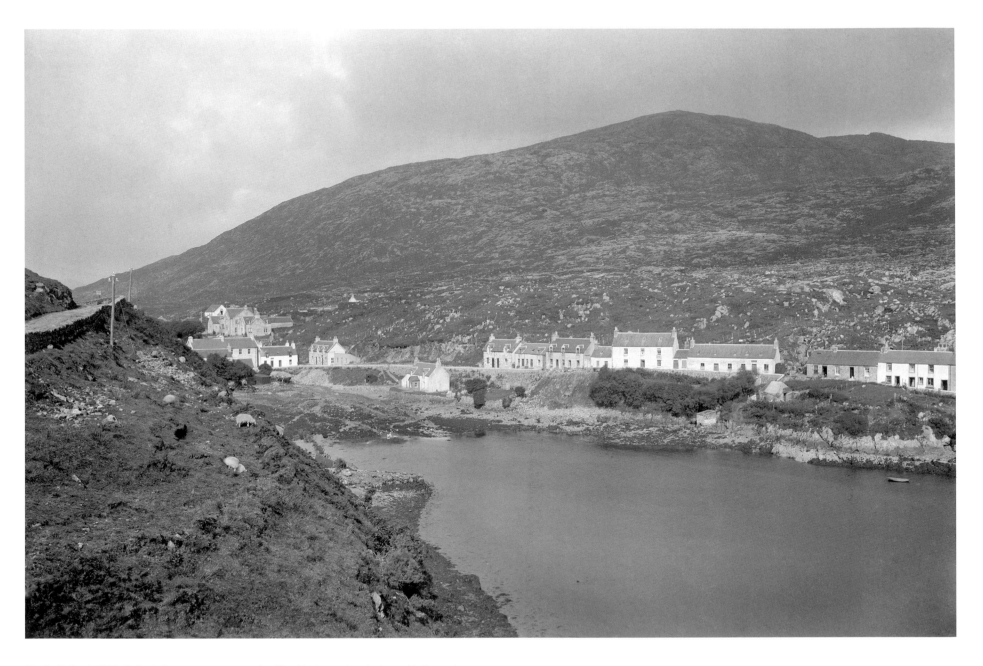

Harris, Tarbert, 1900. Tarbert sits on a narrow stretch of land between two lochs and is the main settlement on the island of Harris. Steamers regularly visited Tarbert on the journey between Glasgow and Stornoway. The main street of houses dates to the mid-nineteenth century. SC746917

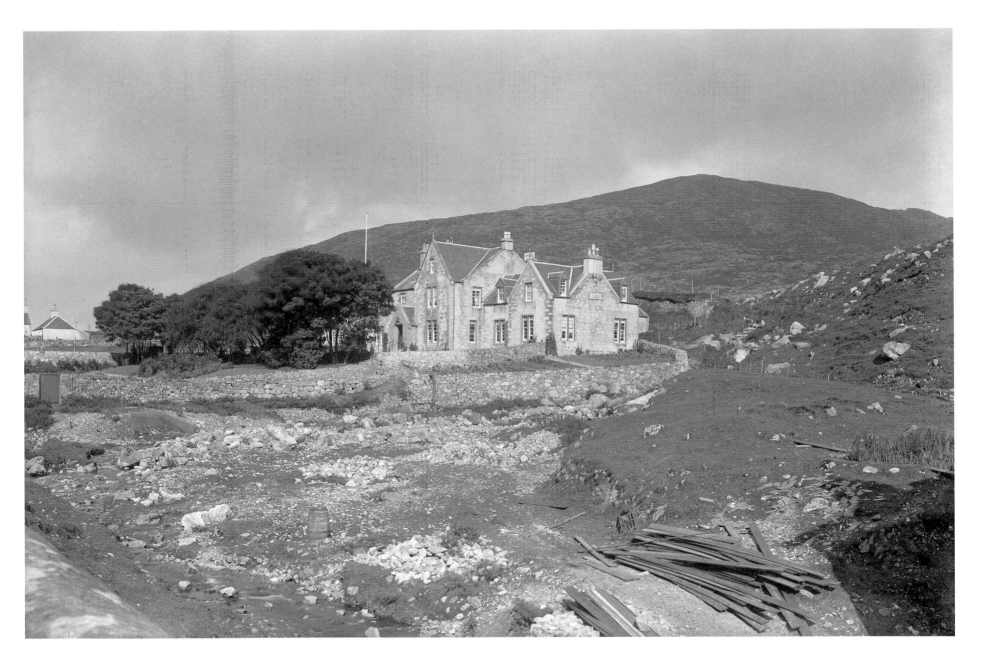

Harris, Tarbert Hotel, 1900. Built in 1865, the hotel continues in business today. This may be one of the hotels where Beveridge stayed on his travels. SC746805

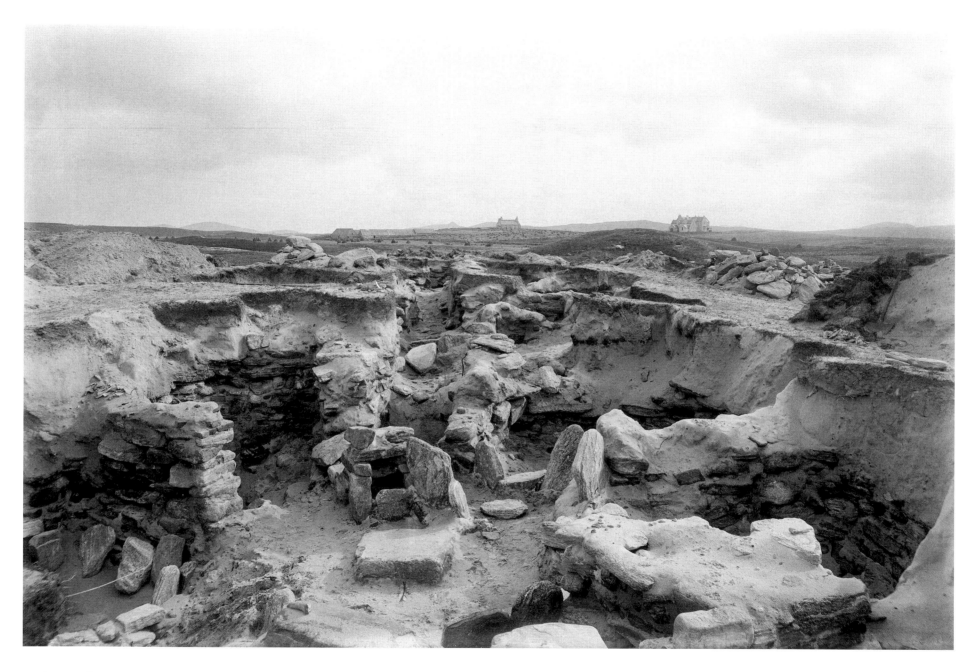

North Uist, Vallay, Bac Mhic Connain, excavation, 1919. Beveridge began full excavation of a number of sites on his estate in Vallay – his house is in the distance to the right. Work stopped during the First World War but resumed in 1919. Here Beveridge has uncovered a wheelhouse, a type of circular house with radiating stone piers supporting the roof and dating to c.400BC–200AD. SC450960

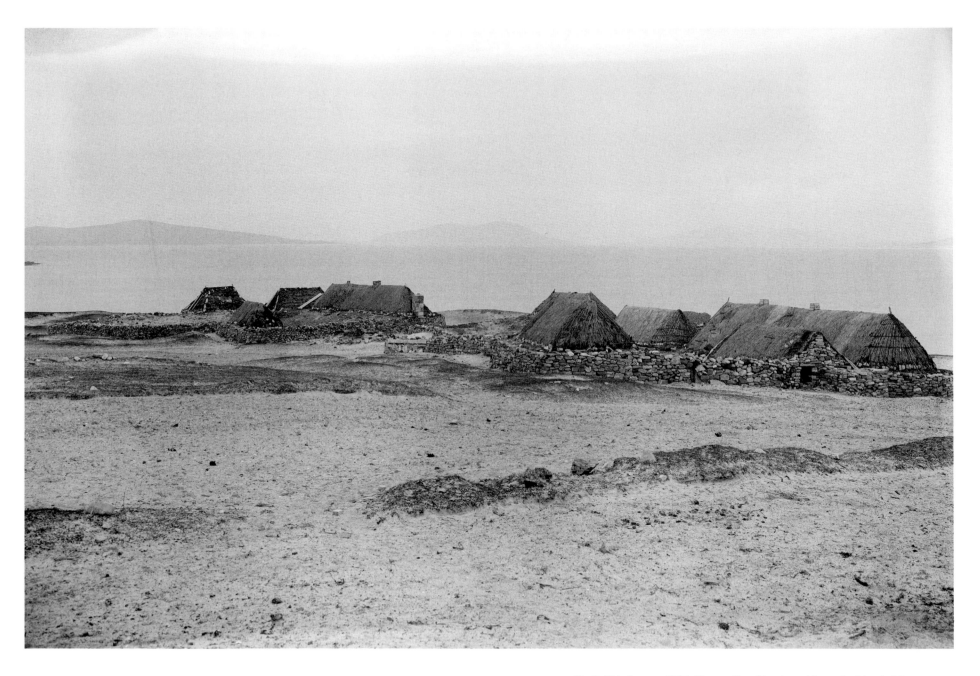

North Uist, Boreray, 1904. The small crofting township on the island of Boreray was occupied until sixteen crofters were evacuated at their own request in 1923. SC746932

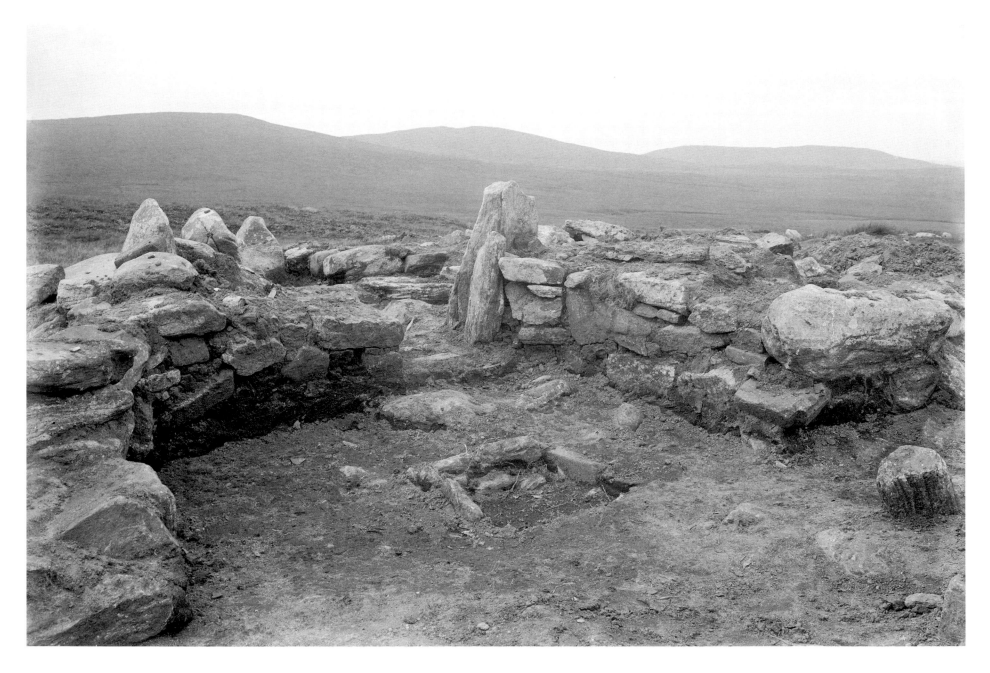

North Uist, Buaile Risary, 1906. A large grass-covered mound was partially excavated by Beveridge to reveal a rectangular chamber with hearth. SC1111893

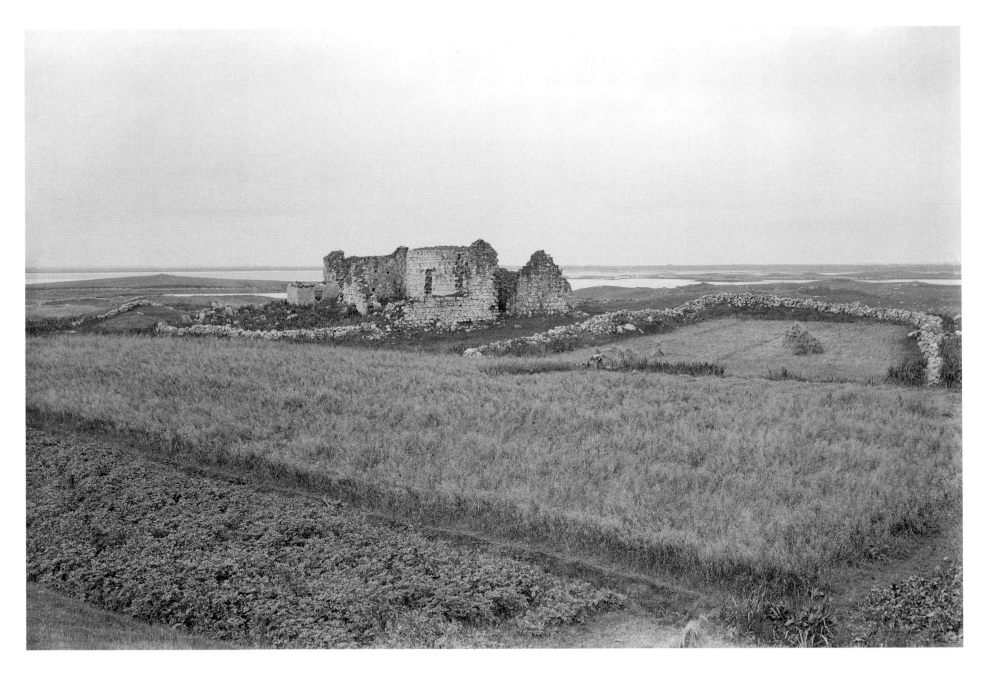

North Uist, Carinish, Teampull na Trionad, 1897. This important pre-Reformation church, possibly of twelfth-century date, was still used for worship in 1728. Connected to it by a passage is a later chapel, Teampull Clann a'Phiocair. A small graveyard lies beside the chapels. SC747048

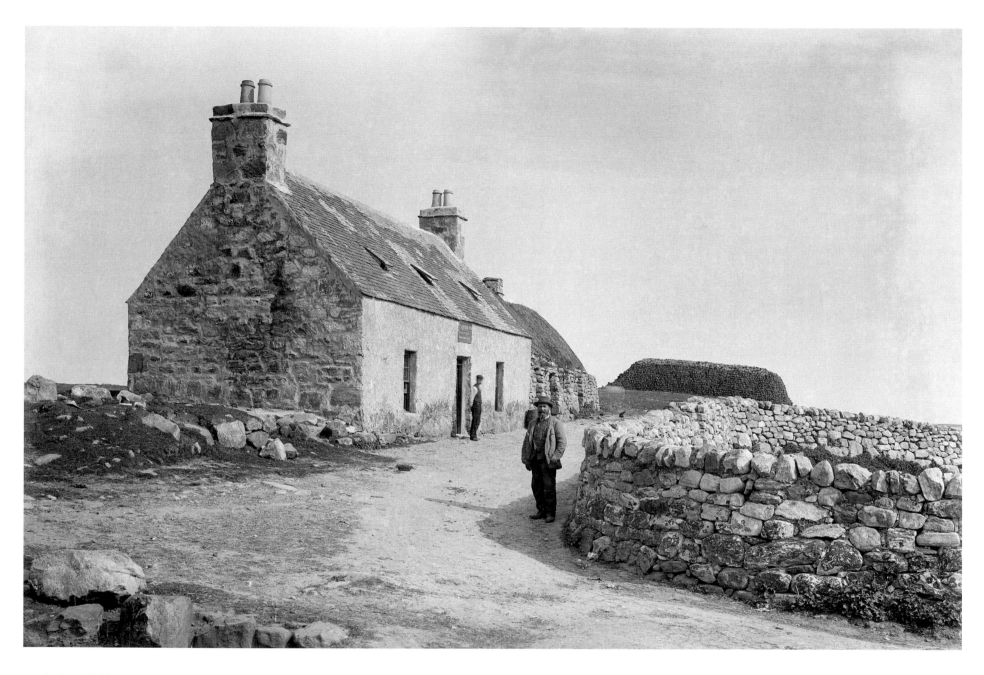

North Uist, Carinish Inn, 1900. Dating to the early nineteenth century, this is probably the oldest inn on the island. SC746888

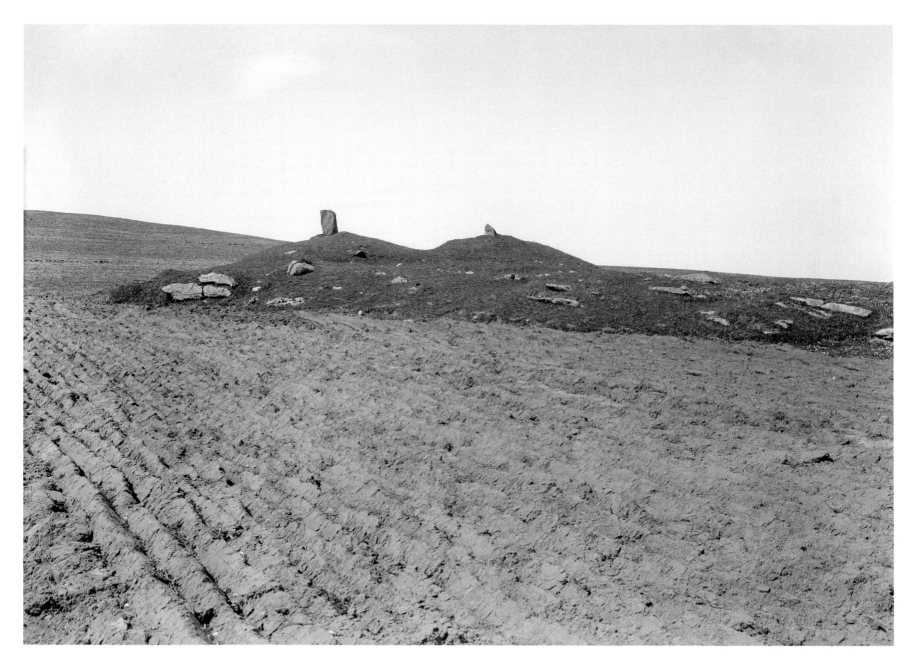

North Uist, Port nan Long, Crois Mhic Jamain, standing stones, 1905. Small standing stones sit on the summit of two grass-covered mounds. SC1112040

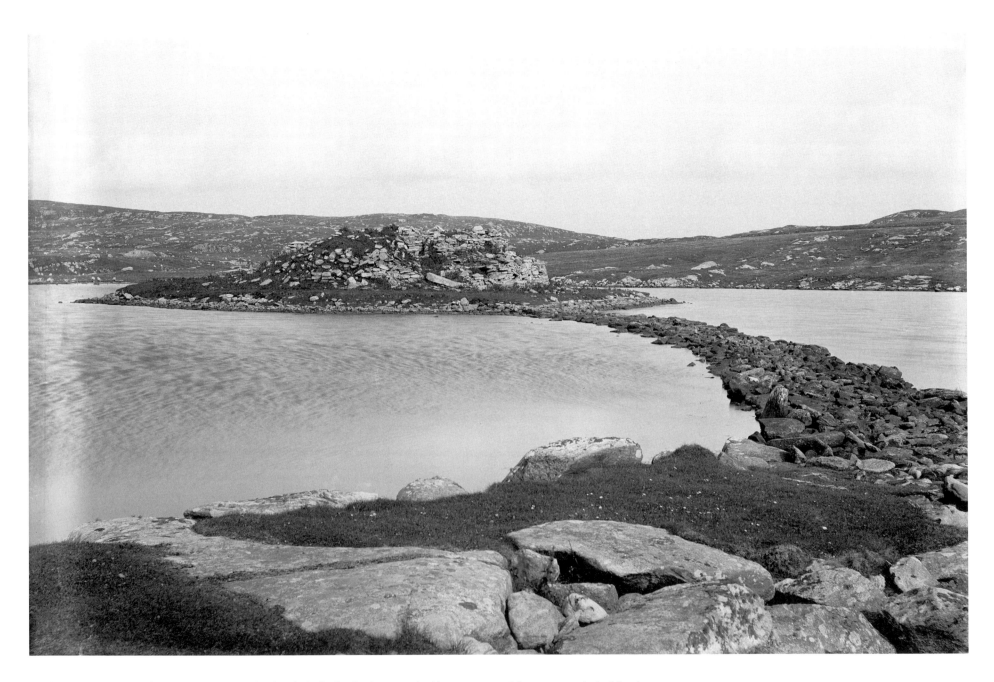

North Uist, Dun an Sticir, dun, 1907. Built on an island in the loch, the dun is approached by a causeway. A later rectangular building has been constructed on top of the dun and was possibly associated with Hugh MacDonald, factor to North Uist in the 1580s. SC338276

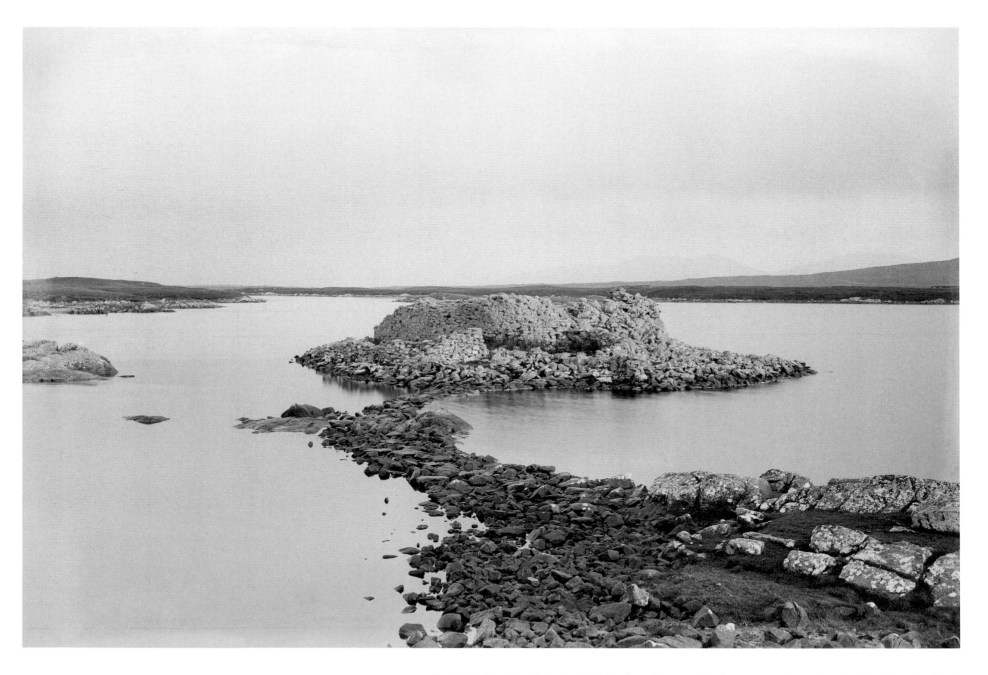

North Uist, Dun Torcuill, broch, 1897. Dun Torcuill is one of the best preserved examples of an island broch on North Uist. Connected to the shore by a causeway, the island is completely walled round its edge. SC450961

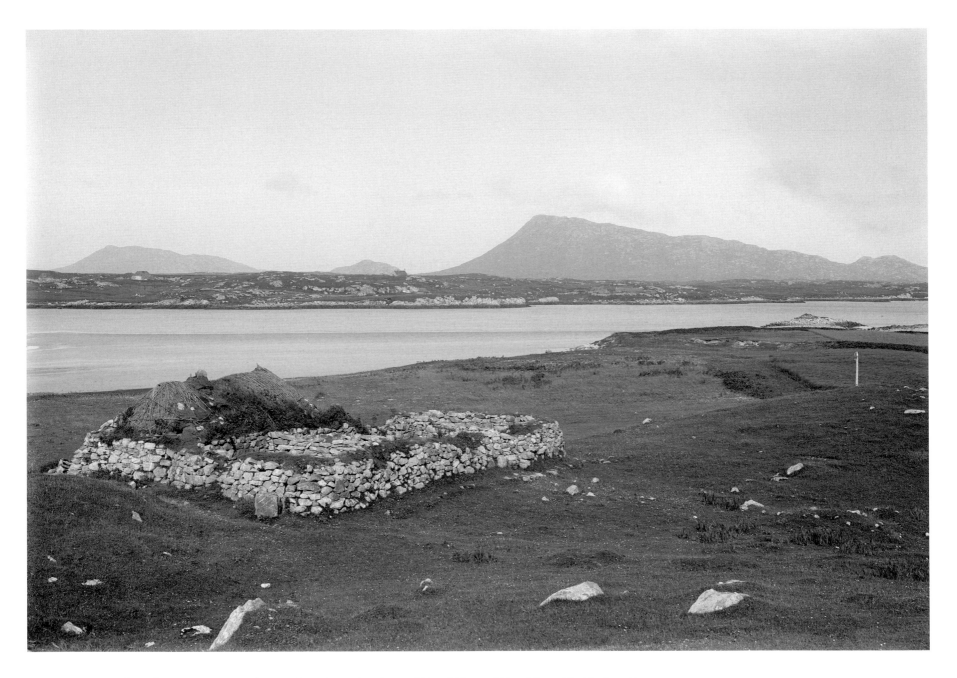

North Uist, Eilean a'Ghiorr, farmstead, 1906. This farmstead was situated on the small islet of Eilean a'Ghiorr. When visited by Beveridge, the islet was accessible at low tide but is now linked by the main road and causeways to North Uist and Benbecula. SC746941

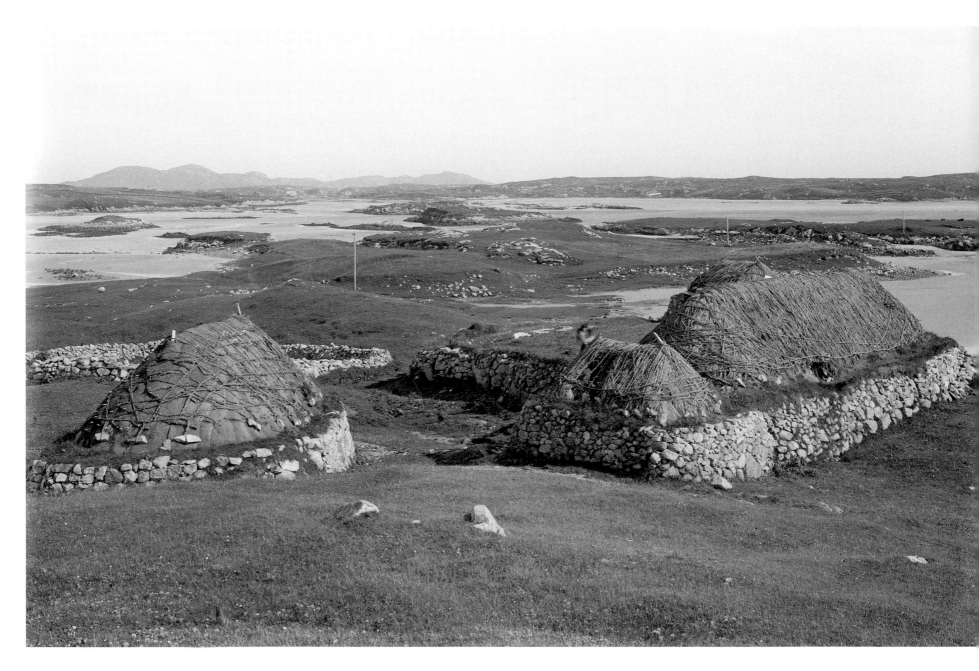

*North Uist, Eilean a'Ghiorr,
farmstead, 1906. SC746292*

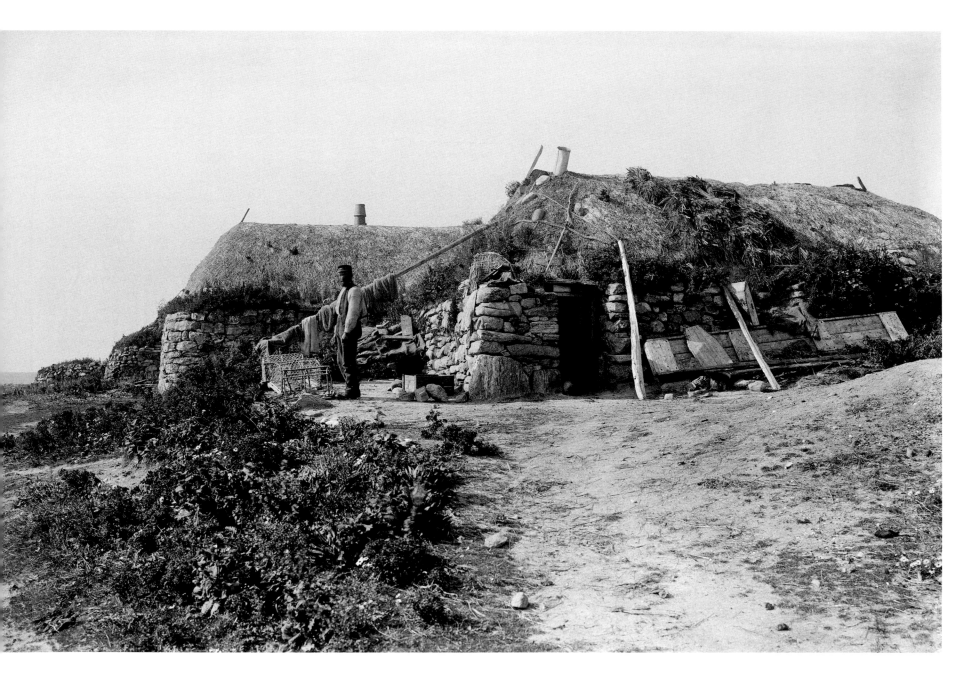

North Uist, Hougharry, township, 1904. A detailed view of a group of houses in the township with lobster creels, clothes and ropes drying over a pole, boxes and general everyday clutter. SC1115962

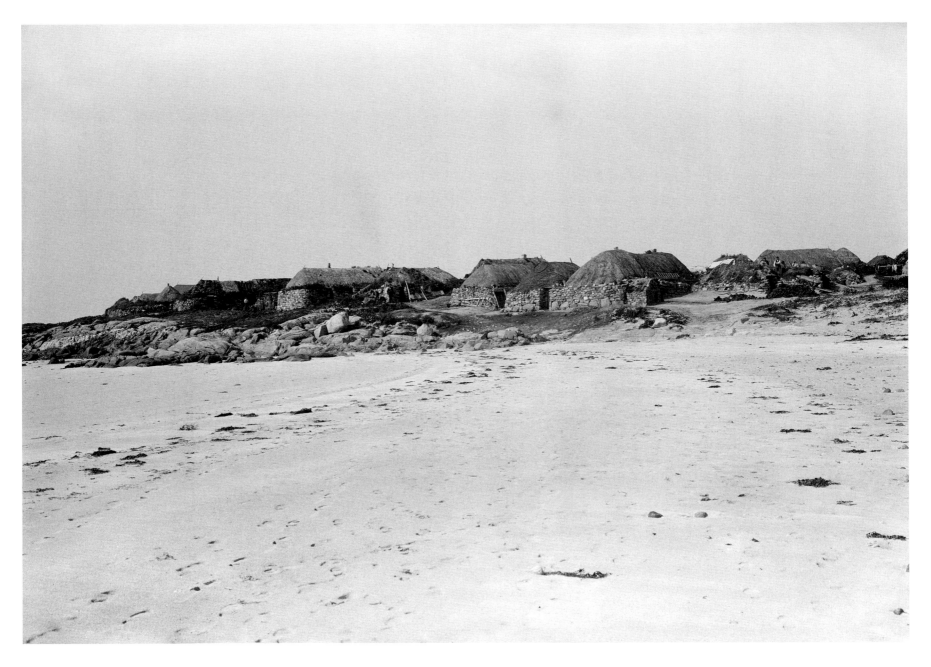

North Uist, Hougharry, township, 1904. The crofting township of Hougharry sits just above the shore line. A number of people are working amongst the crofts. SC746924

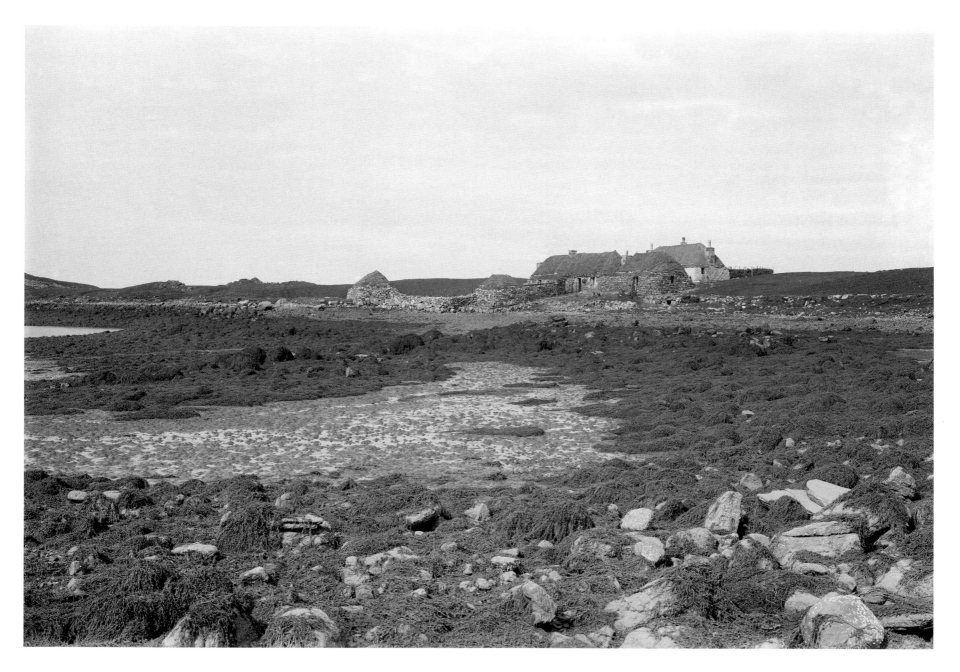

North Uist, Eilean Leiravay, farmstead, 1903. To the west of Lochmaddy pier, the farmstead at Eilean Leiravay was only accessible on foot at low tide. Beveridge notes that one or more families still lived here. SC746952

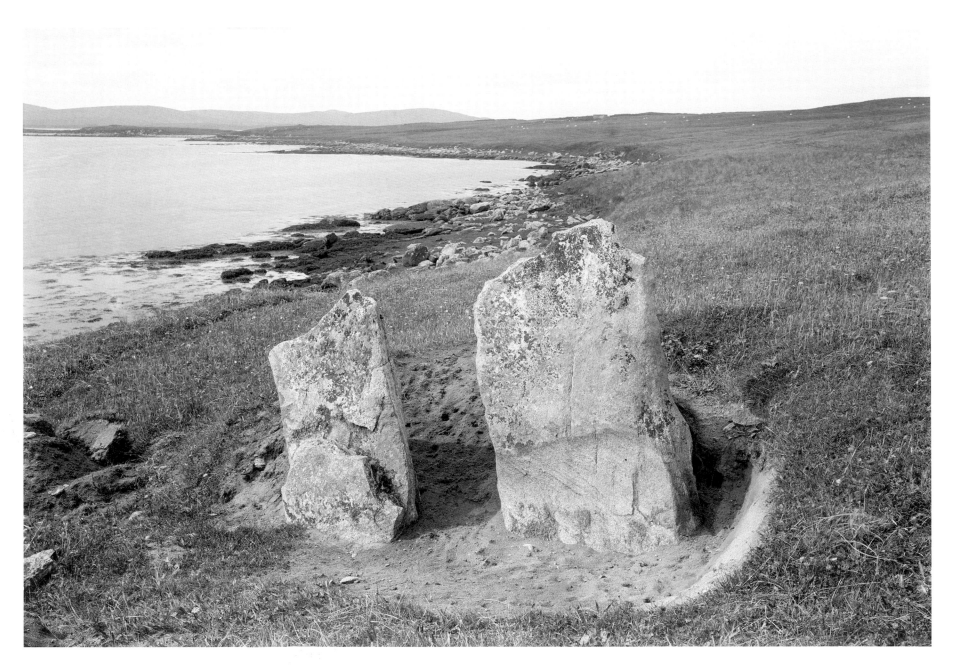

North Uist, Vallay, Leac nan Cailleachan Dubha, chambered cairn, 1904. Two upright stones attached to a slight mound were identified as a possible chambered cairn by Beveridge. SC1111849

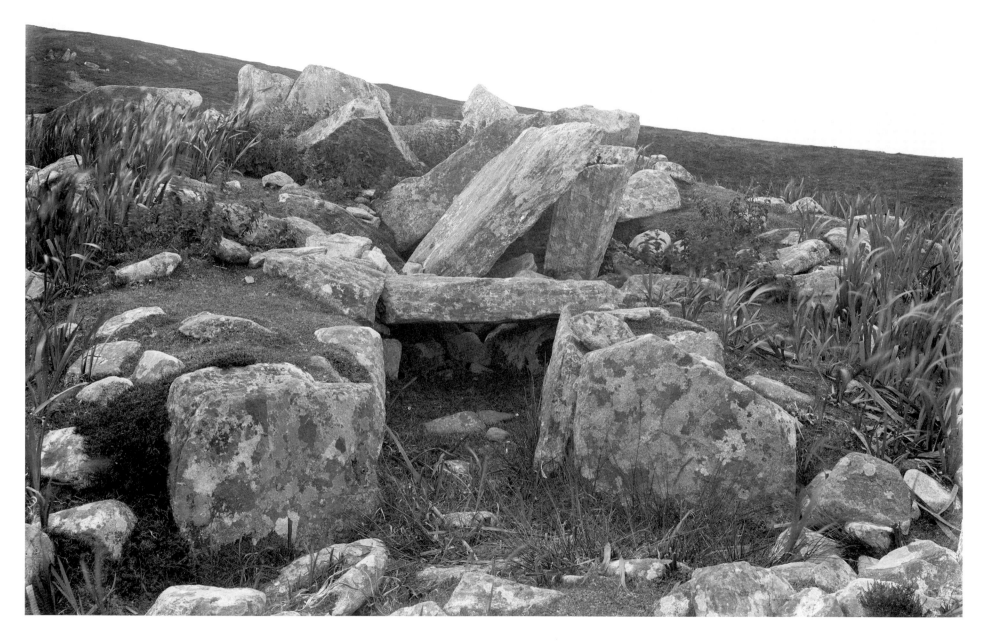

North Uist, Loch Glen na Feannag, chambered cairn, 1904. Looking into the large chamber of this cairn.
This was one of a number of archaeological sites that Beveridge explored to search for objects. SC1111957

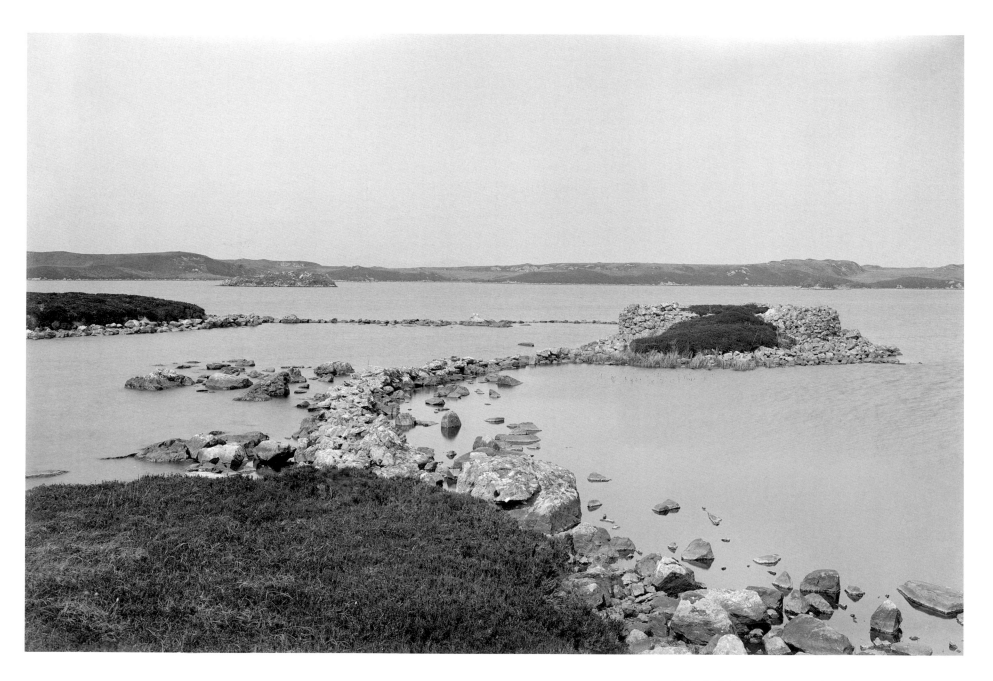

North Uist, Loch Hunder, dun, 1901. Occupying a small islet, the dun is linked by causeways to the shore and another islet. SC1112097

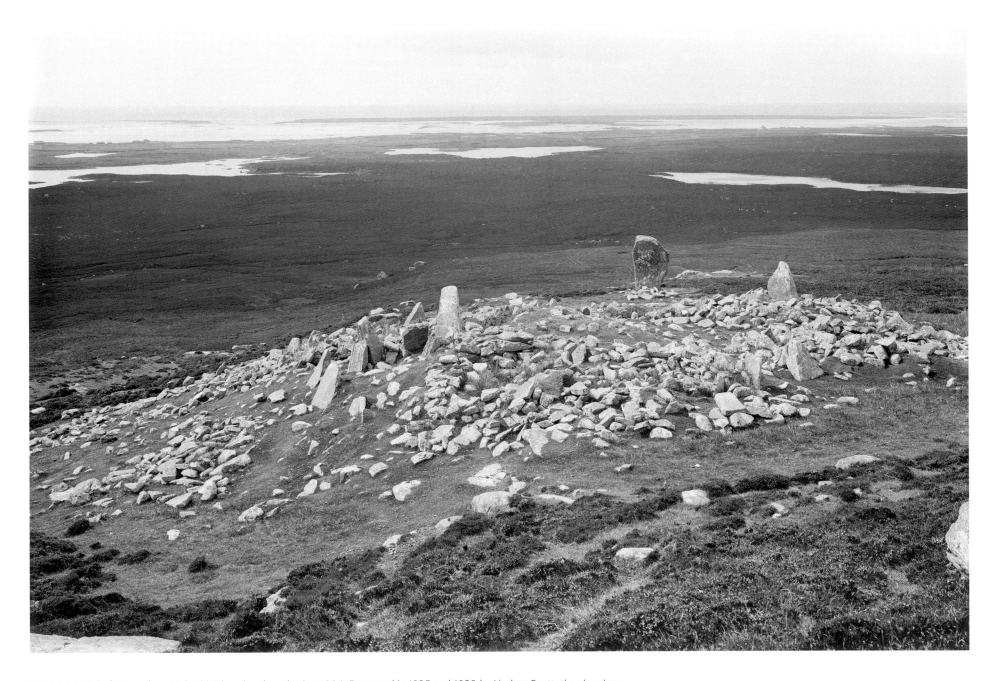

North Uist, Unival, Leacach an Tigh Chloiche, chambered cairn, 1904. Excavated in 1935 and 1939 by Lindsay Scott, the chamber contained a burial cist with the partial skeletons of two people, large quantities of Neolithic pottery and a stone ball. SC335940

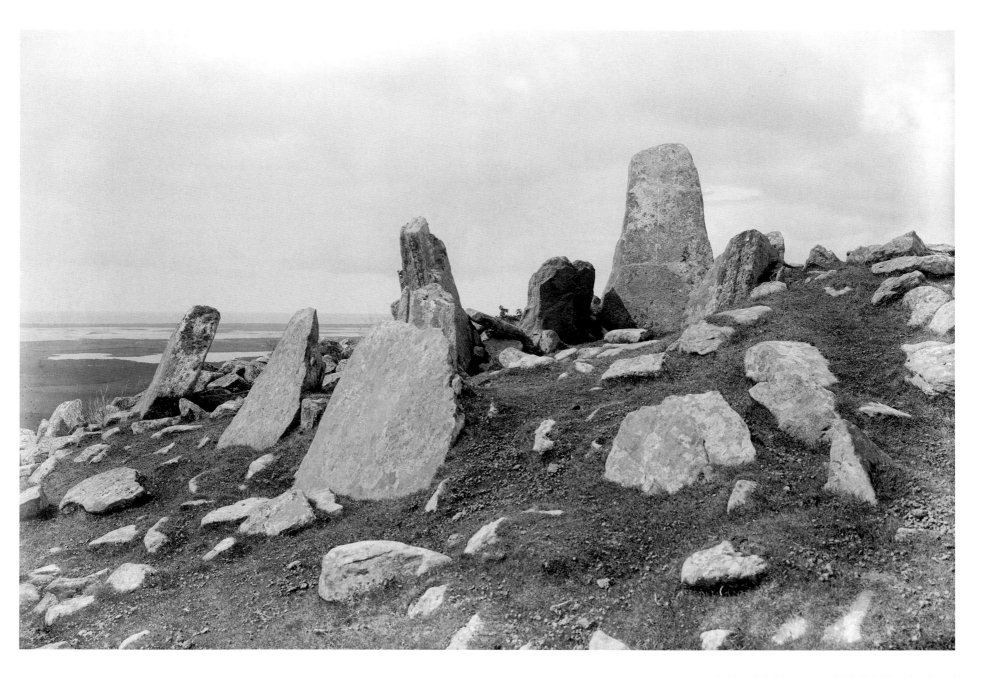

North Uist, Unival, Leacach an Tigh Chloiche, chambered cairn, 1904. Detail of the chamber. SC1111902

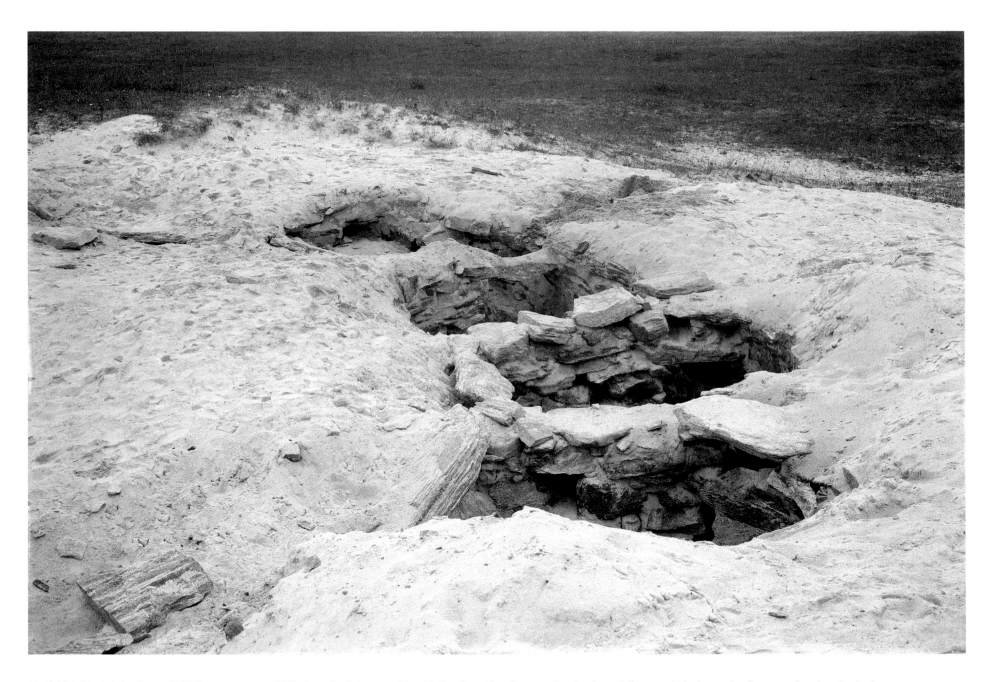

North Uist, Machair Leathann, 1906. In a grass-covered hillock north of the township of Sollas, Beveridge discovered and only partially excavated a large wheelhouse and souterrain. As the site was threatened with destruction, large-scale excavations were carried out in 1956 and 1957 revealing a well-preserved wheelhouse dating to the first or second century AD. SC1112033

Northern Scotland

Travelling round the north and west coasts of Sutherland from Lochinver to Tongue was a slow journey using steamers, ferries and hired carriages. *Black's Picturesque Tourist of Scotland* of 1877 describes it as a journey of 83½ miles with fine mountain views and excellent inns at Scourie and Durness. Beveridge was in the county at least twice in 1886 and 1899, the latter on an excursion to visit the prehistoric brochs.

For three weeks in the late summer of 1894 Beveridge travelled in Orkney photographing the spectacular cliffs at South Walls, the town of Stromness, as well as the wealth of ancient monuments and historic buildings.

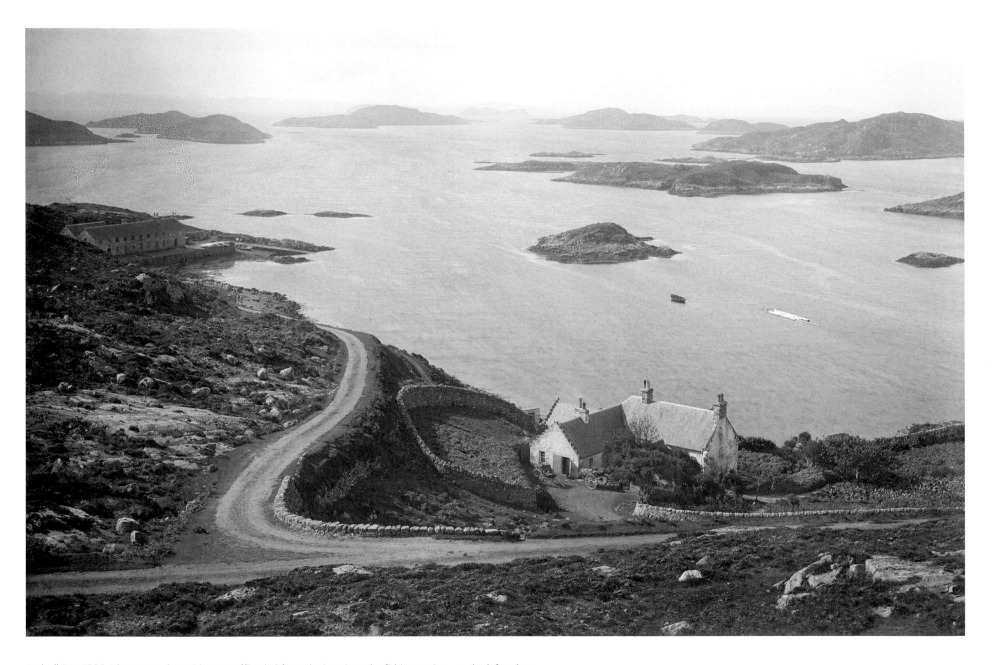

Badcall Bay, 1886. View across bay. Fish were offloaded from the jetty into the fishing station, on the left, where there was a fish house, ice house and accommodation. The 1877 edition of Black's Picturesque Tourist of Scotland *notes that at Badcall 'there is a large store for packing the salmon caught along the west coast'. SC1113647*

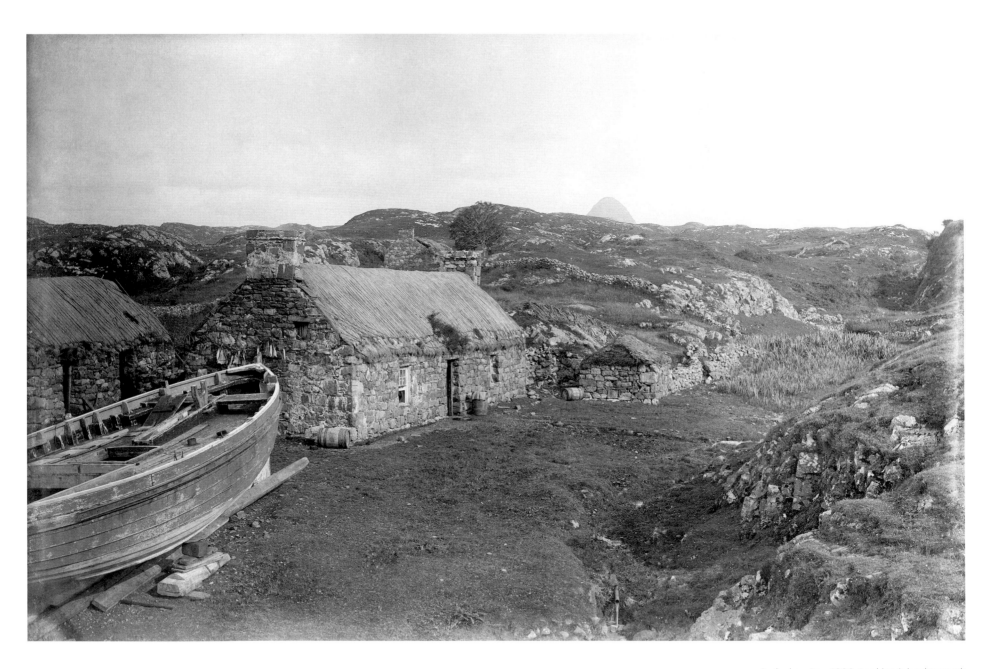

Badnaban Bay, 1886. Looking inland towards Suilven from a croft adjacent to the bay. Fish are drying on a line on the croft gable. SC1113649

Balnakiel, Durness, 1886. A cottage and the roofless, crowstepped ruins of Balnakiel Church overlooking the beautiful sands of the bay. On the front of the croft are a fishing net and line of drying fish. SC1113114

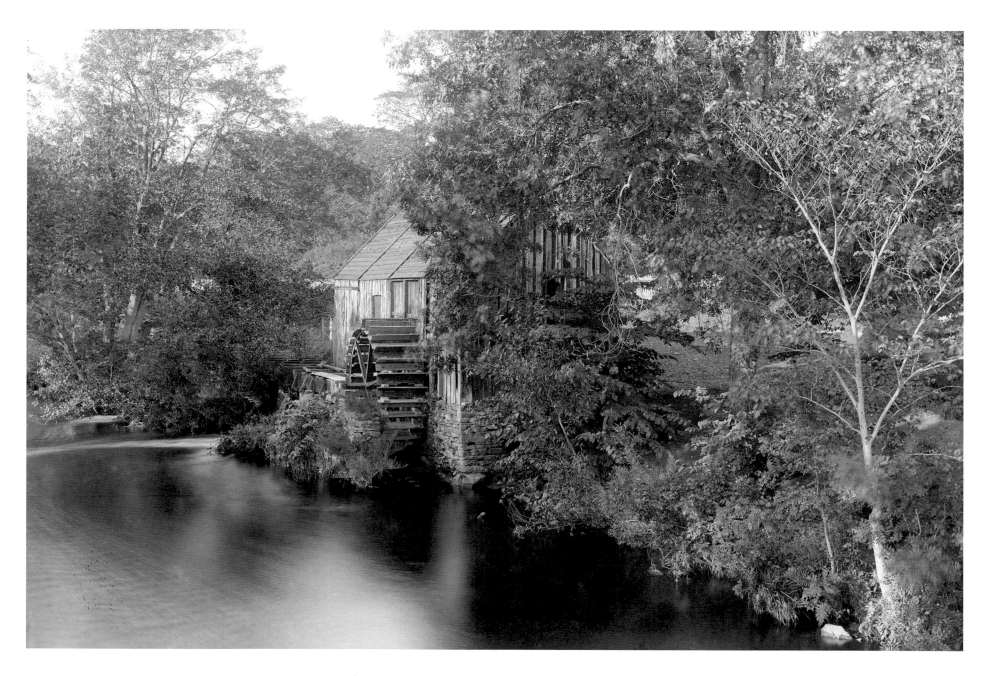

Contin, watermill, 1886. On stone foundations, this timber built corn mill sits on the Black Water. SC917836

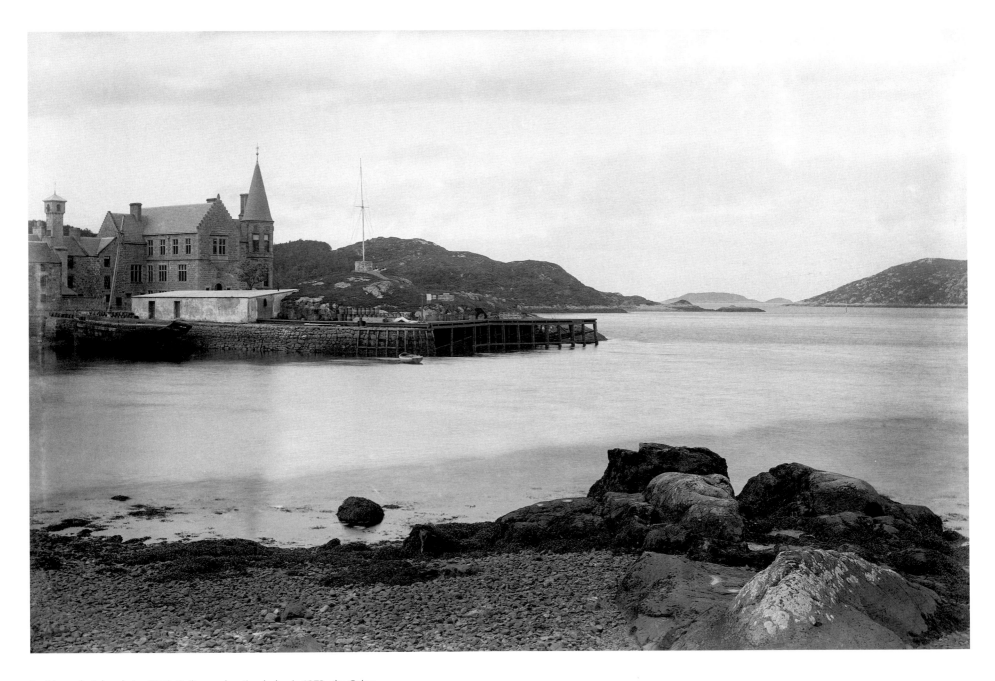

Lochinver, hotel and pier, 1886. Built as a shooting lodge in 1873, the Culag Hotel incorporated components of an earlier herring station. SC1113650

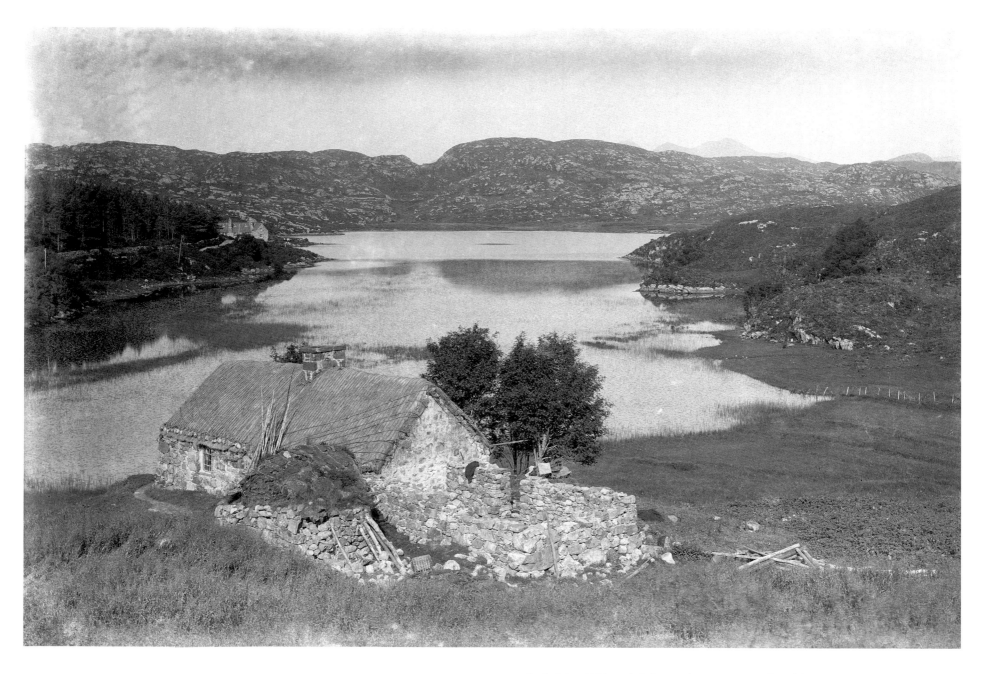

Loch Culag, 1886. Loch Culag was known as an excellent fishing loch for brown trout, rainbow trout and salmon. A keen fisherman, Beveridge may have enjoyed fishing here. SC1113654

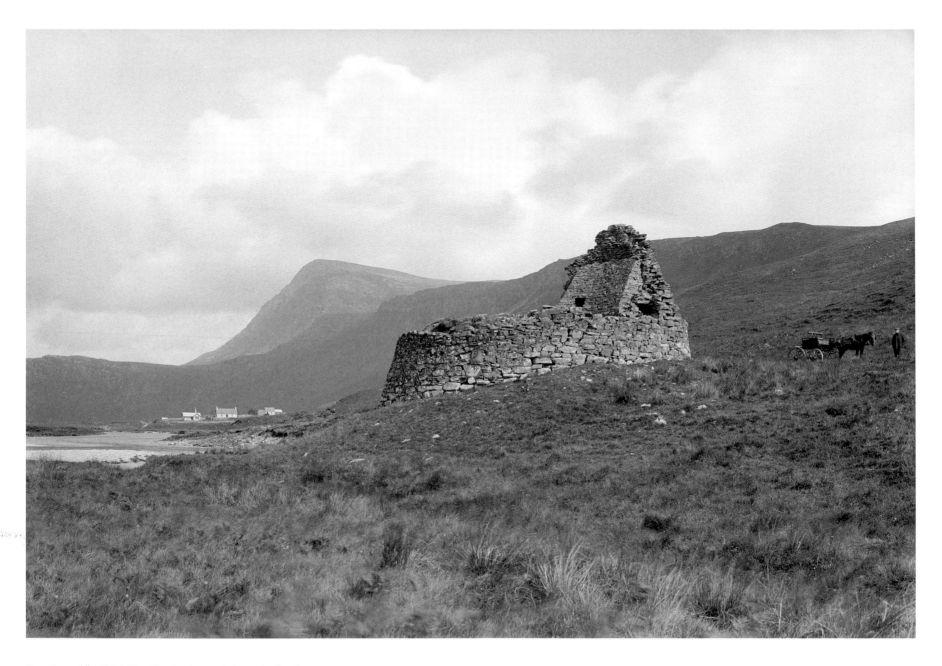

*Dun Dornadilla, 1899. Standing by the road above the Strathmore
River, this is another good example of a broch. Beveridge's mode
of transport can be seen on the right. SC1112985*

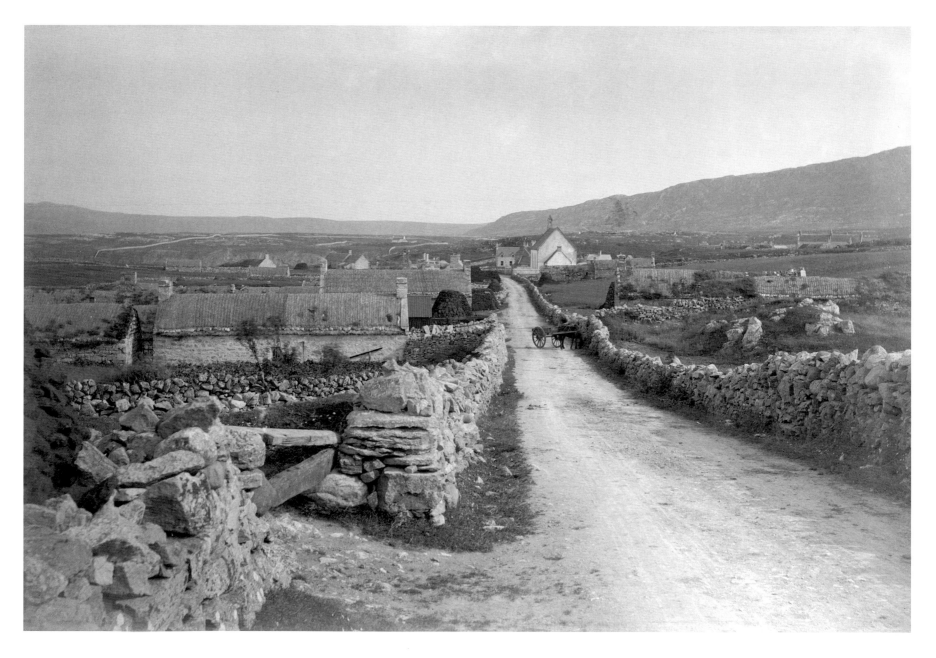

Durness, 1886. The village of Durness developed along the line of the road. As described in The Ordnance Gazetteer of Scotland *by F H Groome, (1883): 900 of the 987 parish residents were Gaelic speaking; the parish church could take 300 worshippers; the school had an average attendance of sixty-three children and the village had a post office, 'with money order and savings' bank departments'. SC1113097*

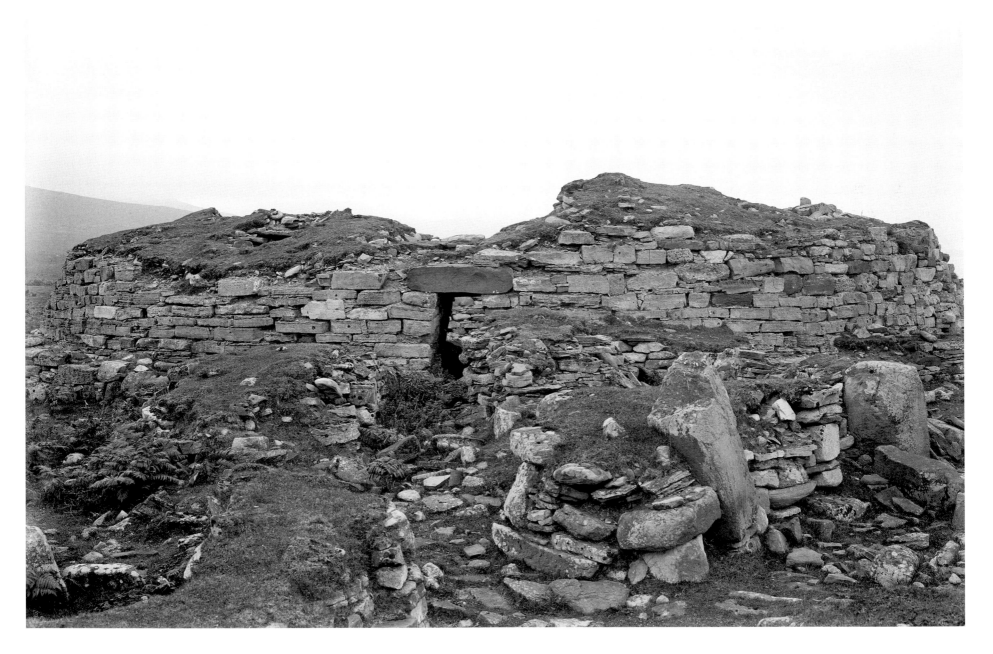

Kintradwell, broch, 1899. The broch sits on the edge of a former sea-cliff above the raised beach. It was originally excavated in 1865 by Reverend J M Joass and was still in good condition when photographed by Beveridge. SC1113653

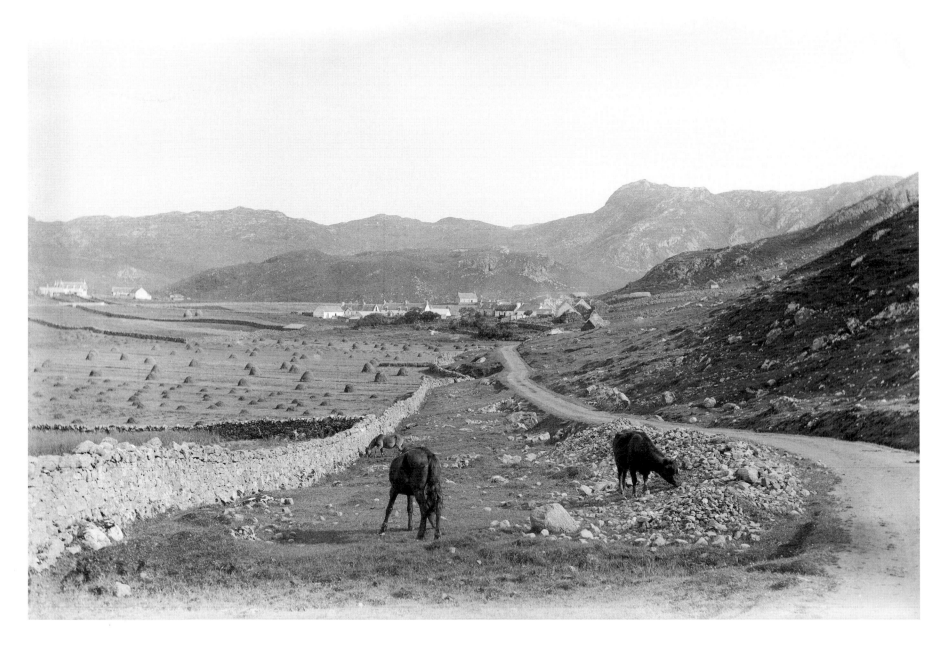

Scourie, 1886. Animals grazing on common ground. Scourie is described in the 1877 edition of Black's Picturesque Tourist of Scotland *as 'a considerable hamlet or township, with enclosed fields, encircling the termination of a well-indented bay'. SC695875*

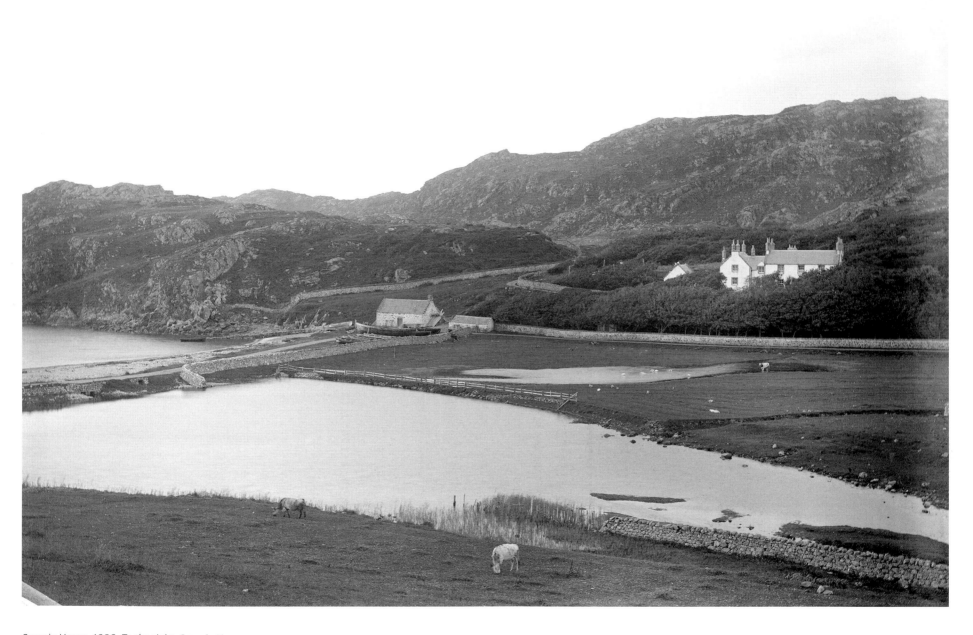

Scourie House, 1886. To the right, Scourie House was home to the former Sutherland estate factor and was built in 1846. SC746340

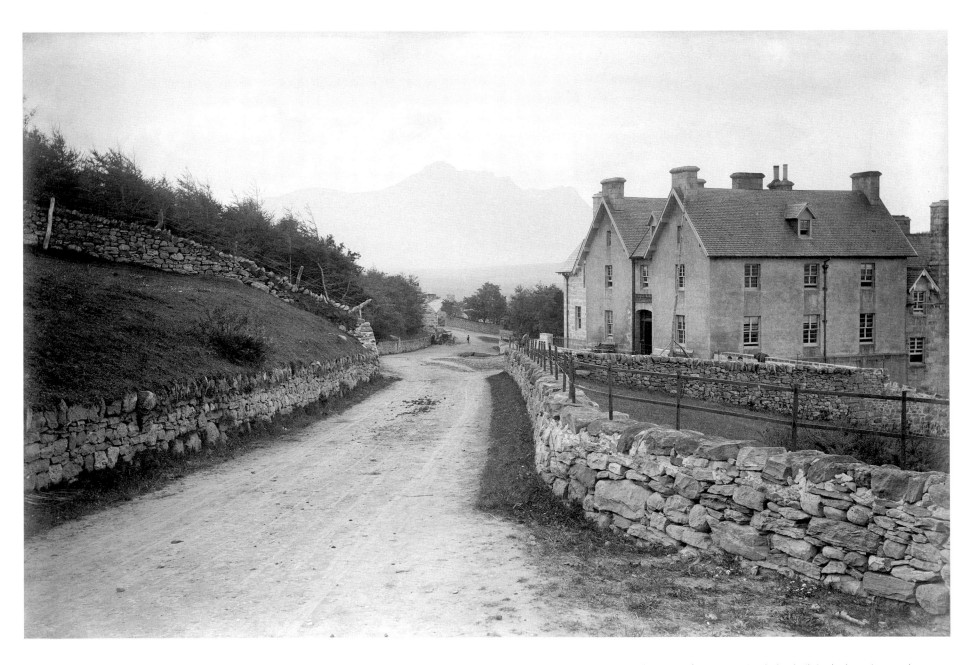

Tongue Hotel, 1886. A former sporting lodge built in the late-nineteenth century and owned by the Duke of Sutherland, Tongue Hotel was one of a number of hotels or inns photographed in which Beveridge may have stayed. SC1113115

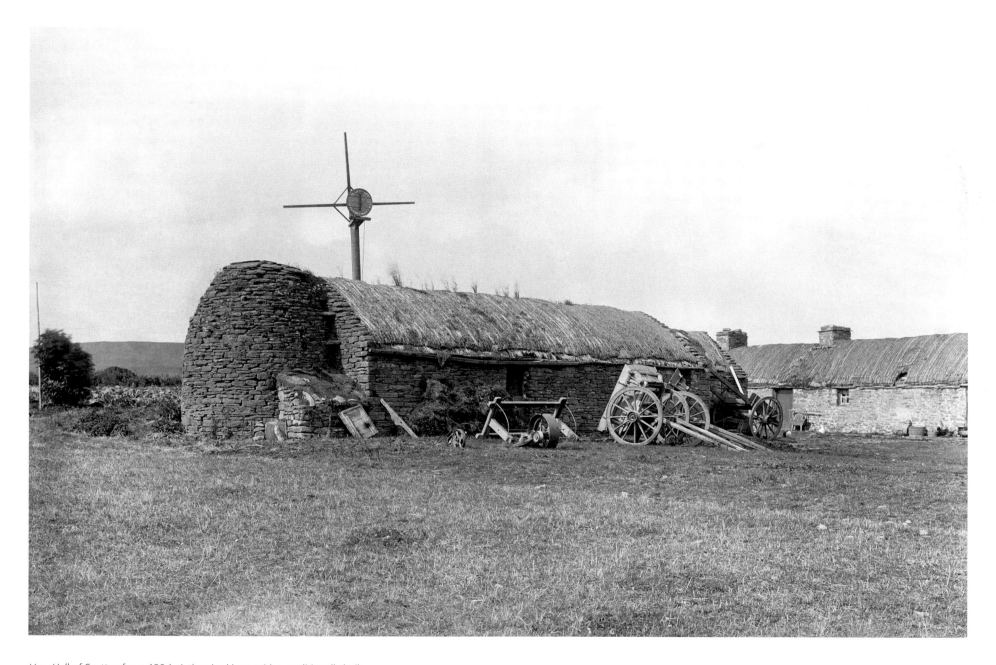

Hoy, Hall of Seatter, farm, 1894. A thatched barn with a traditionally built round-ended grain-drying kiln on its gable end. The windmill would have turned to generate power for a threshing machine inside the barn. SC746873

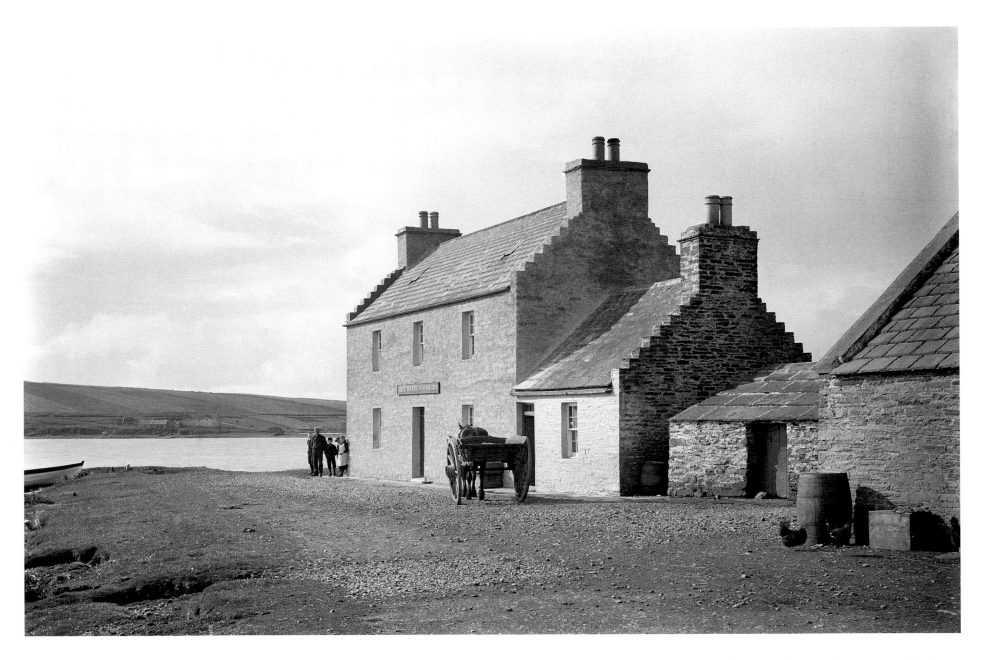

Hoy, North Ness, Ship Inn, 1894. This early-nineteenth-century inn was once the busiest on Hoy. Originally the property of I G Moodie of Melsetter, the inn has a sign above the door which states that the proprietor was J Linklater when photographed by Beveridge. SC746497

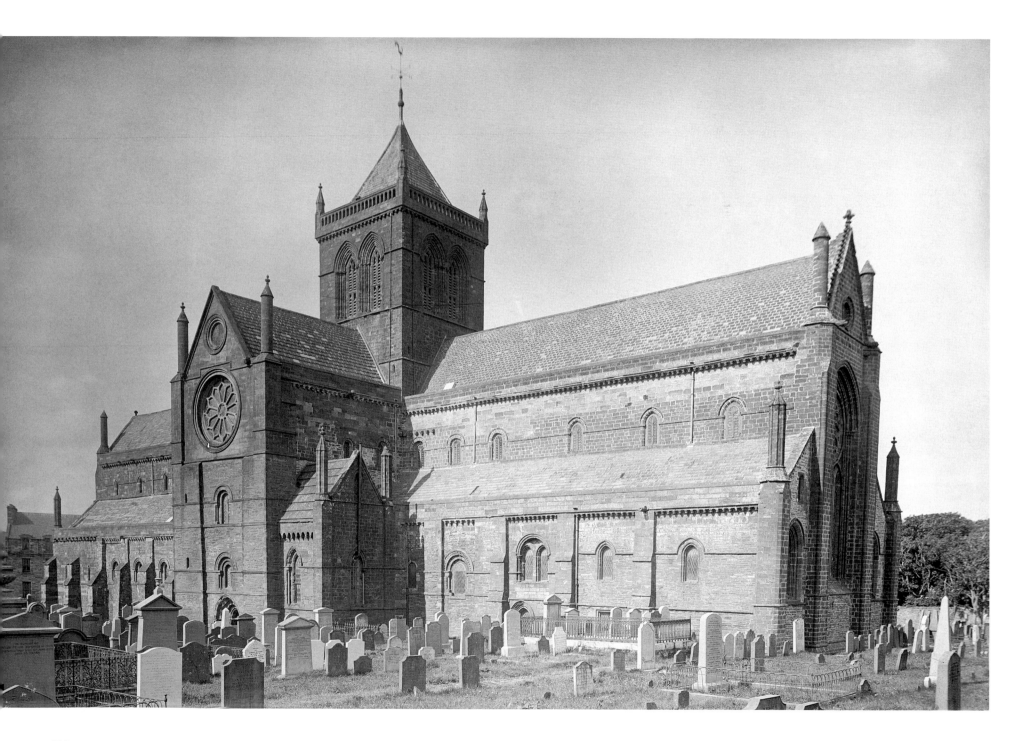

Kirkwall, St Magnus Cathedral, 1894. The cathedral was dedicated to Earl Magnus who was murdered on Egilsay c.1117. Its construction started in 1137 and was completed in the fifteenth century. It is one of only two of Scotland's major cathedrals to survive largely intact since the Reformation. Major renovations were undertaken between 1913 and 1930 by architect George Mackie Watson, who removed many of the eighteenth- and nineteenth-century furniture and fittings to return the cathedral to something like its medieval appearance. SC746786

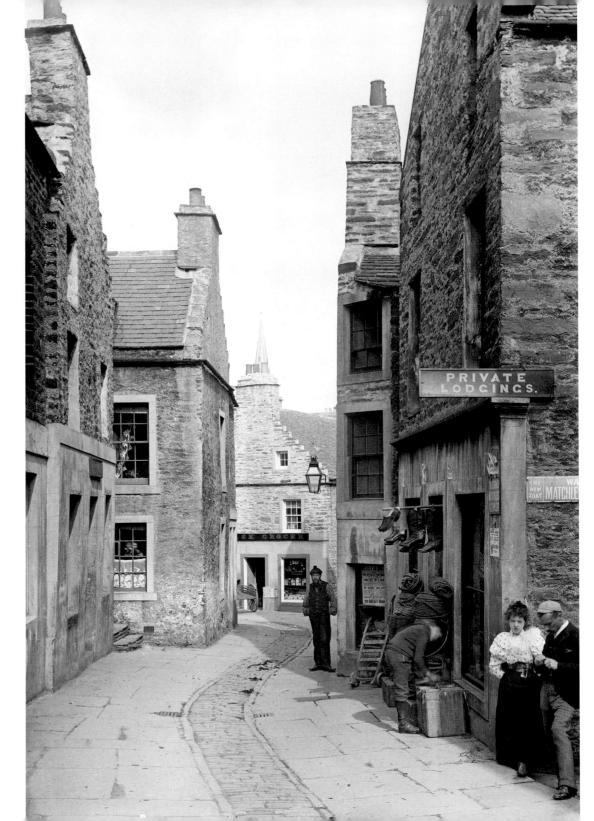

Stromness, Dundas Street, 1894. A narrow street, lit by gas light and lined with a carriageway of stone slabs. Dating from the mid-nineteenth century, the houses with their crow-stepped gables are end-on to the street. Goods on sale in the shop, on the right, include shoes and boots, as well as coils of rope. SC748821

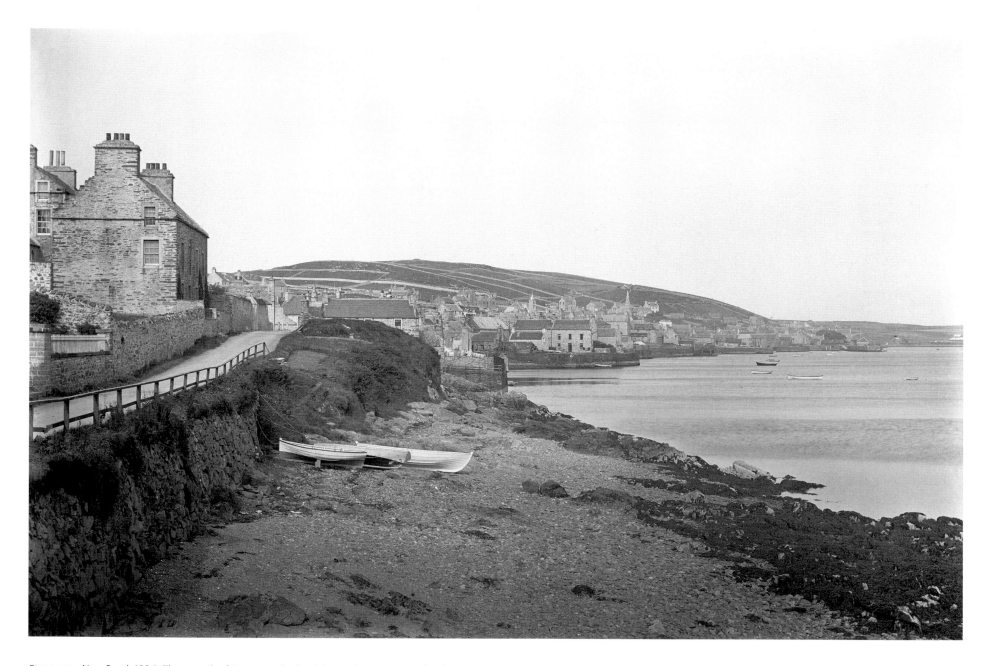

Stromness, Ness Road, 1894. The growth of Stromness in the eighteenth century was closely connected to the arctic whaling industry and the Hudson Bay Company. A cannon along Ness Road was fired to announce the arrival of ships from the Hudson Bay Company. SC748765

Perthshire

Aberdeen

Kinloch Rannoch ● ● Tummel Bridge

Grandtully ●
Weem ● ● Castle Menzies
● Bridge of Balgie

● Dunkeld

Dundee

Perth

● Innerpeffray

Edinburgh

Glasgow

Beveridge spent time in Perthshire in the mid-1880s visiting a number of places in Strathtay and Glen Lyon. His photographs coincide with the recommendations of contemporary tour guides – the historic bridges and castles. As with other areas of Scotland, Beveridge photographed the inns and hotels as tourists do today, to show where they stayed on their travels.

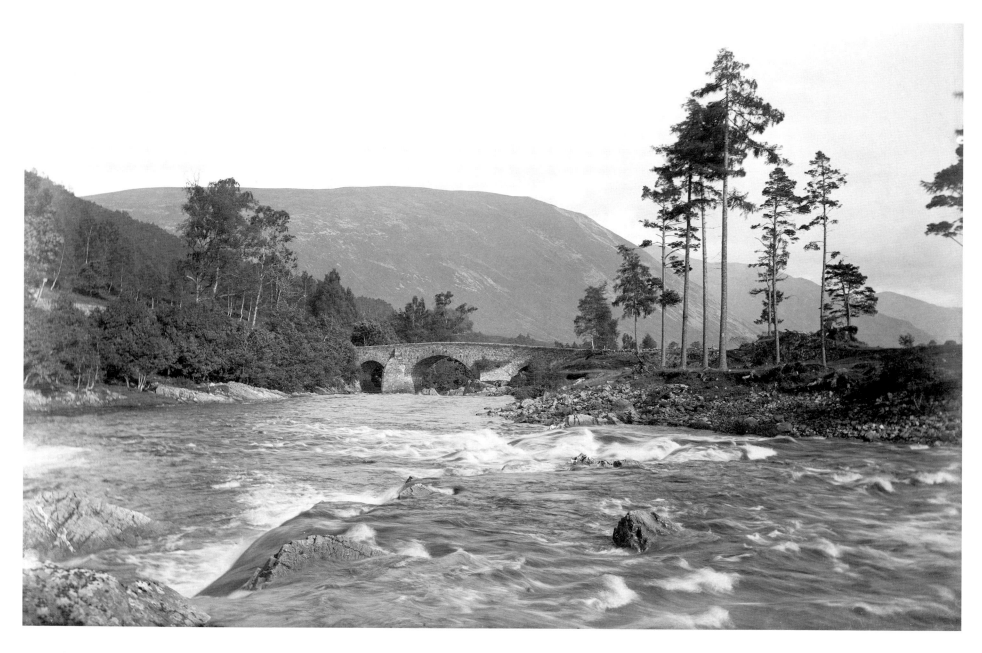

Bridge of Balgie, Glen Lyon, c.1886. On the road linking Loch Tay with Glen Lyon, this large three-arch bridge spans the River Lyon. SC1115904

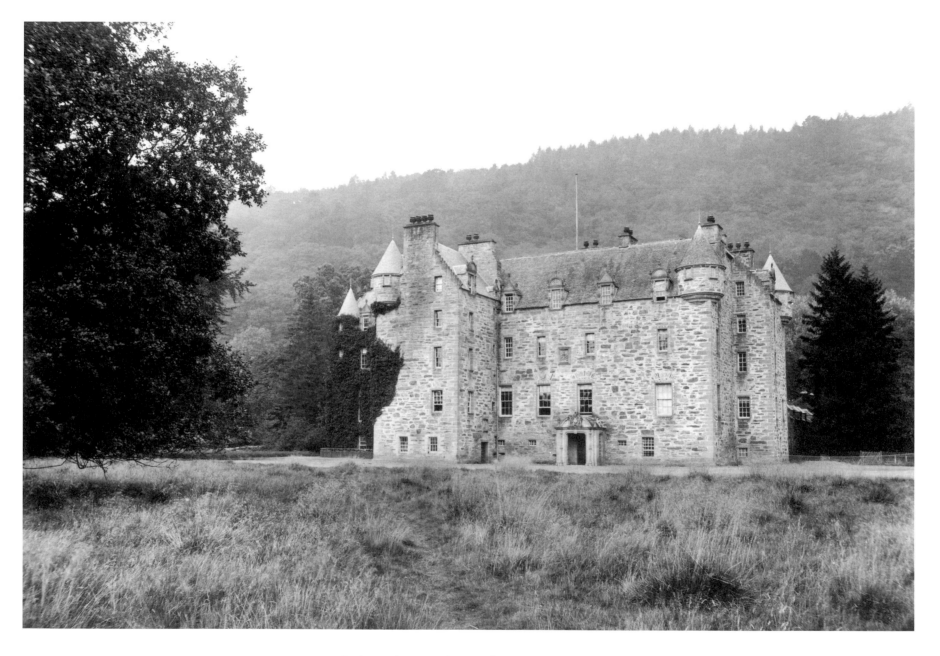

Castle Menzies, 1884. The Seat of the Chiefs of Clan Menzies, the castle dates to the late-sixteenth century and was described in 1882 in The Ordnance Gazetteer of Scotland *by F H Groome 'as having a spacious semi-circular park containing some of the finest trees in Scotland'. The castle was derelict by the 1960s and has now been restored by the Clan Menzies Society. SC743020*

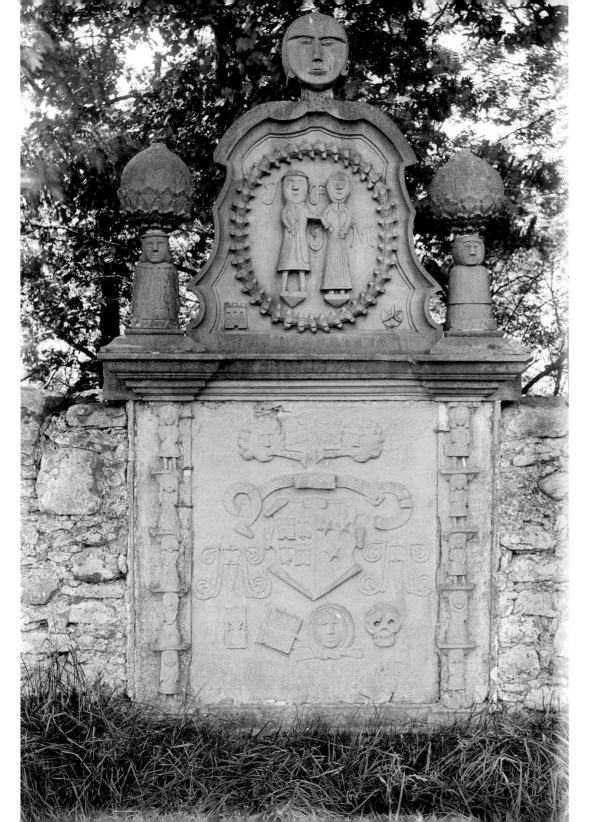

Innerpeffray Church, Faichney Monument, c.1884. An elaborately carved eighteenth-century memorial by John Faichney, a mason, to his wife and children. John and his wife are in the central panel at the top of the monument and forming the pilasters down either side at the bottom are their ten children. The monument has now been moved into Innerpeffray Church. SC1115902

Kinloch Rannoch, 1884. With Schiehallion in the background, Kinloch Rannoch was photographed from a hillside track to the north-west of the village. Today, the mill pond in the foreground is no longer in use and survives as a banked enclosure. SC1115901

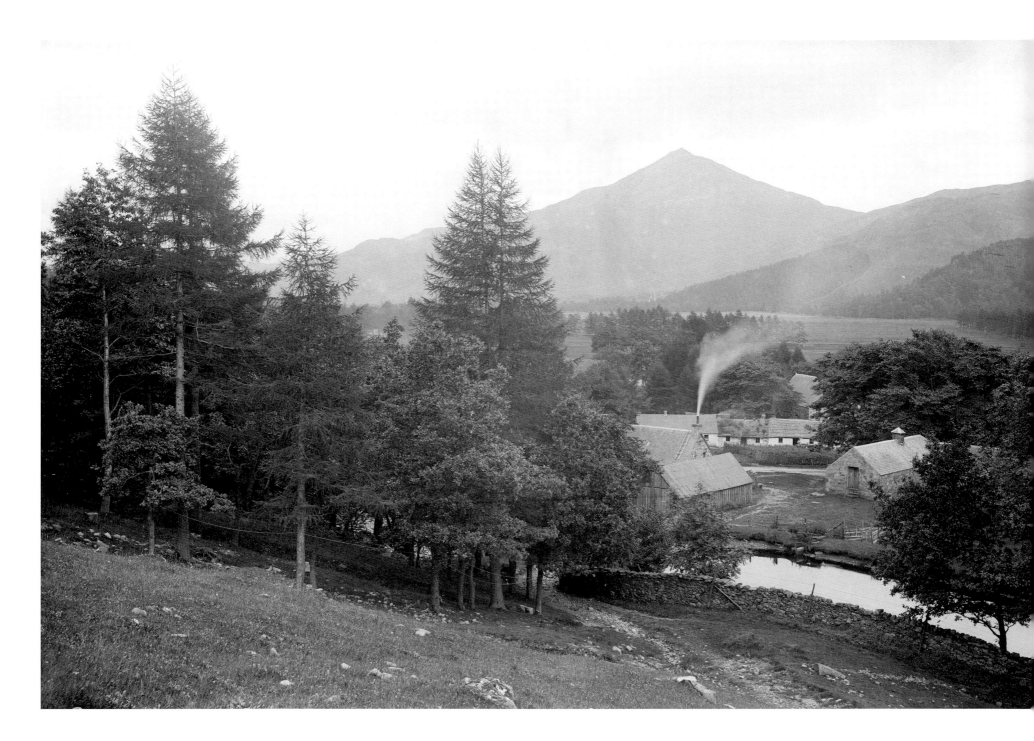

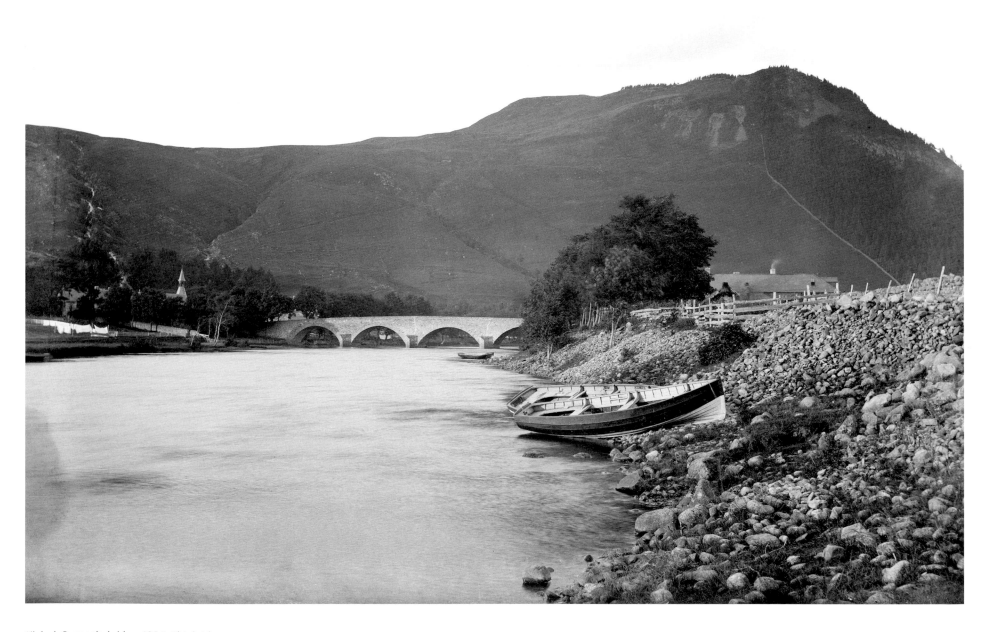

Kinloch Rannoch, bridge, 1884. This bridge over the River Tummel was built in 1764. SC1115900

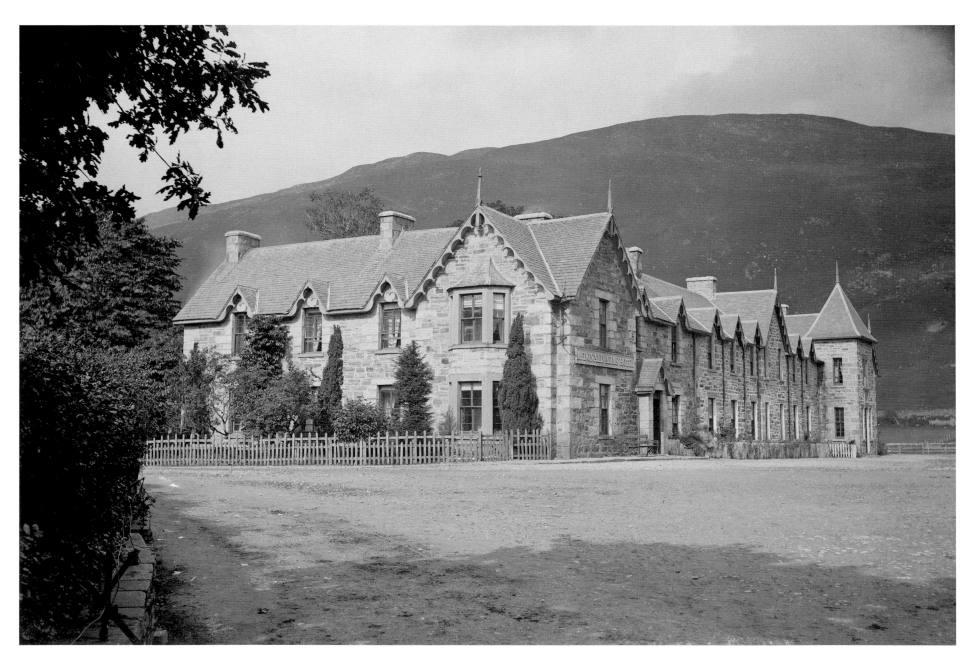

Kinloch Rannoch, hotel, c.1886. Originally a coaching inn, this had become the Macdonald Arms Hotel by the time Beveridge visited in 1886. It is now known as the Dunalastair Hotel. SC1113095

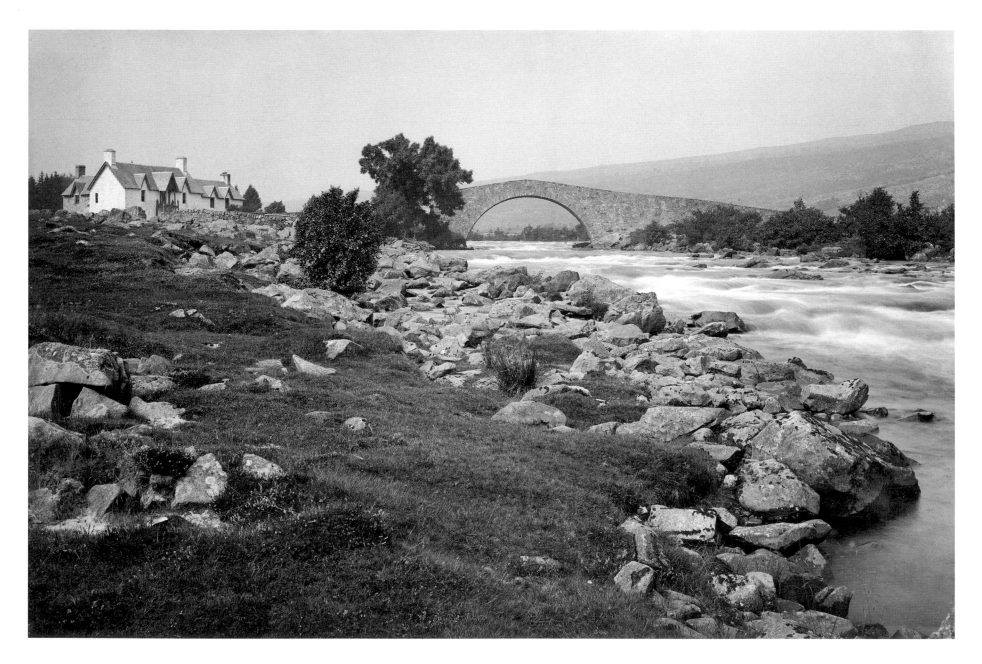

Tummel, Old Bridge, c.1896. This bridge was built in 1733 for
General Wade's military road from Crieff to Dalnacardoch.
A modern steel girder bridge now runs alongside. SC1115898

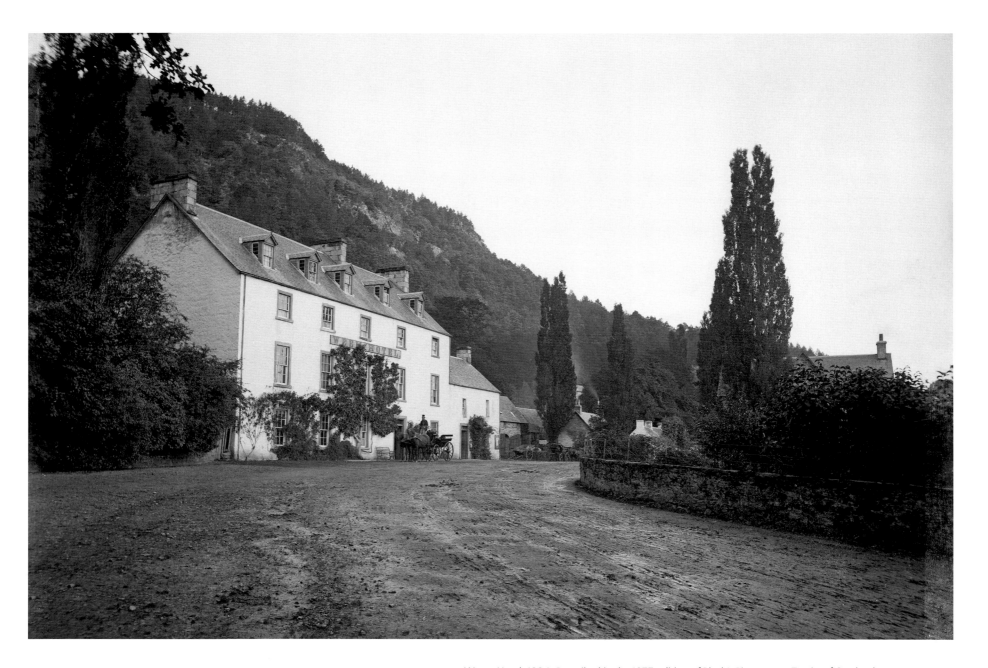

Weem Hotel, 1884. Described in the 1877 edition of Black's Picturesque Tourist of Scotland, a contemporary guidebook, as 'a delightful station for the tourist', Weem Hotel is an historic coaching inn, captured here by Beveridge, with horse and carriage at the door. It has changed little in external appearance today. SC1113099

References

Allen, J R and Anderson, J 1903
The Early Christian Monuments of Scotland, Edinburgh

Beveridge, D 1885
Culross and Tulliallan or Perthshire on Forth Its History and Antiquities, Edinburgh and London

Beveridge, E 1893
The Churchyard Memorials of Crail, Edinburgh

Beveridge, E 1901
A Bibliography of Works Relating to Dunfermline and West of Fife, Edinburgh

Beveridge, E 1903
Coll and Tiree: Their Prehistoric Forts and Ecclesiastical Antiquities, Edinburgh

Beveridge, E 1911
North Uist: Its Archaeology and Topography, Edinburgh

Beveridge, E 1917
The Burgh Records of Dunfermline 1488–1584, Edinburgh

Beveridge, E 1922
Wanderings with a Camera 1882–1898, Edinburgh

Beveridge, E 1923
The 'Abers' and 'Invers' of Scotland, Edinburgh

Beveridge, E 1924
Fergusson's Scottish Proverbs, from the original print of 1641, London

Beveridge, Lord 1947
India Called Them, London

Black, A 1877
Black's Picturesque Tourist of Scotland, Edinburgh

Curle, J 1911
A Roman Frontier and Its People – the Fort of Newstead, Glasgow

Gardner, M L G 2008
The History of Finsbay Lodge, Harris: Life and Fishing on a Hebridean Isle, Bradford

Groome, F H 1882
The Ordnance Gazetteer of Scotland, Edinburgh

Hallen, A W Cornelius 1890
An Account of the Family of Beveridge in Dunfermline, privately printed

Normand, T 2007
Scottish Photography: A History, Edinburgh

Proc Soc Antiq Scot
Proceedings of the Society of Antiquaries of Scotland

RCAHMS, 1928
Inventory of Monuments and Constructions in the Outer Hebrides, Skye and the Small Isles, Edinburgh

Walker, H 1991
Dunfermline Linen: The Story of Erskine Beveridge and St Leonard's Works 1833–1989, Dunfermline

An original storage box containing Erskine Beveridge's glass plate negatives for the Culross and Tulliallan area, 2009. DP052695

Index

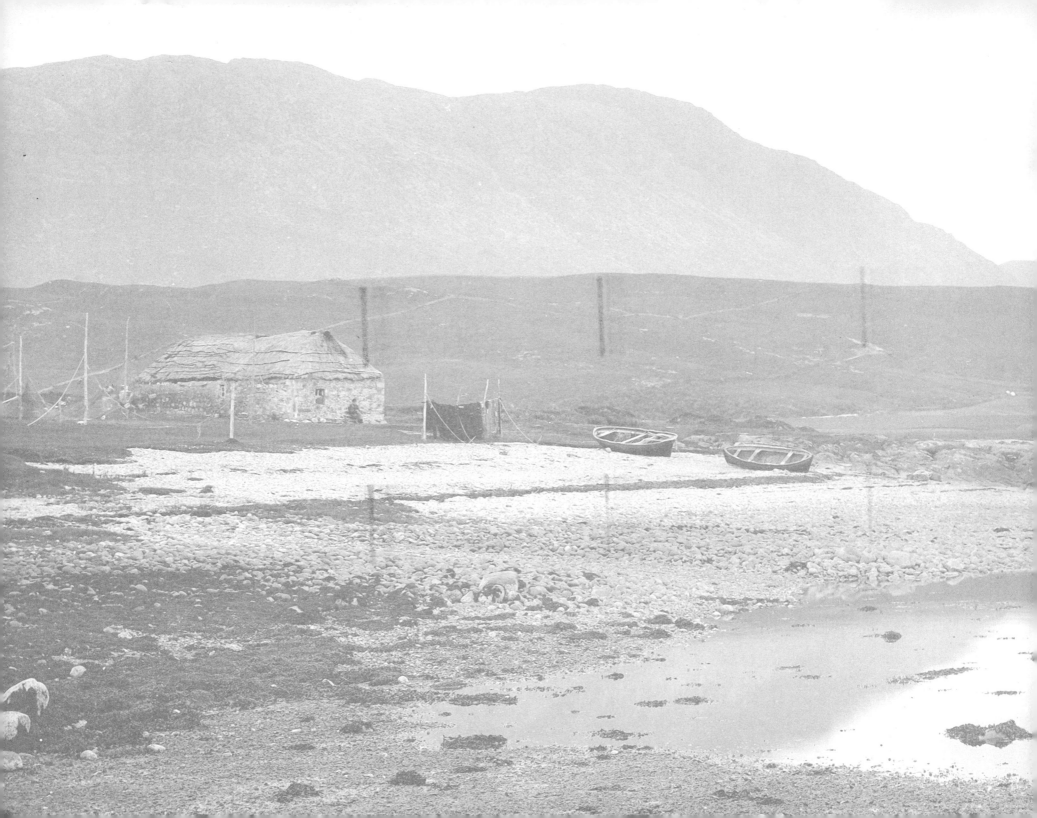